Occult Symbolism in France

Joséphin Peladan and the
Salons de la Rose-Croix

Robert Pincus-Witten

Garland Publishing, Inc., New York & London

1976

Library of Congress Cataloging in Publication Data

Pincus-Witten, Robert.
　　Occult symbolism in France.

　　(Outstanding dissertations in fine arts)
　　Originally presented as the author's thesis, University of Chicago, 1968, under the title: Joséphin Peladan and the Salons de la Rose+Croix.
　　Bibliography: p.
　　1. Arts, French. 2. Symbolism in art--France. 3. Paris. Salons de la Rose-Croix. 4. Peladan, Joséphin, 1859-1918. 5. Ros'crucians. I. Title. II. Series.
NX549.A1P56　1976　　　700'.944　　　75-23809
ISBN 0-8240-2003-0

Printed in the United States of America

A Garland Series

OUTSTANDING
DISSERTATIONS
IN THE

FINE
ARTS

FRENCH OCCULT SYMBOLISM

Fifteen years ago I began to think about occult symbolism in French art;
eight years ago this doctoral dissertation was accepted at the University
of Chicago. What appeared to be a graduate enthusiasm has maintained
an accruing fascination. Symbolist studies have burgeoned, and many
workers in the field have acknowledged my work in text and footnote. In
1968, the dissertation year, I published Les Salons de la Rose+Croix,
1892-1897, in conjunction with the first retrospective reconstitution of
the Rosicrucian salons. Godfrey Pilkington, director of the Piccadilly
Gallery, London, was intrigued by the curious interests of a green grad-
uate student and underwrote the catalogue, now a staple in Symbolist studies.
Pilkington's support in turn spurred the market for esoteric Symbolists of
academic persuasion, and his gallery has become a central clearing house
and information station for works of this kind.

I have been urged to publish my dissertation; the microfilm copy provided
by the University of Chicago is not a convenient study method. Yet, a
changed economic picture, coupled with the inertia of university presses,
scotched a projected publication through conventional university channels
and now has made them seem less attractive. Then too, seven years of per-
sonal development, one marked by an ever-growing commitment to Modernist
and American Studies, have drawn me away from these matters.

The art historical professoriate is not notable for its support of unexplored
regions of art history--such was the state of Rosicrucian studies in the 1960's.

I was made to feel shy about my concerns for the history of provincial
occultism in France in the nineteenth century, and my attention to Josephin
Peladan's maddeningly flamboyant criticism in the 1880's and '90's. I
have always acknowledged the inferiority of most of the art he promoted.
It was never "quality" that intrigued me, but the curiosity of the
events surrounding him--and more, the particular fascinations of Rosicru-
cian art , its sexual and religious focii particularly, allowed me to come
to terms with these elements in my own personality across an earlier
historical mode. More recent scholarship has made me aware that my work
opened wide the question of French, Belgian and English interchange in
the period, a research also that continues apace.

The footloose character of my graduate years permitted me the opportunity
for this overview; just as my subsequent teaching and critical burdens
disallowed time for the modifications it calls for. Among the simple re-
visions, there is a specific note of information: on page 168 I note that
a certain Gabriel Albinet has designed a poster for the third Salon de la
Rose+Croix of which no trace has been found. Oddly, this poster appeared
at auction on November 20, 1969, French Fin-de-Siecle Posters (Sotheby &
Co., London). The entry for item 84 identifies the work as that of the
mysterious Albinet. It is reproduced below as Fig. 67.

Symbolism marks my youth; Modernism my middle years. The time for me to
go back over all of this has passed. I am happy to have the opportunity
to put it forth, if even in an imperfect state.

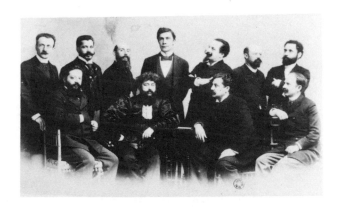

Rose+Croix+Kabbalistique, 1888

Front row, left to right:
 Papus, Peladan, Guaita.
Directly behind Peladan is
 Antoine de La Rochefoucauld.

THE UNIVERSITY OF CHICAGO

JOSEPHIN PELADAN AND THE SALONS

DE LA ROSE+CROIX

A DISSERTATION SUBMITTED TO

THE FACULTY OF THE DIVISION OF THE HUMANITIES

IN CANDIDACY FOR THE DEGREE OF

DOCTOR OF PHILOSOPHY

DEPARTMENT OF ART

BY

ROBERT PINCUS-WITTEN

CHICAGO, ILLINOIS

AUGUST, 1968

ACKNOWLEDGMENTS

The research preparatory to the writing of this dissertation was largely carried out in Paris during 1963-64 at which time I was an Exchange Fellow of the French government. Documentation was conducted at La Bibliothèque Nationale, La Bibliothèque de l'Arsenal (which houses the Fonds Peladan), Le Cabinet des Estampes and La Bibliothèque Jacques Doucet, many of whose staff were especially helpful.

Among the numerous private individuals who helped me I particularly would like to thank Mme Veuve C. Bourdelle, the charming widow of the great sculptor, her daughter and son-in-law, M. et Mme Michel Dufet, who provided me with documents preserved in the Bourdelle Museum; M. Jacques Fouquet, who, as director of the Schuffenecker Estate, permitted me to study personal papers connected with the painter; Her Svend Legind Gravesen, without whose assistance this thesis would never have been attempted; M. Pierre Lambert, secrétaire de la Société Huysmans, who opened the treasury of his library and mind to me; Lensbaron Holger Rosenkrantz and Baron Axel Rosenkrantz who, in 1963, invited me to Rosenholm, Denmark, to interview Lensbaron Arild Rosenkrantz, now deceased, then, I believe, the sole survivor of the Salons de la Rose+Croix; Mlle Yolande Osbert, for breaking my bouts of research with cups of tea in the studio of her father, Alphonse Osbert, where she still resides, and where she exquisitely

recounted the events of her father's life to whose memory she is so piously yet modestly dedicated.

In addition, let me thank M. René-Louis Doyon, author of La Douloureuse aventure de Peladan, who, in both letter and conversation enlarged by view of the Sâr; M. Jacques Lethève, Conservateur of the Cabinet des Estampes and one of the rare historians to have addressed himself to the question of the Salons de la Rose+Croix, for his thoughtful interviews on the subject; Mlle Gisèle Marie, librarian at the Bibliothèque Forney, author of Elémir Bourges ou l'éloge de la grandeur, for her souvenirs of Armand Point.

Last, I want to thank the dissertation directors, Professor Joshua Taylor, Professor John Rewald and Professor Francis Dowley of the Department of Art, the University of Chicago, for debts of gratitude which can never be repaid. Let me indicate but one--the task of advising me on the basis of a fatiguing typescript. Despite this onerous chore, one which spread over several years and across vast geographical distances, these professors' invaluable corrections and points of view were most helpful. Toward the end of this writing, I was helped in the secretarial chores, on this as well as the catalog for Les Salons de la Rose+Croix, published in London this year, by a dedicated assistant, Miss Ida Balboul.

TABLE OF CONTENTS

LIST OF ILLUSTRATIONS

INTRODUCTION

One evening, late in the Spring of 1918, Joséphin Peladan and his wife dined at the famous seafood house, Pruniers. During the meal, he who had been Sâr, attended by a circle of fin-de-siècle votaries, suffered a severe toxic reaction. Patiently nursed, he nonetheless succumbed on June 27, 1918 at the age of fifty-nine.

Peladan was interred at the cemetery in Batignolles, under the name "Joseph Peladan," in the Sépulchre Phillipart, third line, number five. His final resting place has not been undisturbed. The alignments have been carelessly looked after and the location of "3e ligne, no. 5" is no longer certain.[1]

The obituaries were short and unsympathetic since, if remembered at all, Peladan was associated with the then unfashionable literature of the turn-of-the-century. Even Guillaume Apollinaire wrote a hack's obituary, concluding that "This Magus of estheticism, this lover of dead arts, this herald of a hypothetical decadence, will remain a singular figure, magical and religious, slightly ridiculous but of great charm and of infinite delicacy, a lily in his hand."[2]

[1] Information kindly supplied me by M. Hegger de Lowenfeld, Paris.

[2] Signed "G. A.," Mercure de France, July 16, 1918, pp. 372-373.

1

No literary figure of the late nineteenth century had been more ridiculed, lampooned and caricatured. Each review, each newspaper had been prodigal in its coverage of the magus who from one hand let unfurl a banner of the Ideal, Tradition and Hierarchy and from the other a tri-color of Aristocracy, Catholicism and Originality. Caricatures, literary evocations, portraits by disciples, photographic frontispieces all had served to acquaint the public further with the squat, meridional features of the Thaumaturge, the Hierophant in dark velvet doublet and pantaloons, enlivened by lace at the throat and cuffs. For the city the Sâr preferred a flowing white robe covered by a huge cloak.[1] While travelling he went about in an astrakhan hat and long suède boots. The Sâr's Assyrian coiffure and beard were faddishly taken up by such rank imitators as "L'Ymagier" Andhré des Gachons or "Mérovak, the Cathedral-Man."[2]

His costumes and theories made Peladan the butt of much of the piquant and tireless mockery of the period. In the enemy camp were such notables as Rodolphe Cazalis, Laurent Tailhade and Léon Bloy. Their jokes at the Sâr's expense may be remembered longer than the homage of the faithful, such as Léonce de Larmandie and, for several critical years, 1884-1891, Stanislas de Guaïta.

[1] "Je dis qu j'avais lu quelques livres sur l'hermétisme, que j'avais vu M. Peladan se draper d'un morceau d'andrinople rouge qui lui servit de chlamydè . . . " Adolphe Retté, Le Symbolisme, anecdotes et souvenirs (Paris: Vanier, 1903), p. 26.

[2] Felix Hautfort, "L'Homme des cathédrales, Mérovak évoquera l'âme gothique," La Plume, No. 242 (May 15, 1899), pp. 328-325; Maurice Hamel, "Mérovak, L'Homme des Cathédrales," Gazette des Beaux-Arts, jan. 1962, pp. 53-60. Andhré des Gachons will be treated in Chapter IV of the present thesis.

Despite a once immense notoriety, Peladan lived to see his
fame dwindle into nothing. During his lifetime few critics addressed
themselves to the problem of his career. Among the earliest is Georges
Vitoux, whose Les Coulisses de l'au delà (Paris: Chacornac, 1902) re-
counts the history of the rosicrucian schism called the War of the
Two Roses. In 1904 a short biography by René-Georges Aubrun appeared
in the series "Les Célébrités d'aujourd'hui" (Paris: Sansot), which
was wholly sympathetic. Fernand Divoire published in 1909 Les Deux
Idées, Faut-il devenir mage? ... (Paris: Falgue) [1] a comparison be-
tween Eliphas Lévi's diabolism and Peladan's angelism, in favor of
the latter. Divoire's argument occupies a large place in Alexandre
Mercereau's La Littérature et les idées nouvelles (Paris: Falguière,
1912), a muddy discussion which overwhelmed the young Gleizes and
Metzinger. In 1910 the first modern Histoire des Rose+Croix by Paul
Sédir (Paris: Librairie du XXe siècle) spoke of the late nineteenth-
century revival, but with great indifference. Moreover Sédir's dat-
ing of the events is unreliable.

Prefacing a German edition of one of Peladan's novels in
1911, Strindberg made a few non-committal remarks concerning the
author's influence on a body of unidentified students.[2] Several of
the prefaces to posthumous editions of Peladan's novels preserved
the memory of the Sâr's earlier victories and defeats. In 1918,

[1] ... Eliphas Levi, Nietzsche, le surhomme et le mage, la
doctrine des forts.

[2] Joséphin Peladan, Das Allmächtige Gold, Roman, trans. Emil
Schering, forward by Strindberg, portrait of Peladan by Elie Brazil-
lier (München, Leipzig: Müller, 1911).

Gustave-Louis Tautain predicted in a preface to Peladan's <u>Les Dévô</u>-<u>tes d'Avignon</u> that

> Peladan's friends, in short his disciples, his commentators, his exegetes, will guard over the integrity of his glory. They will seek out, in the hundreds of volumes their master has left them, the number of esthetic anticipations that were formulated by him. They will prove that the Salons de la Rose+Croix had a notable influence on the evolution of French painting.[1]

During the 1920's an attempt was made to found a Society of the Friends of Peladan. Among its charter members were Peladan's widow, Victor-Emile Michelet, Gustave-Louis Tautain and René-Louis Doyon. M. Doyon wrote to me concerning this group that "We founded the Society of the Friends of Peladan to please his widow . . . it was a vain attempt. It exists no longer through indifference; the time to organize all that and the work had passed."[2]

In December, 1924, <u>La Nouvelle Revue du Midi</u> honored its Southern-born son with a special issue. Peladan's activities for the Salons de la Rose+Croix are not examined. It remains, nonetheless, an important source of Peladaniana. Throughout the 1920's, the Salons were not referred to. Henri Focillon's standard work, <u>La Peinture au xixe et xxe siècles</u> (Paris: Renouard, 1927-1928), barely mentions them and they are completely overlooked in the third volume, nineteenth and twentieth centuries, of André Michel's equally fundamental <u>Histoire d'Art</u> (Paris: Colin, 1929).

During this period of historical indifference Mario Praz pub-

[1]Joséphin Peladan, <u>Les Dévôtes d'Avignon</u> (Paris: Editions du monde moderne, 1922), preface by Gustave-Louis Tautain, p. 2.

[2]René-Louis Doyon to Robert Pincus-Witten, November 18, 1963, Paris.

lished The Romantic Agony (1933), the towering study of late nine-
teenth-century literature, in which Peladan played a large and,
according to Praz, discreditable role. While Praz offers no apology
on Peladan's behalf, the curious reader was once again directed to
Peladan's work, if only to corroborate Praz's interpretation.[1]

Equally arresting was the chapter dealing with "Esoteric
Symbolism and the Rose+Croix," in the catalog published in 1936 by
the Bibliothèque Nationale, Paris, to celebrate the fiftieth anni-
versary of Symbolism.

In 1937 Victor-Emile Michelet published Les Compagnons de
la hiérophanie (Paris: Dorbon). It is evident that Michelet's
chapter on Peladan owes much to the work of Vitoux. Following the
silence of World War II, René-Louis Doyon published La Douloureuse
aventure de Peladan (Paris: La Connaissance, 1946). Doyon traced
Peladan's career, interpreting it in the light of the Peladan
papers which he classified for the Bibliothèque de l'Arsenal, Paris.
These papers were donated in two groups by the widow of Peladan,
one batch in 1936, the other in 1941. Doyon has a tendency to sac-
rifice his subject to an ornate wit, although he has a sympathy for
Peladan's often impossible character. Doyon's biography, therefore,
is preferable to the tedious, purportedly objective work by Edouard
Bertholet, La Pensée et les secrets du Sâr Joséphin Peladin, of
which four volumes have already appeared under the aegis of the Edi-
tions rosicruciennes, Genillard, Lausanne. Instead of clarifying

[1] Recently A. E. Carter affirmed Praz's initial impression:
The Idea of Decadence in French Literature, 1830-1910 (Toronto:
University of Toronto Press, 1958).

the theories of the Sâr, Bertholet, assisted by Dantinne,[1] succeeds in further obfuscating Peladan's initially complex arena. These volumes are written with all the tractarian faults of myopic disciples.

Alone, the Salons de la Rose+Croix have received almost no scrutiny. Léonce de Larmandie's L'Entr'acte idéal (Paris: Chacornac, 1903) remains the essential work. Wilenski laconically mentions the Salons several times in his Modern French Painters, first published in 1936, and John Rewald's Post-Impressionism from Van Gogh to Gauguin devotes several pages to the Manifestations. But after two world wars the Salons fell into quiescent obscurity which Jacques Lethève's article in the Gazette des Beaux-Arts (December, 1960), "Les Salons de la Rose+Croix," made a first attempt to dispel.

The difficult thing to recognize is that Peladan's was the authentic voice, and manner, and vocabulary, of a six-year episode, the Salons de la Rose+Croix, which, for all their admittedly reactionary aspects, embodied several expressions of late nineteenth-century modernity. For the artists who collaborated with the Salons nothing was at stake. They were given a testing ground. The Sâr in turn lost everything.

From our vantage point the Salons de la Rose-Croix were ultimately a middle ground, therefore a compromise, between the blatant vulgarity of late nineteenth-century academic art and the then almost unintelligible pathways into the twentieth century. Paradoxi-

[1] Dantinne in 1940 brought out his own l'Oeuvre et pensée de Peladan.

cally, the adjective "rosicrucian" may now meaningfully be applied
to an early Bernard or Filiger as it equally stigmatives a vast
body of popular and sentimental art. If we no longer can admire
the vapid Dantes and Beatrices of rosicrucian taste, then at least
our judgment can be tempered with a compassion for a once most mod-
ern ideological struggle.

My assessments are not measurably more radical--though con-
siderably more extensive--than the opinions expressed by the few
historians who have addressed themselves to Peladan's crusade for
a new idealist renaissance. A self-styled visionary, Peladan's
criticism is seriously crippled by an excess of florid and pedantic
display. Owing to his over-riding italianism, fixated in earliest
childhood, the bitterness caused by the accruing triumph of Impres-
sionism grew even more unendurable when the twentieth century wit-
nessed the triumph of abstract art. Abandoned by the young artists
of his generation, even the most idealistic and, therefore, most
sensitive to his appeal, Peladan slowly gave up the role of Sâr and
animator and sought confirmation of his esthetic theories in the
past rather than the living art of the present. This renunciation
is both pitiable and admirable. By so doing, the Sâr once again be-
came human, and we tender him precisely what we withheld during his
tenure as infallible idealistic arbiter: our sympathy.

This dissertation then, not only traces the history of the
Salons de la Rose+Croix, and describes the climate of occult enthusi-
asm in the later nineteenth century, it also traces the career of one
of the most remarkable art critics of the Symbolist Movement whose

eccentric postures ultimately were of greater endurance than his esthetic positions.

CHAPTER I

PROPHETS

Joséphin Peladan's extravagance as art critic, novelist,
playwright, is considerably illuminated if one examines the influ-
ence of his family and milieu. Peladan was born in Lyon, a city
whose major intellectual figures are by and large mystics. We are
concerned with a reactionary extreme although the liberal cause is
perhaps more famous in connection with the Freemasonic lodges which
formed provincial rallying places in favor of the French Revolution.
But where there is one there is the other; the politically monarch-
ic, the religiously ultramontane, the artistically academic. Such
were the inclinations of Peladan's father--le Chevalier Adrien Pela-
dan, and of his brother--Dr. Adrien Peladan fils, and of Joséphin
himself. All three are exemplary figures of the generalizations
one makes about Lyon.

Le Chevalier Adrien Peladan was born on September 8, 1815,
in the first days of the Restoration in Vigan (Gard). His father, a
simple merchant, was unprepared for the poetic ambitions of his son.[1]
Joséphin later was to observe the Lamartinian strain in his father's
earliest poems, Effusions Catholiques (Paris: Debucourt, 1899): "All

[1]See H. Chobaut, "Les Ancêtres de Joséphin Peladan," Nou-
vell Revue du Midi. Bas-Languedoc et Provence, No. 10 (December,
1924), pp. 5-12.

he owned was a crucifix, a bible, and the poems of Lamartine."[1]

Thus, lightly equipped, Adrien went to Rome, received the Pope's blessing and began a new volume of Catholic verse. At this time he earned the honorific titles with which he decorated his future publications. The Order of the Golden Spur was founded in the Roman States by Pius IV in 1559 for meritorious work in the arts and sciences. Renewed successively by Gregory XIII, Sixtus V and Benedict XIV it had been cheapened by too frequent a conference, a traffic even, by Roman dignitaries. In 1821 the French government forbade the wearing of its cross, red ribbon and golden spur. In 1841 Gregory XVI, to whom Adrien dedicated his Melodies Catholiques nouvelles (Paris: Waton, 1841) suppressed the order and replaced it with the order of Saint Sylvester, or the Eperon d'Or reformé, to which Adrien was named Chevalier.

Moreover, the venerable Accademia dell'Arcadia, founded in Rome in 1661 to further the cause of arts and letters, also elected Adrien to its ranks. To commemorate this event Adrien composed an Eloge de Xavier Sigalon, poème précédé des deux muses, hommage à l'occasion de l'agrégation de l'auteur (Paris: Fulgence, 1842).

Sigalon, like Adrien, was born in the Gard in 1787. He went to study at the Ecole du Dessin in Nîmes--where so much of Adrien's later career was also to unfold--and in 1818 joined the studio of Guérin. In 1831 he was once more in Nîmes, leaving for Rome in 1833 with a

[1] Joséphin Peladan, La Décadence Latine. Ethopée VII. Coeur en peine. Commémoration du Chevalier Adrien Peladan et son portrait inédit par Séon (Paris: Dentu, 1890), p. xxv. Henceforth called Commémoration.

commission from Thiers to paint copies of the Sistine Ceiling. Peladan later qualified him as a "victim of his birth in Barbary--and the inanely bourgeois protection of Thiers."[1] During the execution of the commission Sigalon was struck down with cholera. Joséphin regarded Sigalon as a "painter of genius, superior to Ingres, the equal of Sebastiano del Piombo,"[2] a lapse of taste based on filial respect in an otherwise knowledgeable art critic. It must never be forgotten that Joséphin's taste was formed in Lyon where the academic and ideologically surcharged product, that of Chenavard for example, was extravagantly admired. The subsequent relaxing of this tight style, which comes from David, leads to the "ideal" style most closely associated with Lyon, that of Hippolyte Flandrin, Louis Janmot, and towering above all others, Puvis de Chavannes.

In Nîmes, on August 2, 1843 Adrien married Joséphine Vacquerie and on June 18th of the following year the first of his two prodigious sons was born, Adrien Peladan fils. In the meanwhile Adrien père had opened a school, le pensionnat Saint-Louis, which offered a stolid religious education to the boys of the district. In addition to these duties Adrien also founded a newspaper, l'Etoile du Midi, the first of a long succession of newspapers devoted to the cause of the Bourbon restoration. The Revolution of 1848 brought both of these enterprises to an end. Louis Bonaparte

[1] Ibid., p. xvii.

[2] Joséphin Peladin, Oraison Funèbre du Docteur Adrien Peladan fils, avec deux portraits d'après un tableau et une photographie dessinés par L. Legrand (Paris: Librairie de la Presse, 1886), p. 25. Henceforth called Oraison.

suppressed the legitimist press. Adrien left for Paris with his
family where they lived on a meager income earned by Adrien's tutor-
ing of students preparing their baccalaureate examinations.[1]

According to Joséphin, "Napoléon III . . . offered l'Offi-
ciel [the house organ of the Bonaparte family] to Chevalier Peladan;
a useless offer that the royalist writer refused, although he would
have had only an impersonal relationship with the acts of the Em-
pire."[2] Given the importance of l'Officiel, and Adrien's fervent
anti-Bonapartist sentiments, it seems incredible that this should
have transpired. Joséphin himself relates a variant of the story in
his novel Istar. Be that as it may, Adrien refused the post and
left Paris with his family for Lyon. Doubtless the period spent in
Lyon was the most happy and active of his career. His house became
a salon in which the élite of Lyon's intellectuals and artists met.
A whole circle of poets, the so-called "pléiade lyonnaise,"[3] domi-
nated by Joséphin Soulary--in whose honor little Joseph became José-
phin--orientalists, classicists, literary figures, church dignitar-
ies, all frequented Adrien's house in the rue Sainte-Hélène.[4] Among

[1] Eugène Vial, "Adrien Peladan père, journaliste à Lyon
(1856-1870)," Revue du Lyonnais, No. 6 (1922), pp. 91-104, 92.

[2] Peladan, Commémoration, p. xxxiii.

[3] See Paul Marieton, Joséphin Soulary et la Pléiade Lyonnaise
(Paris: Marpon, Flammarion, 1884).

[4] In the Oraison Joséphin cites the poets Joséphin Soulary,
Victor de Laprade, Achille Millieu, Thalès Bernard, Turquety, Xavier
Bastide, Pourrat, Roumieux; the orientalist Bonnety, de Paravey,
Chabas, de Rougemont; the literary figures Canonge, Blanchd de Bré-
nas, de Laincel, L'abbé Joseph Roux; the scholars Péricaud, Morel de
Voleine, Saint-Olive; the archeologists de Saint Audéol, L'abbé
Cochet, de Mirville "et cent autres" (p. 14). In the Commémoration

the painters we find Chenavard's student, Joanny Chatigny, one of
Lyon's best-known artists, then much admired for his robust land-
scapes.[1]

In October 1856 Adrien founded Le Feuilleton which lasted
until April, 1857 when it became La France littéraire, artistique et
scientifique, enlisting its collaborators from among Adrien's circle.
This in turn was absorbed on November 30, 1866, by La Semaine Reli-
gieuse de Lyon which Adrien edited from 1863 to the fall of the Sec-
ond Empire. During this period Adrien also brought out La Russie au
ban de l'univers et du Catholicisme, which he recommended in an open
letter to the attention of community leaders in the hope that they
in turn would recommend it to their constituencies.[2]

In the meanwhile the precocity of Adrien fils was taken into
account and his training was placed in the hands of a celebrated mys-
tic, l'Abbé Paul Lacuria.[3] L'Abbé was also known in art circles

Joséphin adds "le fondateur de l'Anatomie homologique, Peladan fils"
(p. 25). Eugène Vial's article cannot be praised too highly for
placing for the reader, a multitude of minor personalities, the
pride of the local historian, who moved in Adrien Peladan's sphere.
In Joséphin's novel, La Décadence Latine, Istar (Paris: Edinger,
1888), p. 87, he again enlarges the circle of friends surrounding
his father and includes in this list Joanny Chatigny, Chenavard's
pupil.

[1]Chatigny, who died in 1886, was posthumously honored in the
Salon de la Rose+Croix, 1897, which included two of his works, a
portrait of Joséphin's father and another of his brother.

[2]See "Lettre Circulaire de M. Ad. Peladan, en date du août
1854 concernant son ouvrage intitulé 'La Russie au ban de l'univers
et du catholicisme,' et addressée au maires pour leur conseiller
l'achat de cet ouvrage" (Lyon: Vingtrinier, 1854), Bibliothèque
Nationale, Paris, Mp1145.

[3]In one of Joséphin's extraordinary lists we find" "Manou,
Krishnah, Boudha, Zoroaster, Moïse, Orphée, Pythagore, Platon,

through his brother, the painter Louis Lacuria, an intimate friend
of Hippolyte Flandrin and one time associate of Overbeck's student
the church decorator Orsel, also from Lyon. Seeing that Louis was
in straitened circumstances, L'Abbé Lacuria called his brother back
to Lyon where he taught drawing at the Oullins Institution, now the
School of Saint Thomas Acquinas, as he had learned it in Ingres's
studio. Doubtless some of the strong Ingriste and Pre-Raphaelite
streak in lyonnais art is traceable to this artist.[1]

At the age of 12 Adrien fils wrote an Histoire poétique des
fleurs which was printed in the first number of La France littéraire.
Joséphin was to remember that "its style and erudition stunned Sou-
lary. . . ."[2] Adrian père at this time had been unanimously elected
to the Société littéraire de Lyon before which he frequently lec-
tured[3] and began to publish a series of articles in La France litté-
raire which were brought out by Dentu in Paris, later to become one
of Joséphin's chief presses, in 1860. This work praises the cultural
fermentation of the provinces--true enough in the case of Lyon--and
decries Paris as the source of literary corruption, the main abuse
being the tyranny of editors. In 1861 Adrien père brought out a col-

Descartes, Spinoza, Lacuria." Bulletin Mensuel de la Rose+Croix du
Temple et du Graal contenant le catalogue du IVe Salon ouvert du 20
mars au 20 avril, de 10 à 6 h., 5, rue de la Paix, IIIe année, Série
éxotérique, No. 1 (April, 1895), p. 14.

[1]See Claire Tisseur, "Lettre d'Hippolyte Flandrin [à Lacur-
ia]," Revue du Lyonnais, receuil historique et littéraire, No. 29
(May, 1888), pp. 341-350.

[2]Peladan, Oraison, p. 14.

[3]Vial, op. cit., p. 100.

lection of poems called <u>Assises provinciales</u> (Paris: Dillet).

On March 28, 1858--though this sometimes is reported as 1859 --Joséphin was born. His birth certificate carries the name Joseph Aimé Peladan. His brother was fourteen at the time and had just written <u>Coups de fouets scientifiques</u>. At sixteen he was to undertake the formidable task of learning Chinese, probably spurred on by the famous sinologist, Charles de Paravey (1787-1871), an intimate of the family. On Joséphin's account, among the esoteric issues that attracted Adrien fils at the time was the demonstration that the character <u>Fou-Sang</u> in early Chinese writing indicated the American continent; that numbers and letters of all peoples stemmed from a single source; that the writing of antedeluvian times was hieroglyphic; that the name of ancient Judea was "Ta-Tsin." Equally taken with Assyriology Adrien fils studied the monuments of Ninevch and Babylon--a taste in <u>décor</u> that Joséphin did much to popularize at a later date--and sought the ancient appelations of God. Antique notions of the zodiac fascinated him, including one called "androgynous" by Joséphin who later had recourse to this theory in a study <u>De l'Androgyne</u>, published in 1910. Perhaps contemporary scholarship would not credit young Adrien's researches into Sinology, Etymology, Assyriology and Theology. My purpose in signaling these pursuits, which Joséphin gives <u>in extenso</u>,[15] is merely to demonstrate the unnerving erudition of a boy not turned eighteen. Need one add that he was also an amateur painter. Doubtless young Adrien was furthered and flattered by the attentions of the distinguished and erudite

[15]Peladan, <u>Oraison</u>, p. 15.

friends of his father. It is certain that Charles de Paravey is echoed in these undertakings. We know that several of his works were annotated by Adrien père, including the Recherches sur les noms primitifs de Dieu (Roanne, 1866). And Joséphin, writing De L'Androgyne, lifted his "plastic theory" in good part from Paravey's De la création de l'homme comme androgyne et de la femme (Paris, 1864).

Remembering these halcyon days in the provinces, Peladan was to write:

> The oldest recollection of my childhood takes me back to the cénacle in the rue Sainte-Hélène, where, in the midst of library shelves overflowing with brochures and books, I saw pass in a single day robes of sackcloth and violet soutanes, the archdiocese of Algiers and of Saint-Bonnet; where I left the knees of the Vicar of Trévoux for those of Soulary. I still hear the lively Hebrew words, Latin phrases, and now, this corner of Lyon seems like a corner of Florence, transported as if by magic--no, accomplished by the faith of Chevalier Peladan.[1]

Here too, Joséphin received his first lessons, for in the same building the Misses Blanchard, five spinsters, ran an elementary school. From his earliest years Joséphin displayed a clear disposition for his future calling; while his playmates amused themselves with marbles, Joséphin preached chastity and, one day, "illuminé," he forceably baptized one of his Jewish schoolmates.[2] Certain of Joséphin's childhood experiences were later related in the fifth novel of "La Décadence Latine," Istar.

Of his intellectual pursuits, perhaps young Adrien's archaeological work dating from this time remains most interesting to us. At twenty he published a Guide de l'amateur et de l'étranger à Lyon

[1] Peladan, Commémoration, pp. xxxv-xxxvi.

[2] Vial, op. cit., p. 102.

et dans les environs ... [1] The chapter dealing with the ancient his-
tory of the city is still useful. Similarly, other archaeological
works appeared by the young scholar, such as a Guide Historique de
Lyon, [2] a Monographie de la façade de la cathédrale de Nîmes ... , [3]
and a Guide Pittoresque, historique et médical de Saint-Alban ... [4]

Young Adrien, aided by his father, produced a Traitement
Homeopathique de la Spermatorrhée, de la Protatorrhée et de l'Hyper-
sécrétion des glandes Vulvo-Vaginales (Lyon: chez l'auteur, 1869)
which Albert Caillet, the great bibliographer of the arcane, de-
scribed as "a curious work owing to the erudition of its author who
has filled it with philosophical reminiscences and Kabbalistic cita-
tions."[5] Adrien père and fils are typical of a late nineteenth cen-
tury condition, the tendency to synthesize in speculative matters.
The same intellectual feature mars even Joséphin's most considered
efforts.

The capacity for synthesis--Adrien père's between politics
and prophecy, and Adrien fils' between science and arcana, reappears

[1] ... historique, archéologique, scientifique, monumental,
commercial et industriel, sur un plan tout nouveau, etc., avec un
plan de la ville, etc., par Adrien Peladan fils (Paris: Duprat,
1864).

[2] (Roanne: ie Ferlay, 1863), first published in La France
littéraire.

[3] ... archéologie monumentale et iconographique (Roanne: de
Ferlay, 1867, first published in La France littéraire.

[4] ... et ses environs (Roanne: Durand, 1868).

[5] Albert Caillet, Manuel Bibliographique des sciences psy-
chiques ou occultes, III (Paris: Dorbon, 1913), 246.

in even more grandiose forms in Joséphin. Imitating Balzac, whom he
venerated as the greatest modern literary figure, Joséphin subordi-
nated all areas of his polygraphic activities to a great scheme.
His twenty novels are part of La Décadence Latine: Ethopée, a huge
literary fresco depicting the manners of an epoch; his numerous es-
says on art are part of La Décadence Esthétique (Hiérophanie); seven
volumes of philosophy are part of an "Amphithéâtre des Sciences
Mortes."

During the 1860's France was experiencing intense economic
activity, largely spurred by Napoléon III's strong industrial and
colonial sympathies. This materialist attitude was echoed in the
sciences--the familiar figure cited is Pasteur--and in religion. In
1863 Ernest Renan of the Collège de France, the greatest biblical
scholar of his age, published a Vie de Jésus, as accurate a recount-
ing of Jesus's life as was possible at that time. This "Life" which,
after the Gospels, is perhaps the most famous, was considered by a
large section of the population to be a sceptical reconstruction if
not overtly blasphemous. Adrien père retaliated with Satan-Renan
(Roanne: de Ferlay, 1863).

As 1869 drew to a close, Pius IX assembled the first ecumeni-
cal council of modern history. To honor this council, Adrien edited
a huge volume of 588 pages, La France à Rome. Album de la poésie
catholique (Lyon, 1870) containing the offerings of more than a hun-
dred poets dedicated to Pius IX. Adrien contributed a Regnum Dei
and Adrien fils an essay. But perhaps most important, the effects
on the Peladans was incalculable.

Young Joséphin must have been vividly struck by the central
issue of the agenda, the elevation of the doctrine of Papal Infalli-
bility to dogma. Actually the doctrine had been traditionally ob-
served but never before had it been officially promulgated by the
Holy See. Recent political events in Italy had greatly diminished
the secular power of the Church, and Pius IX saw in the doctrine of
Papal Infallibility a restrengthening of the Church's position as a
political agency. Joséphin was to incorporate a blatant imitation
of this church doctrine when later, as Sâr, he declared his views
ex cathedra and infallible [1]

The political events of 1870 brought the "cénacle in the rue
Sainte-Hélène" to an end. In a remarkable aside, Joséphin flatly
asserted that the Peladans had had premonitions of this "Latin an-
guish"[2] and left Lyon after first having warned their neighbors of a
coming German invasion, which, in fact, came to pass a few months
later.[3]

A friendly ecclesiastic, the Archbishop Dubreuil, called the
Peladans to Avignon. From there they continued to Vigan, Adrien
père's birthplace, on to Lille where he directed La Vraie France and
then back again to Nîmes. The Franco-Prussian hostilities gave new
impetus to Adrien's eccentric Bourbonism. In the wake of the Second
Empire he became a fervent Henriciste, that is, a supporter of Henri

[1] Joséphin Peladan, "Restauration de la Rose+Croix esthétique,
parole du Sâr de la Rose+Croix à ses pairs," Le Salon de Joséphin
Peladan (Dixième Année), avec instauration de la Rose+Croix esthé-
tique (Paris: Dentu, 1891), pp. 57-58.

[2] Peladan, Oraison, p. 22. [3] Ibid., p. 19.

V, Bourbon pretender to the throne, spicing his politics with admixtures of prophecy.

Adrien fils, badly myopic, who first had been refused for poor health, then for poor eyesight, was called to the colors. This event made a deep impression on Joséphin who dwelled at length on the ignominy of his brother's military service:[1] the insults of sergeants, the cropping of his brother's magnificent head of hair--a sartorial effect often parodied when lampooning the Sâr--the forced training "like a slave or convict" under inclement weather, the abuse of stupid superiors.[2] After three months Adrien fils was released. Of his own physical examination Peladan recalled that "one pinched me as one might have a pig, me, tabernacle of an immortal soul, premature mediator of the Apocalypse."[3] Fortunately for Joséphin, the universal draft laws of the Third Republic made provisions for seminarists, and various tactics could be deployed until the issue grew stale and perhaps slipped by. In any case Joséphin never performed a military service although he was imprisoned for two days in 1886 for ignoring a notice from his draft board.[4]

On the day Adrien fils was released from the army, he led his younger brother before the Palace of the Popes in Avignon, then transformed into barracks, and gave the following advice: "Only attach yourself to eternal things, be virtuous, create, but only serve

[1]Ibid., p. 27. [2]Ibid.

[3]R.-L. Doyon, La Douleureuse Aventure de Peladan (Paris: La Connaissance, 1946), p. 40.

[4]Ibid., pp. 53-55.

the Church, 'Leges popularum vanae sunt.'"[1]

The influence of Adrien fils on Joséphin can scarcely be ex-
aggerated. He was mentor and hero to his younger brother. "He was
my initiator, and all that I may have written that is new or profound
was taught to me by him," Joséphin acknowledged in the Figaro of Octo-
ber 8, 1885 on the occasion of his brother's untimely and tragic
death. At this time Joséphin also wrote a eulogy for his brother,
the Oraison Funèbre du Docteur Adrien Peladan fils which contains
numerous biographical facts pertaining to the lives of his brother
and father.

Owing to the shifting fortunes of his father, Joséphin had
been shunted about from one Jesuit college to another, first in
Avignon then in Nîmes. Here he received special training from the
occultist Firmin Boissin, "Commander of the Rose+Croix, Prior of
Toulouse and Dean of the Council of Fourteen."[2] The boy's intellec-
tual narcissism ran against the grain of Jesuit training. His grades
were mediocre, and he failed his baccalaureate examinations. These
adolescent years were to supply material for several novels, notably
Istar, L'Androgyne, and Gynandre. His tendency to egocentricity, to
originality and pridefulness, together forming the theological sin
of ipseity, according to Doyon, grew stronger.[3]

[1] Peladan, Oraison, p. 22.

[2] "Commémoration de Firmin Boissin (Simon Brugal)," Catalogue
des oeuvres de peinture, dessin et sculpture exposées au troisième
Salon de la Rose+Croix, du 8 avril au 7 mai (Paris: n.d. [1894]).

[3] Doyon, op. cit., p. 29.

In Nîmes Adrien père continued to preach Bourbonism, hiding his name in transparent disguises. As "A good Frenchman from the Midi" he put forth an _Almanach des Blancs_,[1] the color of the Bourbon flag to distinguish it from the tri-color of revolutionsts and republicans, as well as a _Vie Nouvelle de Henri de France_.[2] An army of Sybils, ecstatics and prophets was assembled in his _Nouveau Liber Mirabilis ou toutes les prophéties authentiques sur les temps présents_.[3] He founded _Le Châtiment_[4] which invoked and presaged the wrath of God on the new republic. _Maréchal_ Mac-Mahon, its president, was vilified as a Judas Escariot for idly sitting by while the Italian Revolution threatened the safety and property of the Pope. Adrien was fined three hundred francs and sentenced to prison for a month and a day, later commuted to six days.[5]

He rashly published an article by his elder son, who had been associated with the paper from its inception, libelling a certain Professor Rouget, physiologist on the Montpellier faculty, for "the most lewd materialism." It was, however, at Montpellier that Adrien fils was to pass his final examinations. On presenting himself for his public orals, he was shouted down by the student body while the dean and faculty impassively sat by.[6] This concluded Adrien fils'

[1] 1ère année (Nîmes: chez l'auteur, 1872).

[2] (6th ed.; Avignon: Roumanville, 1872).

[3] (Nîmes: chez l'auteur, 1871).

[4] _Le Châtiment, journal hebdomadaire, littéraire et politique de Nîmes_, June, 1872 to February, 1875.

[5] Peladan, _Oraison_, p. 22. [6] _Ibid._, p. 23.

university career; while resigning himself to a simple and respecta-
ble practice, he privately continued his occult and homeopathic re-
search.

L'Homéopathie des Familles et des médecins was brought out
in Nîmes in 1875. As in his earlier medical writings, Adrien fils
did not hesitate to incorporate articles on the Kabbala and Saint
Raphael, the patron of medicine.[1]

In November of 1874, Adrien père left Le Chatiment owing to
a clash with M. Adophe Peyre, also a "Chevalier," erstwhile novelist
and future Deputy. In February, 1875 the paper was absorbed by the
Gazette de Nîmes. Adrien père recorded the events leading to this
break in Ma Retraite du Châtiment ... , very tellingly suivie des
dernières prédictions de la voyante de Fontet (Nîmes: chez les li-
brairies, 1874). This capacity for self-justification and blind
rationalization--as if issues were crystal clear and the plaintiff
had but to await the inevitable approbation of history--is even more
marked in Joséphin. His plays are prefaced with the rejection slips
and refusal letters of theatre directors; his Salon criticism begins
with lists of grievances against the ineptitudes of his colleagues.
He courted abuse. This vengeful trait passed in the period for Meridi-
onal fancy, but to our eyes it borders on paranoia. Joséphin's ex-
cesses in letter and garb are by far his least agreeable feature.

[1]The assiduous nineteenth-century bibliographer Otto Lorenz
looks down on this work as merely the repackaging of twelve issues
of L'Homéopathie des familles et des médecins, edited by Adrien fils,
to which a new title page and cover had been added. See Otto Lorenz,
Catalogue Générale de la librairie française depuis 1840, X (Paris:
Chez l'auteur, 1887), 300-301.

Adrien père continued his journalistic activities in a new paper called L'Extrème Droite, which folded on April 29, 1877, from public indifference. Oddly enough, Adrien père's special pleading and prophetic ardor does not seem so strange when presented with the very real political issue centered on Henry V, whose cause was lost, not by the peculiarities of isolated royalists, but rather by his own intransigeance. Indeed, at the fall of the Thiers government in 1873, the Count of Paris--Orleans, pretender to the throne but successor to Henri's claim since the latter's marriage was without issue --had reconciled his interests with those of Henri to form a united royalist front to whose wishes the politically inept Mac-Mahon was prepared to defer. But Henri refused to become a constitutional monarch, clinging to the notions of Divine Right and to undisputed monarchy whose interests were coincidental with those of the Church. This negation of the principles of the Revolution led to the defeat of a Bourbon-Orleans Restoration which actually had been brought before the Assembly for consideration. All Henriciste hopes were thwarted by Henri's death in August, 1883.

Adrien père had proven himself a worthy supporter and was given the honor of bringing out a collection of Lettres d'Henri V, depuis 1841 jusqu'à présent (Nîmes, 1873). According to Bernard Latzarus, one of Adrien père's rare biographers, Adrien was regarded equivocally by the Henricistes of Nîmes,[1] among them a M. de Surville,

[1] Bernard Latzarus, "Poète et Prophète, Le Chevalier Adrien Peladan," two installments in Nouvelle Revue du Midi (Bas-Languedoc et Provence), No. 1 (January, 1924) pp. 4-36 and No. 4 (April, 1924), pp. 193-203. See April, 1924, pp. 195-196. For additional informa-

who lent Adrien certain letters of Henri V for an edition brought out
in eight-page installments in 1874.[1] Certainly there would be much
to fear in a constituency based on the interpretation of prophets
such as Nostradamus. Even Joséphin referred to his father in this
respect as "a dangerous enthusiast."[2]

His career as a journalist over, Adrien père threw himself
into occult research with renewed vigor, and once more father and
first born found themselves occupied with similar questions. In
1878 Adrien père published two volumes: La Vallée des lys, ou His-
toire de la Très Sainte Vierge et de son culte, reprinted in 1880,
1883 and 1889, and praised by Pope Leo XIII. His monumental Preuves
éclatantes de la Révélation par l'histoire universelle (Paris: Palmé,
1878) contained discussions of the kabbala, and of comparative reli-
gion--the fall, the messianic tradition, serpent symbolism in a vari-
ety of cultures including China, India, Persia, and America.

He attempted to revive a veneration of l'éclanche, that is
the wound in Christ's shoulder. However, this cult in which a dis-
creet financial interest played a role--the sale of an engraved re-
production of a Memling painting showing the wound--rebounded. The
Bishop of Nantes forced Adrien's hand and he was obliged to recant,
not without a customary epistolary revenge. On April 2, 1879, Adrien

tion of Adrian père see, too, Joanny Bricaud, "Le Chevalier Adrien
Peladan," Revue d'histoire de Lyon, Etudes, Documents, Bibliographie,
III, Fasc. 3 (May-June, 1904), 228-232.

[1]The name "de Surville" crops up again in the 1893 catalog of
the Salon de la Rose+Croix as a collector of Marquestde Vasselot.

[2]Latzarus, op. cit., p. 196.

published an open Lettre ... au Pape au sujet d'une image de sainteté représentant l'image de la plaie de l'épaule du Christ, propagée par [Adrien Peladan] et blâmée par l'évêque de Nantes.[1]

Undaunted, Adrien continued his researches in the prophetic and numerous editions of a Dernier Mot des prophéties ou l'avenir prochain ... [2] followed annually on each other's heels, their difference being that each successive year saw the addition of a new voyant who predicted the coming of a new political saviour.

These were not, however, the last words. Adrien's best known publication, Les Annales du Surnaturel, a monthly review which continued steadily from 1883 until his death in 1890, was his final testament. On the pages of Les Annales du Surnaturel Adrien gave full range to his synthetic powers, combining prophecy and politics, that left its mark in the occult explosion of the 1880's. "Adrien considered the journalist to be a priest, the newspaper an annex of the pulpit," said Joséphin.[3] On January 18, 1884, Monsignor Besson, the Bishop of Nîmes, denounced Les Annales du Surnaturel for its mixture of piety, politics and supernaturalism.

The fact that the Naundorf claim had been discredited and finally thrown out of the Paris Court of Appeals in 1874 after a half-century of hearings did not deter Adrien from adopting it enthusiastically. The Naundorf affair is a thorny one, and as many pages

[1](Nîmes: Clavel-Balivet, 1879).

[2]... dévoilé par plusieurs centaines de textes authentiques (Nîmes: chez l'auteur), 2 vols. published throughout the 1880's.

[3]Peladan, Commémoration, p. xxix.

were written about it as there were passions aroused. But Adrien
père approached it in highly personal terms. On September 8, 1883
it was revealed to a vague figure named Joséphine Reverdy, who came
from Bouleret (Cher), that, in the event of the death of Henri V,
France would still be saved by a legitimist pretender. In her vi-
sion she saw a new Pope, no longer Leo XIII, approach a mysterious
personnage and crown him king. In Paris, at the same moment, a
photograph of Louis-Charles Naundorf was being distributed. Louis-
Charles was the son of a remarkable impostor named Karl-Wilhelm
Naundorf who, alone of some forty pretenders to the Bourbon crown at
the time of the ascendance to the throne of Charles X, was able to
put forth a claim acceptable in many quarters. He dissembled as
Louis-Charles Bourbon, Duc de Normandie, the second son of Louis XVI,
i.e., Louis XVII. On his death, then, in 1845, his son became--were
his claim respected--Dauphin. According to Mlle Reverdy, the fea-
tures of the unknown king in her vision were identical to those of
Louis-Charles' picture. This was sufficient proof for Adrien and he
published the vision on the pages of <u>Les Annales du Surnaturel</u> as
well as, separately, in the <u>Apparitions de Bouleret ...</u> [1] which knew
several editions. The energy he had formerly expended on Henri V
were now transferred to the Naundorf cause. In 1874 the Naundorf-
cum-Bourbon attempted legally to effect this name change, but the
petition was denied. The question aroused a great deal of public in-
terest, and so much uncertainty was generated--and to some measure

[1] <u>... Cher, Prophéties et à un avenir prochain</u> (Nîmes: chez
l'auteur, 1883-).

never resolved--that we find echoes of it well into the 1890's.[1]

These events, however, paled before the dreadful occasion of the death of Adrien fils. For fifteen years Doctor Peladan had practiced in Nîmes. He was "a luminary doctor; he had the key to hidden things, . . . he knew the secondary causes . . . I Testify," Joséphin asserted, "before the incredulity of the century, that, in 1879, Doctor Peladan . . . told me: I am menaced by dying poisoned by a foreign medicine that I will administer myself."[2] The premonition proved true. On September 29, 1885, a druggist in Leipzig, Wilmar Schwab, compounded an insufficiently diluted preparation of strychnine Doctor Peladan had been using in his homeopathic self experimentation. It swiftly took the doctor's life.

To commemorate this terrible event, Joséphin wrote the Oraison Funèbre for his brother. It is the clearest statement we have of Joséphin's debt to his family. Despite its many failings, the pose of a prophet in his country, the excoriation of the Nimois for their parochialism and barbarism, its heady, facile prose, and its sincerity nonetheless are elements that are missing in Joséphin's other works.[3]

[1] Leon Deschamp's influential review La Plume devoted no less than five of its special issues to the affair. "La Question Louis XVIII," La Plume, Nos. 247-251 (August 1-October 1, 1889).

[2] Peladan, Oraison, p. 29.

[3] "Français et Catholique, le docteur Peladan a été tué par un remède allemand et protestant! ... l'Allemagne est la grande Locuste de l'Occident! ... Voyez que Dieu en le [Adrien fils] faisant seul victime du poison allemand a sauvé plusieurs d'entre vous!" Ibid. On October 8, 1885, Joséphin wrote Le Figaro to warn homeopathic physicians against Wilmar Schwab's pharmacy. He related

The next year Joséphin prefaced his brother's <u>Anatomie Homo-logique ...</u>[1] His father listlessly continued to propagate the cult of Saint Christopher, protecteur de nos sieux ...[2] and to edit <u>Les Annales du Surnaturel</u>, but both of these works had been begun prior to Doctor Peladan's death. In March, 1890, in his seventy-fifth year, Adrien père succumbed. The death of his father marked, for Joséphin, the end of the careers of the two people most responsible for the formation of his complex personality.

Joséphin was just bringing out the seventh novel of <u>La Déca-dence Latine</u>, <u>Coeure en peine</u>, to which he appended the <u>Commémoration du Chevalier Adrien Peladan</u>. Alexandre Séon contributed a litho-graphic portrait of Adrien père which in all likelihood was based on the Joanny Chatigny portrait Joséphin later included in the last <u>Rose+Croix</u> exhibition.[3] Despite Joséphin's perspicacious remarks on his father's career, he was reticent to discuss Adrien père's later activities unless couched in the least precise terms: "Adrien Pela-dan was a saint!"[4] Joséphin avoided relating Adrien's support of

in his letter how his brother "porta à ses lèvres le peu de poudre blanche restée à son doigt" and the ensuing horrical moments. "Aidez-moi à faire un peu de lumière sur la mémoire de ce grand esprit, de je ne serai jamais, malgé mon labeur, que le reflet et l'echo affaiblis." Joséphin Peladan, "Boite aux lettres," <u>Le Figaro</u>, October 8, 1885.

[1] <u>... La triple dualité du corps humain, oeuvre posthume</u> (Paris: Ballièvre, 1886).n

[2] <u>... sauvegard actuelle des fidèles</u> (Nîmes: Chez l'auteur), in several editions throughout the 1880's.

[3] This frontispiece, an impoverished work, representing a seated figure, one hand pressed to his temple, the other resting on a pile of books, suggests number 439 of the 1897 catalog of the <u>Rose+Croix</u> exhibition: "Le Chevalier Adrien Peladan lisant."

[4] Peladan, <u>Commémoration</u>, p. xlvii.

Henri V and there is no mention of Naundorf. These political-prophetic activities were forgotten until Bernard Latzarus's articles of 1924, published in the Nouvelle Revue du Midi.

There can be no doubt that Joséphin's life became a mission predetermined by the extravagance of his father and the broken destiny of his brother. The dynastic sense was extremely strong in Joséphin. We meet variants of his funeral pieces in La Queste du Graal ... [1] as well as skeletal bibliographic listings of the works of both men. Obviously, Oelohil Ghuibor, the fictional character who appears throughout the novels of La Décadence Latine, is modelled on his father.[2]

Nor was his mother overlooked. To celebrate Comment on devient fée, Joséphin published a dedication "A ma mère" in Henri Maazel's influential review of mystical tendencies, L'Ermitage:[3] "My mother, I extend to you this explicit homage, all my work implicitly being consecrated to Your glory; . . . My father was a saint, and my brother a genius; to both destiny has been unrewarding; I alone remain to testify to Your admirable soul. . . ."

But, if Joséphin was to continue a family tradition, he was also going to surpass it. Hence the transition from initiate to magus, to Sâr.

[1] ... Proses lyriques de l'éthopée de la décadence latine (Paris: Au Salon de la Rose+Croix, n.d. [1892]).

[2] R.-G. Aubrun definitely identifies Oelolhil Ghuibor as Adrien père. See René-Georges Aubrun, Peladan (Paris: Sansot, 1904), p. 5.

[3] The dedication is dated is dated August 17, 1892. The review appeared in February, 1893. See pp. 10-11.

CHAPTER II

MAGI

In March, 1881, Joséphin, accompanied by his friend Albert
Marignan, visited Pisa, Milan, Rome, and Florence. The trip con-
firmed an already pronounced italianate taste formulated in Lyon.[1]
The wanderjahr completed, Joséphin made his debut in the Catholic
press. His earliest articles, of a marked Catholic estheticism,
strike an unusual note in the pages of Charles Buet's homilitic,
parochial Le Foyer, Journal de famille.

Buet, an important member of Barbey d'Aurevilly's circle,
took on Joséphin's work on the advice of his literary colleague,
Adrien père.[2] R.-G. Aubrun, in an often repeated error based on
his bibliography of Peladan's work, states that "Le Chemin de Damas"
is Joséphin's first published work. "The Road to Damascus" was pub-
lished on September 18, 1881, but in the August 21 issue of the same
year a front page review called "Le Matérialisme dans l'art" had al-
ready traced in a multitude of cultures the fluctuations of art in
relation to God. Joséphin's comparative litany is present from the
very beginning: in contemporary culture the intimate relationship

[1]Aubrun, op. cit., p. 8.

[2]Letters by Buet, preserved in the collection of Pierre Lam-
bert, Paris, attest to Buet's familiarity with the supernatural
otherworld in which Adrien père moved so freely.

between art and God has been lost owing to numerous materialistic influences. However, one artist of the day must be praised, Puvis de Chavannes. "Two propositions are incontestable," concludes Peladan: "1. Masterpieces of art are all religious, even among non-believers. 2. For nineteen centuries masterpieces of art have all been Catholic, even for the Protestants."[1]

Joséphin was so taken by these catchphrases that he employed them again in his L'Art Ochloratique of 1888, a slightly altered republication of his Salon reviews of 1882 which appeared in Le Foyer, and of 1883 which came out in L'Artiste.

"Le Chemin de Damas," a delicately heretical parable, began in the September 18 issue of Le Foyer (No. 304). It features a dialogue between an urbane priest, read magus, and a young overeducated esthete. The story was published in two installments.[2] The first ends with this thought: bodily vice counts for little in comparison to "spiritual vice, that is the soul annihilating itself . . . that is the supreme vice."[3] (Le Vice Suprême will become the title of Peladan's best known novel which met a wild reception on its publication in 1884.) The priest and the young man pass a roadside chapel housing a medieval virgin. The young man expostulates on its perfection. "That's enough, exclaims the priest. Love art, love the ideal, love the beautiful and keep marching. You are on God's path and are moving towards him."[4]

[1] Joséphin Peladan, "Le Matérialisme dans l'art," Le Foyer, Journal de Famille, No. 300 (August 31, 1881), pp. 177-179.

[2] Ibid., Part I, No. 304 (September 18, 1881), pp. 246-250; ibid., Part II (September 25, 1881), pp. 268-271.

[3] Ibid., p. 250. [4] Ibid., p. 270.

Joséphin was convinced of the redemptive function of art.
As Stanislas de Guaïta said to Joséphin Peladan in an undated (1886?)
letter: "Exoteric Catholicism buys itself back through art."[1] If
any proof were needed to demonstrate that Joséphin considered himself
to be the priest of his affected story, one had only to wait for his
next article in Le Foyer, called "L'Art Mystique et la Critique Con-
temporaine."[2] In this essay Peladan aggravates the situation. He is
a zealot. His criticism a mission. The entire first period of his
critical writing is shot through with an apostolic note. His task,
as he saw it, was the reformation of contemporary esthetics. To do
so he set up simple categories based on the academic hierarchy:
human representation is superior to still life, and so on. "There-
fore, however impoverished the execution of mystical painters may be,
they are still the greatest painter because all ideal is the mystical
ideal."[3] Because of this concept Peladan can refute the superiority
of official contemporary art and justify an admiration for the Ital-
ian Primitives. "What they were ignorant of," Peladan said of the
Primitives, "four thousand painters in Paris know today. What they
knew none know any longer. . . . One rejects miracles, but, on the
esthetic level can one imagine a greater miracle than this--a work
of art which surpasses Raphael, and which, technically speaking, is

[1] Lettres inédites de Stanislas de Guaïta au Sâr Joséphin
Peladan. Une page inconnue de l'histoire de l'occultisme à la fin du
xix siècle (Neuchatel: Editions Rosicruciennes, 1952), pp. 99-100.
The letters are presented by Emile Dantinne with an important intro-
duction by Dr. Ed Bertholet. Hereafter called Lettres inédites.

[2] Le Foyer, No. 313 (November 20, 1881), pp. 387-388.

[3] Ibid., p. 388.

beneath that of an Epinal print."[1]

The September, 1881 issue of **L'Artiste** carried Peladan's article on Rembrandt.[2] Peladan had been invited to collaborate with Arsène Houssaye's prestigious periodical on the advice of its director Jean Alboise who had read and liked Peladan's study of the Dutch master.[3]

Needless to say, Rembrandt was subjected to Peladan's italianate ideal. He was a picturesque artist, according to Peladan, whose drawing was inaccurate and color raucous. His work lacked the eternal feminine and a single truly beautiful woman. But whereas da Vinci ". . . places the sphinx-like smile on Mona Lisa, the Florentine, on the Greek lips of Saint John, Van Ryn, deprived of (a sense of) plastic form, nevertheless knows how to put in a half-open mouth and the fixity of a glance a complex and modern feeling, so rich in innuendoes and reticences, so filled with hidden emotions and thoughts at rest."[4]

From the very first, then, Peladan drove home certain favored notions: art is ideal, redemptive, italianate. As will become customary, "Rembrandt" concludes in glorious rhetoric:

Reflect on this painter that copied no one and that no one could copy . . . who created everything, his drawing, his color, his light, his ideal . . . who wrought miracles through means so

[1]Ibid.

[2]First given as a lecture to "l'Esthétic Club" and which also appeared as a separate brochure.

[3]Aubrun, op. cit., p. 9.

[4]Joséphin Peladan, "Rembrandt," L'Artiste, September, 1881, pp. 326-335; pp. 331-332.

mysterious and outside natural laws that the startled admiration
by an intellectual retraction is brought back to the times of
Raymond Lulle, of Paracelsus, to Cornelius Agrippa, and imagines
a pact with Satan. This absolutely unique oeuvre, . . . isn't
it a spell as strange as those of the Kabbalists and necroman-
cers. Is not Rembrandt the Magus of painting--the Thaumaturge
of art.[1]

In March, April and May, 1882, L'Artiste carried Peladan's

essay on Marion de Lorme, the famed seventeenth-century courtesan

whose life inspired several works, the best known by Victor Hugo.

Peladan's study of manners under Louis XIII was also printed sepa-

rately in 1882 by the Bureaux de l'Artiste.[2] It carried a picture

of Marion de Lorme etched by Adrien Nargeot, an engraver doubtless

in the employ of the review as other examples of his work are found

on its pages.[3]

At the same time that Peladan was collaborating with L'Ar-

tiste, a series of Salon reviews appeared in Buet's magazine, now

called Le Foyer Illustré, in deference to the charming wood engrav-

ings which decorated its flimsy pages.[4] For the most part these re-

views restate Peladan's admiration for Chenavard and for Puvis de

Chavannes whose Pro Patria Ludis dominated the Salon of that year.

Peladan also admired the "exquisite, exotic savor"[5] of Félix Regamey,

[1] Ibid., p. 335.

[2] Reprinted in 1921 by La Connaissance, Paris.

[3] For example, an ably engraved "Judith" after A. Lanson,
L'Artiste, April, 1883, p. 234.

[4] Le Foyer Illustré, No. 339 (May 21, 1882), pp. 387-390; No.
340 (May 28, 1882), pp. 402-404; No. 342 (June 11, 1882), pp. 24-27.

[5] Joséphin Peladan, "Le Salon de 1882," L'Artiste, June,
1882, p. 25.

one of three brothers who studied under Lecoq de Boisbaudran (and
who became his biographer),[1] whose paintings were based on Japanese
themes. He later showed at the Salon de la Rose+Croix of 1893 but
is remembered today for his collaboration with La Plume and for the
role he played in popularizing a taste for the oriental.

From the French seventeenth century Peladan turned once more
to the Italian Renaissance. In January, 1883, L'Artiste published
"Le Grand Oeuvre d'après Lionardo [sic] da Vinci,"[2] part of a pro-
posed series: Les Etudes de sciences mortes later to be called La
Décadence Esthétique (Hiérophanie), the generic name of Peladan's
art criticism of the 1880's. Le Grand Oeuvre is, of course, the
great work of the alchemist, a sub-theme which haunted the symbolist
movement. It refers to the magical, kabbalistic change of the es-
sence of a thing, from either a world of ideas or of sense percep-
tions to an ultimate and divine world of pure cause. Materially,
this change is effected by the use of the philosopher's stone, it-
self a symbol of his arcane knowledge gleaned from the Kabbala as
well as a millenarist symbol. On the most vulgar level this change
is dramatized by the transference of mercury into gold. The change,
in essence, is "the great work."[3]

[1] Félix Regamey, Horace Lecoq de Boisbaudran et ses élèves,
notes et souvenirs (Paris: Champion, 1903).

[2] Pp. 41-48.

[3] Enid Starkie contends that the colors mentioned in Rimbaud's
Les Voyelles correspond to alchemical transmutation and that his ac-
quaintance with occult matters was based on extensive readings, nota-
bly in the work of Eliphas Lévi. We know that this poem became the
doctrinaire basis of René Ghil's Instrumentaliste movement. Enid
Starkie, Arthur Rimbaud (New York: New Directions, 1961), pp. 162-
164.

Peladan's article was based on a so-called Leonardo drawing published by the <u>Calcographie du Louvre</u>, in which, according to the author, Leonardo depicted the art of making gold. Peladan called this kind of drawing a "penthacle," employing a kabbalistic term for a symbolic illustration or decorative arrangement of the transference of metals. Peladan adds that several great artists were alchemists, including Van Eyck and Parmigianino.

In successive months, February and March, 1883, Peladan published articles on the Municipal Museum and the Jusky Collection in Nîmes.[1] The latter article, "La Collection Jusky de dessins de maîtres anciens à Nîmes," is especially rich in the kind of flamboyant opinion that marks his art criticism. Despite Peladan's discrediting of the Impressionist movement, which we recognize as dominant in its time, he held certain opinions that were, in their way, original or at least arrestingly quixotic. In the face of Impressionist painterliness Peladan insisted on the superiority of line as he saw it in Puvis de Chavannes, himself a descendant of the Lyon-born Louis Janmot, and on late nineteenth-century Leonardism. "Line," Peladan contends, "is sufficient for metaphysical expression: it is the letter of plastic writing. . . ."[2] The modern movement is condemned. "The Impressionists and other anarchists of the esthetic, tails unfurled from <u>l'Enterrement d'Ornans</u> . . . have set into circu-

[1] Joséphin Peladan, "Les Musées de Province: Le Musée municipal de Nîmes," <u>L'Artiste</u>, February, 1883, pp. 93-105; "La collection Jusky de dessins de maîtres anciens," <u>L'Artiste</u>, March, 1883, pp. 184-201.

[2] Peladan, "La Collection Jusky," <u>loc. cit.</u>, p. 184.

lation a pathetic technique which appears serious to the untutored.
In plain speech, _plein air_ means the ignorance of perspective; _local
tones_ the ignorance of drawing . . . because there are no _local
tones_ in nature in which the only _beautiful spots_ are those of the
varnish on wagons and of fresh posters. Air, in bathing forms, har-
monizes the transitions of color, and if local tone is logical in
its setting, which in its proper distance from the spectator will
have sufficient layers of air, it is _idiotic_ in an easel painting
which is looked at up close. What Renaissance master would have
exhibited something painted with the elbow like _le Bar_ by M. Manet
at the Salon of 1882?"[1]

"La Collection Jusky" concludes with an apostolic formula
that Peladan had already discovered in "Le Salon de 1882" for _Le
Foyer_: "The contemporary School only has a future if it begins to
draw. Drawing is the Catholicism of the fine arts--outside of it,
no salvation!"[2]

It is not difficult to see how this young man, Peladan was
now twenty-four, of special and "superior" taste, would aspire to
the circle of Barbey d'Aurevilly. "Les Dimanches de Barbey d'Aure-
villy,"[3] found the "constable of French letters," now in his declin-
ing years, surrounded by a group of ardent admirers which included
Charles Bluet, Léon Bloy and Armand Hayem (better known as a collec-

[1] _Ibid._, p. 185.

[2] _Ibid._, p. 186. Compare this to the conclusion of "Le Salon
de 1882," _loc. cit._, p. 27: ". . . outside the Church, no salva-
tion."

[3] Charles Buet, "Les Dimanches de Barbey d'Aurevilly," _La
Revue Encyclopédique_, 1896, pp. 31-36.

tor than as a poet). Barbey's apartment in the rue Rousselet became
one of the most important literary salons of the late nineteenth
century, vying with Mallarmé's "Tuesdays" in the rue de Rome and the
grange of Edmond de Goncourt. Peladan set his sights on the Barbey
circle and devoted a ferocious cult to the biographer of Beau Brum-
mel and the author of the Contes Cruels.

Of the writers of the period Barbey was the only one, except-
ing Verlaine, whom Peladan admired without reserve. Above all was
Balzac, then came Barbey. Joséphin contributed a critical study on
Barbey's work to L'Artiste.[1] Notwithstanding the fact that portraits
of contemporaries were excluded from the Salons de la Rose+Croix,
Barbey, Verlaine and Joséphin himself were exempted from this rule.
Joséphin even broke with Charles Hayem, the brother of Armand, when
he attempted to borrow Levy's portrait of Barbey for the 1894 Salon
de la Rose+Croix. In Joséphin's assessment of "L'Oeuvre de Edmond
et de Jules de Goncourt," he flatly asserted that "I am unswervingly
convinced that Balzac is at least the equal of Homer, Dante and
Shakespeare--and after Balzac comes Barbey d'Aurevilly. . . ."[2]

Barbey, in turn, aided Peladan by contributing two prefaces,
one to L'Art Ochloratique, the other to Le Vice Suprême, which as-
sured these works, particularly the latter, an extraordinary success.

In May, 1883, Peladan began to publish his critique of the
official Salon called "L'Esthétique au Salon de 1883" which was car-

[1] Joséphin Peladan, "Jules Barbey d'Aurevilly et son oeuvre
critique," L'Artiste, July, 1885, pp. 31-36.

[2] L'Artiste, August, 1884, pp. 120-129; p. 122.

ried by L'Artiste through June and July. These articles were repub-
lished in 1888, along with "Le Salon de 1882," which first appeared
in Le Foyer Illustré, under the title L'Art Ochloratique.[1] Barbey's
preface, actually a letter to Peladan dated August 20, 1883, just
after he had finished reading the articles published in L'Artiste,
said: "I have read nothing--in esthetics--of this competence,,--of
this science and this eloquence. And what keenness of perception!"[2]

From the very first and famous lines, "I believe in the
Ideal, in Tradition, in Hierarchy," Peladan announced a crusade for
a new art. With extravagant literary conceit, rapid and inspired,
with a kind of divine authority, Peladan denounced the senile neo-
classicism promoted by the Ecole Nationale des Beaux-Arts and the
official Salons as well as the materialism of the realist trends in
painting (or Naturalist in literature). Impressionism, since it is
based on direct sense perception--hence materialistic--had to be dis-
credited. The new, ideal art of which Peladan became the loquacious
herald, was to be achieved not so much through a fundamental revision
of prevailing conceptions of form, but through a radical change in
content. In place of consecrated academicians "who push mediocrity
beyond the limits of all decency,"[3] Peladan proposed an art suffused
with meaning, with idea. "The Ideal is not any idea; the ideal is
all idea made sublime, carried to its furthest point of harmony, of

[1] Joséphin Peladan, La Décadence Esthétique, Vol. I: L'Art
Ochloratique. Salons de 1882 et 1883 (Paris: Dalou, 1888).

[2] Ibid., p. xi.

[3] Peladan made the comment about Bouguereau. Ibid., p. 97.

intensity, of subtlety."[1]

L'Art Ochloratique, from the Greek word ochlos meaning mob, is, to say the least, extremely dogmatic. Painters, sculptors, architects, all received special injunctions. Yet, for Peladan, the chief figures of contemporary art were not exhibited at the Salon of 1883. He hailed them nonetheless in a "Salut aux absents" which became a staple lyric effusion of all subsequent Salon reviews. "The Allegories of Puvis de Chavannes, the Satanics of Félicien Rops, the hermetic poems of Gustave Moreau are the three exemplary manifestations of the immutable triangle of idea."[2] In addition to these three Peladan also saluted the absent Paul Baudry and Ernest Hébert.[3]

Peladan's attitudes--as much as the contemporary Impressionist exhibitions--were in revolt against the supremacy of salon art and bourgeois taste. "The Bourgeoisie is impossible for art which imperiously requires either aristocracy or rabble. . . ."[4] Peladan concluded: "I inscribe on the closed portals of the Salon of 1883 this epitaph, the worst, which avenges a blasphemed Ideal; Bourgeois Salon!"[5]

With the publication of "L'Esthétique au Salon de 1883," Peladan's reputation as an art critic was made; in so doing he had rejected the claims of the two most important and opposing factions

[1]Ibid., pp. 156-157. [2]Ibid.

[3]Barbey d'Aurevilly, an erstwhile art critic, may have been influenced by his zealous disciple. He, too, praised Paul Baudry highly in his Sensations d'Art (Paris: Frinzine, 1886).

[4]Peladan, L'Art Ochloratique, pp. 108-109.

[5]Ibid., p. 213.

of the period, the academicians and the Impressionists. Nonetheless, he gave voice to the aspirations of still another moderately progressive group, among whom we find scattered members of the group which will come to be known as the School of Pont-Aven and the later Nabis, as well as an even larger group of artists nostalgically attracted by the past and sensitive to mystical suggestion. Peladan's affirmativeness and genius for organization were to weld this heterogeneous body of artists into a single unit, if only for a short period.

"L'Esthétique 'a l'Exposition Nationale des Beaux-Arts," Peladan's next attack of the official Salon, was published in October, November and December of 1883 in **L'Artiste**. This article is notable for a dramatic reversal. As a means of attacking the academicians, Peladan praised Manet who had died in April. Antonin Proust, Minister of Fine Arts of the ill-starred Gambetta regime, had offered to exhibit three Manets, among them "The Bar," at the Salon as a memorial to his friend. The Salon jury obstinately refused to show two of them so Proust withdrew them all at the affront. "I don't like Manet," protested Peladan, "but he belongs to the history of art the way a schism belongs to the history of religion. Manet was an artist and I would not claim as much for half the members of the jury. . . . Don't you realize, Municipal Gentlemen of the Hackneyed, that in exasperating Manet, through your ostracism, you were responsible for a number of his failures. If you had been fair with him, had not rejected him so often, he would have modified his **plein air**; and a moderate Manet would have been a master. In any event he is an executant . . . and there is in Manet . . . as a painter of passages

certainly enough to satisfy Velasquez."[1]

In short, Peladan "panned" the Salon. Whatever its consolations, they are easily guessed at: Puvis de Chavannes, Gustave Moreau, Félicien Rops, Hébert and Paul Baudry.

In December the three articles concluded with an extensive statement of one of Peladan's principal esthetic obsessions--androgynous perfection. The theme of the androgyne occupies a large place in Peladan's work. It reappears throughout the twenty novels of La Décadence Latine and, as such, is central to the late nineteenth-century novel which never quite recovered from the erotic travesty of Gautier's Mademoiselle de Maupin. It will be combined with Peladan's already heady Italianism; prose poems in praise of Leonardo's "John the Baptist" and "Mona Lisa" occur at frequent intervals. It was an extravagance for which Peladan paid dearly--he was to be nicknamed "le Sar Pédalant"--and the ridicule of his contemporaries only served to force him into more extreme statements and ludicrous postures.

There is no doubt that the theme of the androgyne in Peladan's work is in part inspired by the neurotic curiosity common to a whole school of late nineteenth-century authors and painters for whom the androgyne offered still greater possibilities of erotic interplay. In this respect, Peladan's L'Androgyne and Gynandre are no less tainted than, say, Rachilde's Monsieur Vénus. But something in Peladan's work raises it above fashionable erethism and that is

[1]Joséphin Peladan, "L'Esthétique à l'exposition nationale des beaux-arts," L'Artiste, December, 1883, pp. 260-261.

his awareness of the fundamental place of the androgyne in religious
issues. Peladan's father and brother had both already addressed
themselves to this matter. Peladan recognized in the androgyne the
symbolic manifestation of the "coincidentia oppositorum," as Nicolas
de Cusa called it, a divine neutral stasis which is "the least imper-
fect definition of God."[1] Hence Peladan's immense admiration of the
Plato of the Symposium and the Balzac of Séraphita-Séraphitus.

"Statuary," Peladan asserts, "has but one theme, the human
body, under its double form of masculine and feminine. All synthe-
sis is a ternary. What then is the plastic result of man and woman?
The androgyne. . . . I propose this aesthetic theory: The andro-
gyne is the plastic ideal."[2]

Peladan discusses the androgyne in terms of its primitive
architectural expression, the menhir and the cromlech, to manifesta-
tions under the Greeks for whom the androgyne was "the esthetic ex-
pression of the highest metaphysic."[3] The key to the myth is found
in Plato's Symposium and Peladan retells Aristophane's famous story
of sexual division and subsequent search. Peladan's nineteenth-
century examples includes Byron's Don Juan, Mademoiselle de Maupin,
"George Sand en personne," the heroines of Barbey d'Aurevilly among
others. "Outside the androgyne, this synthesis of form, there are
no immortal statues.--Outside of dogma, this synthesis of mystery,

[1]Mircea Eliade, Mephistophélès et l'Androgyne (Paris: Galli-
mard NRF, 1962), p. 93.

[2]Joséphin Peladan, "L'Esthétique à l'exposition nationale
des beaux-arts (3ᶜ et dernier article)," L'Artiste, December, 1883,
pp. 433-475; p. 433.

[3]Ibid., p. 435.

there is for art, no salvation!"[1]

The official Salon of 1883 is buried with a "shameful epitaph . . . which avenges a degraded ideal, for the mob are those who neither think nor weep: <u>fashionable Salon</u>!"[2]

The signal artistic event of 1884 was the commemorative retrospective of Edouard Manet's painting held at the <u>Ecole Nationale des Beaux-Arts</u>. Peladan reviewed the exhibition for <u>L'Artiste</u>.[3] He found Manet "without ideal, without conception, without emotion, without poetry, without drawing,"[4] but nevertheless admired <u>Mlle Victorine en Espada</u> for her "androgyne grace"[5] and admitted that "after Courbet, Manet was the great teacher . . . of painting of the second half of the century who illuminated contemporary method."[6]

In May, 1884 <u>Le Groupe des Indépendants</u> held a little publicized first exhibition, which included among others, Seurat and Redon, but they went unnoticed. Later, many of the artists who figure on the lists of the <u>Indépendants</u> would also exhibit with the <u>Salons de la Rose+Croix</u>. Brussels too was experiencing a burgeoning modernist activity. In the same year <u>les XX</u> held their first Salon. Fernand Khnopff, one of the founders of the group, would later be a

[1]<u>Ibid</u>., p. 439.　　　[2]<u>Ibid</u>., p. 475.

[3]Joséphin Peladan, "Le procédé de Manet d'après l'exposition de l'école des beaux-arts," <u>L'Artiste</u>, February, 1884, pp. 101-107. An English translation by Michael Ross appears in <u>Portrait of Manet by Himself and His Contemporaries</u>, ed. Pierre Courthion and Pierre Cailler (New York: Roy, 1960), first published as Pierre Cailler, <u>Manet Raconté par lui-même et ses amis</u> (2 vols.; Genève: Cailler, 1953). Peladan's article is not mentioned in G. H. Hamilton, <u>Manet and His Critics</u> (New Haven: Yale University Press, 1954).

[4]<u>Ibid</u>., p. 103.　　　[5]<u>Ibid</u>., p. 107.　　　[6]<u>Ibid</u>.

regular exhibitor of the Salon de la Rose+Croix and one of its major
figures. Georges Minne and Georges Lemmen, who joined les XX the
following year, were also to exhibit with the Rose+Croix, as well as
the Dutch artist, Jan Tooroop, equally of the XX. Xavier Mellery,
Emile Fabry, Josef Middeleer, Henri Ottevaere, Jean Delville, who
bridged the Belgian Symbolist experience from les XX, which folded
in 1893, to found Pour l'Art, were also represented at the Rose+Croix
exhibitions. Delville, in turn, became Peladan's voice, arranging
idealist exhibitions in 1896 and after based on the format established
by Peladan when the latter's had ceased to exist.

If the May Indépendant show went unobserved, the official
Salon, of course, was heavily "covered." Peladan's review appeared
in the June issue of L'Artiste. Nothing seemed important to him ex-
cept Puvis de Chavannes's "Le Bois Sacré." "Puvis de Chavannes,"
wrote Peladan "is so great an artist that he can free himself from
the whole of past art and treat this subject as if he was its inven-
tor . . . horribly phillistine Lyon seems to greatly desire to expi-
ate its dullness through each of its celebrities; Ballanche, Chena-
vard, de Chavannes, Soulary are transcendant idealists."[1]

Peladan's admiration for Italian primitive art is again
taken up in his July article for L'Artiste, "Les Musées de Province:
Le Musée Gower à Nîmes."[2] In August L'Artiste carried Peladan's ap-
praisal of "L'Oeuvre de Edmond et Jules de Goncourt." Peladan grants

[1] Joséphin Peladan, "Salon de 1884, peinture," L'Artiste, June,
1884, pp. 414-454; pp. 424-425.

[2] Joséphin Peladan, "Les Musées de Province: Le Musée Gower à
Nîmes," L'Artiste, July, 1884, pp. 32-43.

them their roles as initiators of the realist novel, eighteenth cen-
tury historians, instigators of Japanese taste, roles already claimed
by Jules. Peladan admits their contribution as chroniclers of man-
ners, as inaugurators of "a theatre psychologically different from
the syllogistic one of M. Dumas fils."[1] But what does this amount to,
Peladan asks? "Realism, Pompadour and Japan, three steps toward de-
cadence, a marvel of novelty under the pen of the Goncourt, but
quickly cheapened by their imitators. . . ."[2]

Nor was Peladan finished with literary criticism. In Septem-
ber L'Artiste published a pendant piece, "La Seconde Renaissance
française et son Savanarole." It was one thing to damn the Goncourts
with ambiguous praise and quite another to criticize Zola whom Pela-
dan overtly vilified. Zola, of course, became the bête noire of the
Salons de la Rose+Croix. For the fifth exhibition of 1896 Armand
Point and Léonard Sarluis depicted an ideal creature half Perseus
and half Saint George dangling at arm's length the severed head of
Zola.

Peladan's article appeared under a pseudonym, one of many he
assumed in the period. These false names either were titled, pos-
sessed a noble particule, or were outright travesties, paralleling
his manner of dress which is marked by a desire for rank and trans-
vestiture. "Guy de Valogne," later called a Marquis, is sickened by
Zola's "creatures [who] have a body but no soul, a pulse but no heart,
a belly but no brain."[3]

[1]Joséphin Peladan, "L'Oeuvre de Edmond et Jules de Goncourt,"
L'Artiste, August, 1884, pp. 120-129; p. 121.

[2]Ibid., p. 122.

[3]Guy de Valognes [Joséphin Peladan], 'La Seconde Renaissance

Peladan's ability to strike off an article at a moment's no-
tive--which explains a great deal of his repetitiveness--led him to
undertake the direction of his own magazine. On October 1, 1884,
the _Revue des Livres et des estampes, critique mensuelle de tout ce
qui s'imprime en France_ was put out in the bookshops. This sixteen-
page periodical--covered in yellow like the famous _Yellow Book_ and
Mercure de France of a succeeding decade--was ornamented with a
winged sphinx spouting flames atop a column. It cost a franc and
knew three issues. The first number is particularly impressive.
Among the books reviewed are Barbey d'Aurevilly's _Ce Qui ne meurt
pas_, Edmond de Goncourt's _Chérie_, Alphonse Daudet's _Sapho_, Emile
Zola's _La Joie de vivre_, J.-K. Huysmans' _A Rebours_, Jean R. Riche-
pin's _Les Blasphèmes_, Théodore de Banville's _Nous Tous_, Paul Bour-
get's _Essais de Psychologie contemporaine_. The reviews were largely
written by Peladan under various names. By now it is fairly easy to
anticipate the treatment these various works received. _Ce Qui ne
meurt pas_ "is a masterpiece of intensity which would be Byron's were
it not d'Aurevilly's."[1] Of Zola: "In place of originality . . . he
has nerve; he dares."[2]

A Rebours presented certain difficulties. Though Huysmans
was associated with the naturalist circle of Zola, _A Rebours_ is no
longer a naturalist work. It is estheticizing and admires many of

française et son Savanarole," _L'Artiste_, September, 1884, pp. 205-
217; p. 213.

[1]Joséphin Peladan (ed.), _Revue des Livres et des estampes,
critique mensuelle de tout ce qui s'imprime en France_, October 1,
1884, p. 2.

[2]_Ibid._, p. 4.

the things that excite Peladan, not the least being Gustave Moreau's painting. A Rebours contains perhaps the best known description of a painting in fiction, which Peladan takes into account when he praises the "majestic description of 'Salomé' by Gustave Moreau, this masterpiece owned by Mr. Hayem. . . ." Peladan recognized the radical implications of Huysmans' book and announces "Mourning at Médan [Zola's country house]!"[1]

A short note in the first issue briefly covered Peladan's Introduction à L'Histoire des peintres de toutes les écoles, depuis les origines jusqu'a la Renaissance, Quattrocentisti: L'Orcagna, a monograph based on souvenirs of his Italian journey and the new photographic reserves of Braun and Company. But a long review of Peladan's first novel, Le Vice Suprême was published by a certain André Berlié. The novel enjoyed an immense vogue; more than twenty editions were published through the 1880's and 1890's. Barbey d'Aurevilly contributed a flattering preface, and the frontispiece by Félicien Rops is one of his best works (Fig. 1). As Berlié noted in his review, d'Aurevilly also recognized the Joséphin was attacking a panoramic novel in the manner of Balzac, and he paid homage to Peladan's idiosyncratic personality. "The author of Vice suprême possesses three of the most hated things of the present day. He has aristocracy, Catholicism and originality."

The protagonists of Le Vice suprême are the Princess Léonora d'Este and the Magus Mérodack. The princess, a paragon of vice, hungers for unusual sexual experiences sublimated into a platonic

[1] Ibid., pp. 5-6.

relationship with Mérodack, incidentally, one of the pseudonyms used by Peladan. They embark on a series of adventures which may be seen as an ardent non-consummation, at once flamboyant and sterile. The Princess-Magus balance constitutes the basic dialogue in Peladan's literature and numerous couples, such as the Princess Riasan and Nebo in Curieuse, continue this erotically distended colloquium.

Peladan's novels are romans à clef, and it is very likely that Princess d'Este is modelled, in part, on Henriette Maillat, a vague literary personality of the day--it is not even known what she looked like--who was for a time Peladan's mistress, living with him in the top-floor rooms of a house on the corner of the rue de Seine and the rue des Beaux-Arts. When her relationship with Peladan cooled, she became Huysmans' mistress without, however, taking new quarters.[1] One of Willy's most successful books, Maîtresse d'esthètes, probably ghosted by Jean de Tinan, transformed Henriette Maillat into the character Ysolde Vouillard and Peladan into the Magus Sautocrack.[2]

The Princess d'Este is also partiall modelled on a woman painter, Jeanne Jacquemin, who knew a small degree of celebrity in the later years of the century. Remy de Gourmont published her work in the Mercure de France.[3] Her illustrations fuse the cartilaginous

[1] On the basis of unpublished letters from the Collection Pierre Lambert, Paris.

[2] Jacques Lethève cites the novel as a reflection of "La Connaissance des peintres préraphaélite en France," Gazette des Beaux-Arts, May-June, 1959, pp. 315-328.

[3] Frontispiece, May, 1892, etched by A. M. Lauzet, after Jeanne Jacquemin's "La Fin du Jour": a severed female head sinks

profiles and severed heads of Redon with the jewellers preciosity of
Moreau. Clearly in line with Rose+Croix taste, she was excluded
from the confraternity's exhibitions because of a magical rule which
prohibited the collaboration of women. Jean Lorrain took up her
cause for a while but, in 1903, turned on her in an article called
"Victime," which related the amorous adventures of a certain Mrs.
Lostein, understood by many to be Jeanne Jacquemin. Lorrain lost
the ensuing litigation and had to pay heavily--both money and a
prison sentence--for his indiscreation.

Madeleine Octave Maus recalls that during the 1885 exhibi-
tion of les XX in Brussels, Fernand Khnopff exhibited a group of
drawings, hors du catalogue, intended as illustrations for Peladan's
Vice suprême, some of which were also shown at the first Salon de la
Rose+Croix. Among them was a female nude representing the Princess
Leonora d'Este, in whose features the celebrated singer Rose Caron
recognized her own portrait. She demanded that the work be removed
and Khnopff, in an aristocratic and prideful gesture, smashed the
picture glass with his cane and threw the tattered drawing at the
singer's feet.[1]

The most important result of the publication of Le Vice su-
prême was that it brought Peladan and Stanislas de Guaïta together.

into a chalice; a tiara radiates halo-like emanations; hair falls
across brows and gloomy eyes. Remy de Gourmont in "Les Premiers
Salons," Mercure de France, May, 1892, finds J. J.'s work perfectly
suited to the taste of the Salons de la Rose+Croix, an opinion re-
iterated by Jacques Lethève, "Les Salons de la Rose+Croix," Gazette
des Beaux-Arts, December, 1960, pp. 363-374, fn. 10.

[1]Madeleine Octave Maus, Trente Années de lutte pour l'art,
1884-1914 (Bruxelles: Librairie de l'Oiseau Bleu, 1926), pp. 35-36.

In 1882, Peladan had already left Nîmes for Paris,[1] the year in which Stanislas de Guaïta had also left Nancy for the capital. Born to Alsatian nobility in 1861 and schoolmate of Maurice Barrès, Stanislas de Guaïta began his career as a poet. Barrès remembers that "grace came to him when a reading of *Vice Suprême* lead him to study Eliphas Lévy [i.e., *l'Abbé* Constant, historian of magic] and to visit M. Saint-Íves d'Alveydre [i.e., noted occultist]."[2] René Philipon, who catalogued Stanislas de Guaïta's important occult library at the time of his death, concurs in this. "Indeed," writes Philipon, "shortly before the publication of *Rosa Mystica* [1885, written 1884] Stanislas de Guaïta had met several ardent young men . . . Albert Jhouney, Paul Adam . . . Joséphin Peladan. . . ."[3]

On November 3, 1884 Guaïta wrote to Peladan: "I have just read your beautiful book 'Le Vice suprême,' and reread it several times . . . it seems genial to me, the hermetic gust which blows through your work."[4] Two weeks later, on November 15, Guaïta continues: "It is your *Vice Suprême* that revealed to me (to me, sceptic, although respectful of all holy things), that the Kabbala and High Magic could be something other than a trick."[5]

The subsequent issues of Peladan's periodical lack the bril-

[1] Aubrun, *op. cit.*, p. 8.

[2] Maurice Barrès, *Un Rénovateur de l'occultisme. Stanislas de Guaïta (1861-1898)* (Paris: Chamuel, 1898), p. 17. The death date given in Barrès' title is in error, doubtless typographical. St. d. G. died December 19, 1897.

[3] René Philipon, *Stanislas de Guaïta et sa bibliothèque occulte* (Paris: Dorbon, 1899), p. iii.

[4] *Lettres inédites*, p. 51. [5] *Ibid.*, p. 52.

liance of the first number, nor dispose themselves as easily to dis-
cussions of literary petite histoire. There are, however, a few in-
teresting items. The November issue contains a review of Barbey
d'Aurevilly's L'Amour Impossible et la bague d'Annibal and Léon
Bloy's Propos d'un Entrepreneur de démolitions, arresting because of
the later Bloy-Peladan feud. "M. Bloy," Peladan remarked innocently,
"will remain one of the masters of invective and imprecation."[1] Paul
Mariéton's book, Joséphin Soulary et la pléiade lyonnaise, gives
Peladan an opportunity to praise his namesake. The two volumes by
Jules Clarétie (Secretary of the Comédie Française), Peintres et
Sculpteurs contemporains, containing short biographical studies of
the consecrated official artists of the Third Republic, are seen as
"unacceptably optimistic; when will the three great contemporary
masters--Félicien Rops, Puvis de Chavannes, Gustave Moreau--have
their turn???"[2] Ernest Renan is taught the real meaning of Nirvanâ
in a critique of his Nouvelles Etudes d'histoire religieuse. Under
the pseudonym de Valamont, Peladan reviews his own father's Vie et
culte de Sainte Christophe ... gravure d'après Hemling [sic]. Pela-
dan's brother, Le Docteur Peladan, contributes a review of Littré's
monumental Dictionnaire de Medecine. There are two interesting
notes on the arts, one concerning Henry Cros and Charles Henry's
L'Encaustique et les autres procédés chez les anciens. "The author
of the masterpiece of the exhibition of the artistes indépendants
. . . is not only a sculptor and painter, but is also erudite and

[1] Revue des Livres et des estampes November 1, 1884, p.
19.

[2] Ibid., p. 22.

cultured. . . . The Discovery of M. H. Cros is worth immortality for him in technology, but esthetically he has had it twice already, as a painter and sculptor."[1] The other concerns Félicien Rops' frontispiece for Le Vice suprême, included under the column called "Estampes":

> . . . he [Rops] raises on a pedestal the coffin of the last Lat-iness as if it were a sentry-box opened by the last Latin, him-self a skeleton of a socialite, his skull tucked under his arm, a monocle screwed into his eye-socket; a flight of ravens cir-cles above the bier, in which, hitching up her skirt and playing with her fan, the skeleton of the Latiness simpers obscenely; in low relief, the two little corpses of Romulus and Remus suck at the withered dugs of the wolf![2]

On the inside back cover of this and of the last issue of La Revue des Livres et des estampes is an advertisement for the Annales du Surnaturel au XIXe siècle ... Director: Adrien Peladan, "knight of pontifical orders, honored by diverse briefs of their Holinesses Pius IX and Leo XIII."

The feature article of the last issue is a review of Le Livre du Désir, to be published the next year, by the Princess Anna I. Dinska, which is to say, Peladan himself. Princess Dinska, "Mademoi-selle Baudelaire," Peladan calls her, is supposedly Russian. Very likely he meant to evoke, by a similarity of sound, the memory of Balzac's great love and patroness, "La Hanska." Le Livre du Désir is an elegant piece of hackwork, containing illustrations by Puvis de Chavannes, as well as Alexandre Séon and Vincent Daras, who later participated in the Salons de la Rose+Croix.

Although a discussion of Taine's Les Origines de la France

[1]Ibid., pp. 28-29. [2]Ibid., p. 32.

Contemporaine was promised for the January issue, La Revue des Livres et des estampes succumbed at the end of 1884 for want of subscribers. It was not until 1906 that Peladan published a Réfutation Esthétique du Taine (Paris: Mercure de France).

Eighteen eighty-four also concludes with an article on Courbet in the December issue of L'Artiste. Evidently Peladan will take strenuous exception to Courbet's work. Of the "Enterrement d'Ornans," he writes "the composition is non-existent," and of "The Bathers," they "are in great need of a bath."[1] This said, however, he also admits that "The influence of Courbet has been great and profitable; it has raised the well-painted to a position of honor; with less originality of technique he has been a professor as was Manet after him."[2] This granted, Peladan contends that one must still choose between Realism and Idealism, i.e., between the two Gustaves, Courbet or Moreau. "To admit the 'Enterrement d'Ornans' in the Louvre is a denial of all esthetic; either M. Gustave Moreau, the mythical painter, or M. Gustave Courbet, the realist painter, is wrong!"[3]

Eighteen eighty-five still found Peladan in travesty. Princess A. Dinska's Etrennes aux dames. Le Livre du Désir was published. It listed a variety of desires, twelve eternal, fourteen modern, including a "désir juif." Its heterogeneous illustrations—whatever was on hand at the Librairie des Auteurs Modernes—included

[1]Joséphin Peladan, "Etudes Esthétiques de Décadence: Gustave Courbet," L'Artiste, December, 1884, pp. 406-412; p. 409.

[2]Ibid., p. 411. [3]Ibid.

several old master drawings, also found later in the illustrated
catalog of the Rose+Croix exhibition of 1893, a smattering of Puvis
de Chavannes ("Le Rêve"), Clairin, and an Henri Martin drawing of
Dante and Virgil watching the shades of Paolo and Francesca go by.

The "Marquis de Valognes," still Peladan, published the
first series of Femmes Honnêtes with a frontispiece by Rops and
twelve illustrations by Bac, a well-known illustrator of the day.
Among his pieces for the quasi-erotic work we find a "Lucie-Berthe"
illustrating Peladan's little lesbian parable. Rops' frontispiece,
"La Foire aux Amours,"[1] depicts a female nude in a flowered hat,
seated on a cage of cupids in various stages of escape. An old pro-
curess, vaunting her daughter's (?) qualities, motions to an unseen
passerby. Idling in from the lower left is a Ropsian concept of a
beribboned turtle. The Femmes Honnêtes was so successful that a
second series was published in 1888.

As simple "Miss Sarah" Peladan published a disarming volume
called Autour du Péché for the Librairie des Auteurs modernes. The
cover of the book is ornamented, like a premonition, with a rose.
The book is an erotic ABC--"Céder le plus tard possible," "Dévote,
celle qui donne rendez-vous à l'eglise," etc.--as well as a résumé
of Les Saisons amoureuses. The hours of the day are also humorously
and erotically treated.

At last Peladan threw off his girlish frocks and consecrated,
under his real name, two serious studies to major figures in his

[1] Maurice Exsteen, L'Oeuvre gravé et lithographié de Felicien
Rops (4 vols.; Paris, 1928. See II, 292. Several variants are
cited.

hagiography. The July, 1885 issue of L'Artiste carried "J. Barbey
d'Aurevilly et son oeuvre critique," an important essay on the
writer, the cardinal points of which have already been alluded to.

Félicien Rops, of the three major contemporary artists on
whom Peladan lavished praise (Rops, Puvis de Chavannes, Moreau--none
of whom, incidentally, ever exhibited at the Salons de la Rose+Croix)
was the one with whom Peladan had the closest dealings.[1] Puvis de
Chavannes broke with Peladan in 1891, although the painter's students
were closely allied with the movement; Gustave Moreau kept in touch,
but refused to exhibit with the group despite the fact that many of
his students did, most notably Georges Rouault in 1897.

Félicien Rops, who had no students although his work had a
wide influence on a certain type of jaded illustration which pre-
vailed through World War I, was intimately associated with Peladan's
work, especially through the 1880's. Some of his finest etchings
were created as frontispieces for Peladan's Ethopée and other writ-
ings: Le Vice suprême (1884), Femmes Honnêtes (1885), as we already
know, and Curieuse (1886), L'Initiation sentimentale (1887), A Coeur
perdu (1888).Peladan's subsequent collaborators of importance were
Fernand Khnopff and Alexandre Séon, who joined him during the epoch
of the Salons when Peladan made a point of employing artists associ-
ated with his exhibitions.

"Félicien Rops" was first published in 1885 in La Jeune Bel-
gique and was subsequently reprinted in a special issue of La Plume

[1]A group of Peladan-Rops letters is preserved in the Musée
des Beaux-Arts, Brussels, but, unfortunately, I have never seen them.

in 1896 devoted to Rops. As Huysmans was later to do in his famous essay on Rops, published in Certains (1889), Peladan attempted to evoke the enormous sexual appetite and character of Rops' work. The greater the power of the female in a culture, the greater is decadence, contends Peladan, "and like a suble master, Rops immediately understood that today the possessed are the atheists and the positivists and that his [Satan's] fiend, in the category of morality, was woman; and he formulated this admirable synthesis: . . . Man possessed by Woman, Woman possessed by the Devil."[1] Peladan launched this slogan in 1883, in his May Salon review when he wrote "Man, puppet of woman, woman puppet of the devil,"[2] and it has since come down to us as one of the period's famous catchphrases.

At this time interest in the occult was burgeoning in Paris. Emond Bailly's bookshop, La Librairie de L'Art Indépendant, published La Haute Science [i.e., alchemy and kabbalism] and publishers such as Chacornac, Dorbon and Chamuel specialized in arcane subject matter. In addition to Stanislas de Guaïta and Peladan, poets and writers such as Huysmans, Villiers de l'Isle-Adam, Jules Bois, Elémir Bourges, Paul Adam, Oswald Wirth, and Edouard Schuré were drawn into the mêlée in varying and often inimical roles. To this list one must add Saint Yves d'Alveydre and the occult popularizers, Dr. Gérard Encausse, known as Papus, and l'Abbé Constant known as Eliphas Lévi. Occultist revues proliferated in this golden age of the little review: L'Initia-

[1] Joséphin Peladan, "Les Maîtres contemporains: Félicien Rops, Iere étude, extrait de la Jeune Belgique (Bruxelles: Callewaert père, 1885), p. 15.

[2] See Peladan, L'Art Ochloratique, pp. 49-50.

tion, the voice of the Rosicrucian movement, _Le Lotus bleu_, that of
Mme Blavatsky's, and later Annie Besant's, Theosophists, stand out
with _La Lumière_ and Papus's _La Voile d'Isis_ from hundreds of feebler
efforts. Recall Adrien Père _Annales du Surnaturel_ in this respect.
Rémy de Gourmont's _Idéalisme_ synthesized various streams. The major
periodicals, notably the _Mercure de France_, carried special columns
devoted to the question. The finest were signed Edouard Dubus. _Le
Coeur,_ edited by Jules Bois, was a lushly produced art review of
Catholic-occult inclinations, financed by Count Antoine de la Roche-
foucauld after he broke with Peladan during the first _Salon de la
Rose+Croix_. Peladan retaliated with his _Bulletin Mensuel de la
Rose+Croix du Temple et du Graal_.

Many literary and artistic figures gravitated about this oc-
cult core: Mallarmé, Rimbaud, Verlaine, Pierre Louÿs, Henri de Reg-
nier. Among artists, Rops, Toulouse-Lautrec, and Redon all stopped
by frequently at Bailly's bookshop, as well as Debussy. Young Erik
Satie became the official composer of the Rose+Croix movement.[1] In
the mid-1880's, this diffuse group of occult enthusiasts was fasci-
nated and appalled by the activities of a certain _Abbé_ Boullan.[2]
His career resembles those of numerous minor satanic personalities[3]

[1] See Victor-Emile Michelet, _Les Compagnons de la hiérophanie,
souvenirs du mouvement hermétiste à la fin du xixe siècle_ (Paris,
n.d. [1937]).

[2] For information dealing with Boullan see Joanny Bricaud,
L'Abbé Boullan (Paris: Chacornac, 1927); Robert Baldick, _The Life of
J.-K. Huysmans_ (Oxford: Clarendon, 1955).

[3] For example, the Abbé Van Haecke of Bruges who performed
Black Masses and a constellation of women featuring Berthe Courrière
who fed consecrated wafers to stray dogs, on Rachilde's testimony.

of the day, though his was more dramatic and genially demonic than the rest. He became a <u>cause célèbre</u> involving many of the principal personalities of the symbolist movement.

Owing largely to the fact that Huysmans modelled his character Dr. Johannès (<u>Là-Bas</u>) after him, Boullan has become quite well known in recent years so that one need only trace his biography roughly.[1]

The early career of Boullan, who was born in 1824, suggests that were he to have remained within the bosom of the church he might have become a distinguished theologian. His studies were conducted in Rome, where he received a doctorate in theology, after which he entered into the services of the Congregation of the Precious Blood. He had strong literary ambitions and published several translations and lives of church leaders and visionaries. But by the end of 1859 his career had already taken a suspect turn. Associated with a certain Adèle Chevalier, he founded the Society for the Reparation of Souls. This society would shortly be charged with indecent practices and misrepresentation. Convicted of fraud, he was imprisoned in Rome where he served a term of three years from December, 1861 to September, 1864. During this period he secretly wrote a confession on fourteen pieces of pink paper known as the <u>Carnet Rose</u>. It subsequently passed into the hands of Huysmans and is now in the Vatican library. Fragments have been published.[2] We know

[1]See, too, Michel Provost and Roman d'Amat, <u>Dictionnaire de biographie française</u> (Paris: Letouzey, 1954), pp. 1362-1363.

[2]P. Bruno de J.-M. "La Confession de Boullan," <u>Les Etudes Carmelitaines</u> (Paris: Desclée de Brouwer, 1948), special issue on Satan.

from the confession that Boullan attributed miraculous powers to con-
secrated hosts mixed with human excrement, and that at the conclusion
of a black mass of December 8, 1860, Boullan sacrificed at the altar,
the child to which Adèle Chevalier had just given birth. These
crimes became known only after Boullan's death.

In 1870 Boullan began to publish the Annales de la Sainteté
au XIXe siècle, which lasted until 1875. The series carried occult
recipes for assuring sexual unions with Satan and even with Jesus
Christ. He also availed himself of a sacred relic, Christ's mantel
without seams, preserved near Paris, in Argenteuil, to cure an epi-
leptic. The Archbishop of Paris excommunicated Boullan in 1875 for
his activities.

Boullan then set out for Lyon, center of the Vintrasian cult,
and won the good graces of Vintras who thought himself to be the re-
incarnation of Elias, one of the prophets of Jesus' coming. In
December, 1875 Vintras died and Boullan claimed to be his successor.
Assisted by a certain Julie Thibaut, Boullan perfected the Provicti-
mal Sacrifice of Mary and the Sacrifice of Glory of Melchizedek,
originally instituted by Vintras.[1]

The core of Boullan's and Vintras's teaching was the promised
redemption of mankind through religiously performed sexual unions, in
this respect recalling the teachings of the Ganneau, the celebrated
Mahpah of the 1830's. It is evident that Boullan is a late manifes-
tation of the chiliastic prophet who preached "sexual promiscuity

[1]See l'Abbé Boullan, "Sacrifice Provictimal de Marie," La
Tour Saint Jacques, No. 10 (May–June, 1957), pp. 182-192. On the
Sacrifice of Glory of Melchizedek see Baldick, op. cit., p. 188.

without original sin,"[1] a fundamental proposition of all millenary prophets. Towards the end of 1885 Stanislas de Guaïta had contacted Boullan by mail. Oswald Wirth, who had met Boullan in August, 1885, had already embarked on a long correspondence with him. These sets of letters were to be used against Boullan when the Rosicrucian group condemned him. Moreover, Guaïta visited Boullan in 1886 and, from his first meeting, realized the Boullan fell "into deadly error with regard to Spiritual Marriages."[2]

In 1886 the great tide of articles by Peladan ebbed, and he turned once more to the novels of La Décadence latine. Curieuse was published with a frontispiece by Félicien Rops representing a nude female, an openwork skirt falling about her knees, embracing a huge herm. A piece on Franz Hals appeared in the April issue of L'Artiste. The death of Adrien fils inspired Joséphin's Oraison Funébre du Docteur Adrien Peladan fils which we examined earlier. In September, Jean Moréas published in the pages of the literary supplement to Le Figaro the historic document called the Symbolist Manifesto. Edouard Drumont brought out in 1886 his infamous work, La France juive, a virulent example of the patent anti-semitism which runs through the period and which echos throughout Peladan's work. In 1886 Stanislas de Guaïta visited Boullan in Lyon and at the end of the year set up a tribunal to judge Boullan which ran into the

[1] Norman Cohn, Pursuit of the Millenium. Revolutionary Messianism in Medieval Europe and Its Bearing on Modern Totalitarian Movements (New York: Harper, 1961; first published in 1957), pp. 185-186.

[2] Lettres inédites, p. 106.

next year. In May, 1887 Boullan was denounced as a vile sorcerer
and worse by the Rose+Croix group. The results of the enquiry held
fire for four years, until the Rose+Croix had been inaugurated as a
formal body and Guaïta had published his Temple de Satan (1891). In
1886 Guaïta brought out the first of his Essais de Science maudites,
Au Seuil du mystère which praises Peladan lengthily and places him in
the forefront of contemporary occultism.

Peladan's most important article in 1886 was published in
four monthly instalments under the Shakespearean pseudorym, Trincu-
lo--the clown in the Tempest--in the April through July issues of the
_evue du Monde Latin. L'Artiste apparently could no longer risk so
renegade a critic on its pages. The Salon de 1886 is nevertheless
Peladan's least contentious review, lacking the curious and unbalanc-
ing dogmatic appendages which form often the most interesting portion
of his opinions. The 1886 Salon exhibited, for Peladan, nothing
either outrageously poor or outstandingly good. As a general tend-
ency he remarks on the greater acceptance of pleinairisme. He at-
tacks, of course, the prevailing notions of representationalism and
the immense vulgarity of the Salon as an institution. Among the
practical suggestions offered to counter the mediocrity in which the
official Salons were drowned was one offered by the sculptor Dalou
who pressed to have the number of entries reduced, hoping thereby to
enlarge the percentage of higher quality work. The proposal was not
carried out. For Peladan the very vacuity of the work of the offi-
cial circles was the central issue. "The Institute finds itself in
complete inferiority. The greater portion of Professors of the

School are surpassed by their students. . . ."[1]

In 1887, Peladan brought out Volume III of the Ethopée, L'Initiation sentimentale, with a frontispiece by Rops, one of the artist's best plates. The symbolism is easily understood although the work is composed of multiple elements: a half-skeletal huntress, with huge buttocks, seen from the rear, in a tight corset. She is winged and roses bind her skull. In her hand she holds a severed head wearing a feathered cap. A cloak and quiver fall about her legs and she stands on a winged pelvic bone which reads at the same time as the face of a huge moth.[2]

In France a growing vogue for things English was supplied with a translation of D. G. Rossetti's sonnets, translated "littérale-ment" and "littérairement" by Clémence Couve. They were prefaced by Peladan. The preface is a stupefying expostulation of the Neo-pla-tonic core of the Dante-Beatrice relationship and includes a detour which examined the Dante scholarship of Rossetti's father--an echo of Peladan's own dependence on his father's work. Much is made of the lurid exhumation of the poems' manuscript from Miss Siddall's grave.

Eighteen eighty-eight was marked by several important events for Peladan. The novels continued unabated. Two were brought out, A Coeur perdu with an etching by Rops and Istar with one by Fernand

[1] Trinculo [Joséphin Peladan], "Le Mois, Salon de 1886, II," Revue du Monde Latin, pp. 102-120; p. 120.

[2] Erasthène Ramiro [Eugène Rodrigues], Catalogue Descriptif et analytique de l'oeuvre gravé de Felicien Rops (Paris: Conquet, 1887), p. 635. The Ramiro catalog clafifies the inscription from Saint Augustine: Diaboli Virtue in Lombis. The Ramiro catalog is frequently quite piquant, especially the tongue-in-cheek description of Rops' numerous erotic plates. Exsteen's catalog, op. cit., is more densely illustrated.

Khnopff marking the beginning of the artist's collaboration with
Peladan. The cover of A Coeur perdu is illustrated by Louis Morin.
An inferior work, it is interesting because it obviously presents a
likeness of Peladan in the robes of a Babylonian-Assyrian priest
blessing a bare-breasted female covered in jewels and seated on a
throne, also of the same operatic period. All this is a feeble echo
of the day's preferred Salomé theme. Rops' frontispiece depicts a
female nude bound to a tree by a serpent which bites her beneath the
breast. The tree rises behind the head of the victime, its branches
filled with fruit from which she plucks an apple.[1]

Khnopff's cover for Istar is a poorly integrated arrangement
of typography and soft-ground etching[2] which represents a female nude
seen to the waist, her hands bound above her head, beneath an orna-
mental panel. In 1892 Alexandre Séon decorated a reedition of the
novel for Dentu. The bound female nude seen à mi-corps is kept. Her
hair falls about her and around her hips a fallen cloak. She is set
against a kind of heraldic shield. The illustration, very strongly
marked by Puvis de Chavannes, is quite charming and is reproduced in
the catalog to the 1892 exhibition of the Salon de la Rose+Croix and
La Queste du Graal (1892), a selection of "proses lyriques de l'étho-
pée." Istar is dedicated to Count Léonce de Larmandie who will be-
come Peladan's companion in arms and the first historian of the

[1] In the branches is the motto: Eritis Similis Deo. Exsteen
catalog, op. cit., Vol. III, No. 520.

[2] The balance is still unresolved in his poster for the 1891
exhibition of Les XX. See M. Bauwens, T. Hayashi, [?] La Forgue,
J. Meier-Graefe, and J. Pennell, Les Affiches étrangères illustrées
(Paris, 1897), p. 109.

<u>Salons de la Rose+Croix</u>.[1] Istar is dated July, 1888 and was written
in Bayreuth.

The second series of <u>Femmes Honnêtes</u> was published by Dalou
under Peladan's real name. It contains a handsome frontispiece by
Fernand Khnopf and a set of pedestrian illustrations by José Roy.
The cover, by Roy, for example, depicts a girl riding a serpent, the
kind of erotic imagery favored and better exploited by Franz Stück
and the Munich Secession artists. The Khnopff soft-ground repre-
sents a mysterious female in great shadow. Khnopff's work was exhib-
ited at the official Salon of 1888 and Peladan's description of the
piece will be examined in my discussion of his important review of
this exhibition.

The Salons of 1882 and 1883 were republished by Dalou as <u>L'Art
ochloratique</u>. Peladan's ascerbic denunciations and arcane allusions
by now had outgrown the pages of a magazine. From 1888 on his Salon
reviews were to appear as separate books, first at Dalou, then Dentu.
The review of the Salon of 1888, <u>Le Salon de Joséphin Peladan</u>, is a
dogmatic and vituperative masterwork. As is so common in his large
essays, Peladan begins with a list of grievances. They relate to
the difficulties he had of gaining access to the Official Salon on
the three days reserved for critics. In 1881 Ernest Hébert had
given him a card;[2] in 1882 Puvis de Chavannes. In 1883, while at

[1]Comte Léonce de Larmandie, <u>Notes de psychologie contempo-
raine, l'Entr'acte idéal, Histoire de la Rose+Croix</u> (Paris: Chacor-
nac, 1903).

[2]This neglected artist is fairly treated in Peladan's criti-
cism. See Joséphin Peladan, <u>Ernest Hébert, son oeuvre et son temps,
d'après sa correspondance intime, et des documents inédits; par
Peladan avec une preface de Jules Clarétie</u> (Paris: Delagrave, 1910).

work for L'Artiste, he took the precaution of applying for his pass
under the name of Charles Bigot. By 1885 La Société des artistes
français had learned their lesson and Peladan was refused entry even
though he had arranged with a publisher to bring out--as part of his
feminist series--La Femme au Salon, a plan which never came to frui-
tion. In 1886 he managed to slip by with a pseudonym. In 1887, the
publisher Edinger had engaged Peladan to write La Vérité au Salon,
but a certain "Vigneron quelconque" would not let Peladan in, and
the work was never written. In 1888 Peladan was allowed in because
Puvis de Chavannes again pressed for his admission.

The most important aspect of Peladan's 1888 Salon are the
dogmatic assertions which incorporate features of the Salon of 1883
and adumbrate the roles and regulations of the Salons de la Rose+
Croix.

> 1. With the exception of Puvis . . . no contemporary can
> touch mystical painting;
> 2. History painting does not exist as a genre since noth-
> ing exists except that which is born with immortal principles;
> 3. Painting is patriotic when it is good and not only be-
> cause it represents French soldiers. . . .[1]

The Official Salon remains the great meeting place of the
ochlos. Meissonier dominates the bourgeois taste of the day since
he "is the painter of parvenus"[2] by whom Peladan particularly meant
M. de Rothschild. There are exceptions, however, such as Charles
Hayem, also of a Jewish banking family (they had not yet broken over

[1]Joséphin Peladan, 1888, Le Salon de Joséphin Peladan, cin-
quième année (Paris: Dalou, 1888), p. 22.

[2]Ibid., p. 18.

the portrait of Barbey d'Aurevilly) who owned forty paintings by Gustave Moreau.

The greatest painting of all is Leonardo's Saint John the Baptist in the Louvre, owing evidently to its androgynous perfection. We recall the argument from the earlier review of the Salon of 1883.

Among the works Peladan most admires are the two frontispieces that Khnopff executed for Istar (Fig. 2) and Femmes Honnêtes:

> Nude against a column of the pillory, hands bound to a bronze placard bearing the words calibari justitiia, Istar, the incarnation of the Chaldean Venus has fainted or is dead, her eyes closed, mouth sealed, her noble body still bright, the soul gone: on the abdomen an old hag, provincial medusa, whose tresses are made of octopus tentacles, flattens itself, sordid and profane, on the divine lap.
> The other, a brother figure, hypocrite but thoroughbred, grows furious and fights over his garments with two hands, bursting forth from the darkness, with two metaphysicians, encircled at the wrists with the heavy and large bracelets of an assyrian sâr, with this Persian epigraph, Pallentes radere mores.
> With these two figures Fernand Knopff [sic] has entered a path in which he will create marvelous things--the emotional nude, that is to say, the expression of the model apart from its movement.[1]

Peladan salutes the glorious absentees, Puvis de Chavannes, Gustave Moreau and Félicien Rops. From the dedication of Istar we learned that Peladan spent July at the Bayreuth festival. Peladan, too, played a small role in the endemic Wagnerianism of the Symbolist Movement. In 1895 he published Le Théâtre complet de Wagner, a key work in determining the chronology of the pre-history of the Salons de la Rose+Croix. In it Peladan relates how, during a performance of Parsifal, in the summer of 1888, he first conceived the idea of organizing these manifestations. "I conceived at that time,

[1] Ibid., p. 88.

in a single flash, the foundation of the three orders of the Rose+
Croix of the Temple and the Grail, and resolved to become so far as
concerned the literary theatre, a disciple of Wagner."[1]

Strictly speaking, Peladan's chronology is slightly mistaken.
We know that Peladan had been allied with a body of young intellectu-
als attracted by occult questions. One might say that Boullan and
Parsifal played equally inspirational roles, since in May, 1888[2] the
governing council of twelve of the Rose+Croix+Kabbalistique had already
been formed, headed by Stanislas de Guaïta and Peladan.

The teachings of the Rose+Croix+Kabbalistique purportedly
comes from the fifteenth-century visionary Christian Rosenkreutz, al-
though his actual existence is in serious doubt. Numerous historians
of the movement contest it.[3] The issue of his historical reality is
far less important than the mysteries which accrued to his name.
Among the more interesting ones, revealed to initiates of the Rose+
Croix, were the transference of metals, the prolonging of life
throughout centuries, the knowledge of what transpires at great dis-
tances, the kabbalistic distillation of the secrets hidden in num-
bers, words and things. To even the most casual student the rela-
tionship of these propositions to millenial prophecy and to Jewish
mysticism, particularly that of Abulafia, is self-evident.[4]

[1] Joséphin Peladan, _Le Théâtre complet de Wagner, les XI
opéras scène par scène_ (Paris: Chamuel, 1895), p. xii.

[2] Doyon, _op. cit._, p. 82.

[3] Paul Arnold, _Histoire des Rose+Croix et les origines de la
Franc-Maçonnerie_ (Paris: Centre National de la Recherche Scienti-
fique and Mercure de France, 1955); René Guenon, _Le Théosophisme,
histoire d'une pseudo-religion_ (Paris: Nouvelle Librairie Nationale,
1921), p. 144, fn. 1.

[4] G. G. Scholem, _Major Trends in Jewish Mysticism_ (New York:

We must accept at face value that the initiates into the
rosicrucian mysteries were granted startling powers or believed that
they were. In an open letter to the President of the French Repub-
lic, for example, Peladan, imitating Leonardo's famous letter to
Ludovico il Moro in Milan, baldly asserted: "I have the means of
seeing and hearing at the greatest of distances, useful in control-
ling enemy councils and suppressing espionage."[1] In a letter from
Stanislas de Guaïta to Peladen we read: "The other night I was flu-
idically attacked with enormous violence and I sent the poisonous
current back to its center or pole of transmission, with the result
that the magician himself became the victim."[2] The magician in ques-
tion was Boullan and on Boullan's death the rosicrucian circle will
actually be accused of having murdered him at a distance.

The long and fascinating history of rosicrucianism, which
includes such fabulous characters as Nicolas Flamel and Robert Fludd,
is incidental to our study. A certain element must be kept in mind,
however, namely that by the end of the eighteenth century rosicru-
cianism was liberally intermingled with aspects of Freemasonry--the
highest degree, for example, of the Freemasonic rite is the Rose+
Croix.[3] In the nineteenth century, the circle of the Rose+Croix+Kab-

Schocken, 1956; first published in 1941), esp. p. 132.

[1]Sâr [Joséphin] Peladan, Théâtre de la Rose+Croix, La Promé-
théide, trilogie d'Eschyle en quatre tableaux, avec un portrait en
taille douce (Paris: Chamuel, 1895), p. vii.

[2]Lettres inédites, p. 124.

[3]Marguerite Loeffler-Delachaux, Le Cercle, un symbole (Genève:
Editions de Mont-Blanc, 1947), p. 185.

balistique attempted to separate the essential kabbalistic teachings
from the accumulations of centuries. Much of its work, notwithstand-
ing a basic lack of analytical faculty, resembles aspects of what
today is referred to as comparative religion. The Rosicrucians were,
of course, handicapped in this task by their lack of scientific ap-
praisal, with, perhaps, the exception of Stanislas de Guaïta. Rather,
they were impressed by Eastern magical and religious manifestations
which they called upon to testify to the truth of their own pro-
Western teachings. The kabbalistic aspects of Judaism, as well as
Buddhist doctrines, were especially attractive. In adopting these
esoteric gnoses they felt that their Christian holdings, albeit
heretical, were substantiated and expanded. With this sensibility
in the air it is easier to appreciate why the Nabis should have been
called "prophets." It appears that Cazalis and Sérusier were Rosi-
crucians,[1] and there is no question that Schuffenecker was a Theoso-
phist.[2]

It was difficult for Peladan to support the oriental incur-
sions into rosicrucian Christianity. Two attitudes were especially
intolerable; the superiority of the Kabbala over the New Testament,
and anti-Popism. The Pope was considered, in fact, the anti-Christ.
Peladan's refusal to admit these propositions will lead to his break
with the Rose+Croix+Kabbalistique.[3]

[1]François Aman-Jean [son of Aman-Jean, the painter, who col-
laborated with the Salons de la Rose+Croix], L'Enfant Oublié (Paris:
Buchet-Chastel, 1963), p. 73.

[2]Manuscript, Collection Jacques Fouquet, Paris. The unpub-
lished writings of Schuffenecker are discussed in Chapter III.

[3]Bertholet's essay which precedes the Lettres inédites indi-

Within their own circle, the Rose+Croix+Kabbalistique was a
secret society in which the adept moved upwards as he satisfied
proofs of his accruing mastery. To the outside world, the Rose+
Croix+Kabbalistique was an organ for the diffusion of occult infor-
mation and the antagonist of black magic and satanism. In the latter
role, Boullan was unanimously judged guilty on May 23, 1888, accord-
ing to Guaïta's account in Le Temple de Satan.

The Rosicrucian group continued strong into 1889. Papus
founded L'Initiation, the periodical of the Rose+Croix+Kabbalistique,
and published an important article on "Les Sociétés d'Initiation en
1889," in its third issue. General occult interest widened. Inde-
pendent Rosicrucian lodges were formed in England and Germany.
Edouard Schuré proposed in his influential Les Grands Initiés that
Moses, Buddha, Orpheus and Jesus Christ, among others, all echoed a
like, but forgotten, religious impulse.

Léonce de Larmandie, poet, occultist, and the future "Comman-
deur de Gebural," wrote an "etude physiologique et documentaire,"
Du Faubourg Saint-Germain en l'an de grâce 1889 (Dentu), a study of
the upper classes in late nineteenth-century France which explores,
among other questions, the introduction of the Jew into the French
aristocratic milieu. Larmandie himself was born to the aristocracy,
and through him Peladan was able to move into its rarified circles.
In 1896, Peladan was to marry the widow Countess Le Roy de Barde,
Larmandie's cousin, and although the marriage was shortly annulled,

cates that personality clashes between Peladan and Jhounet may have
been an additional factor.

Larmandie did not hold it against his mentor whom he regarded as "the greatest of the young men . . . who sees in the Jews the retainers of the most ancient and elect metaphysical formulae of humanity,"[1] an opinion which coincided with the Rosicrucian point of view.

Peladan published the sixth novel of the _Ethopée_, _La Victoire du Mari_. It contained a black framed commemoration of Barbey d'Aurevilly who had died in April, 1889, a medallion portrait, a labored cross-hatched affair of Barbey d'Aurevilly's beaked profile executed by a certain "Countesse Antoinette de Guerre." "The Constable of Letters is dead!" wrote Peladan, "No more will I call anyone in this world Master."[2]

The deluxe edition carried a frontispiece by Fernand Khnopff,[3] and the ordinary edition one by Alexandre Séon. The work by Séon represents a winged warrior in a short tunic standing guard before a sphinx, a wavy sword between his legs. It is reproduced again in the 1892 Rose+Croix catalog as well as in _La Queste du Graal_.

Barbey's passing was to have troublesome results for Peladan. In the waning days of Barbey's life, Peladan had had the temerity to alert a former mistress of Barbey of his imminent demise. Once there had been a question of marriage and, without warning, Mme de Bouglon

[1] Cte Léonce de Larmandie, _Du Faubourg Saint Germain en l'an de grâce 1889. Etude physiologique et documentaire_ (Paris: Dentu, n.d. [1889]), pp. 27-28.

[2] Joséphin Peladan, _La Décadence Latine_, _Ethopée VI_, _La Victoire du Mari, avec commémoration de Jules Barbey d'Aurevilly et son médaillon inédit par la Comtesse Antoinette de Guerre_ (Paris: Dentu, 1889). The novel is dated 1888 and dedicated to "Mme la Comtesse Antoinette de Guerre, Statuaire."

[3] According to Caillet, _op. cit._; I have been unable to locate it.

appeared in the death chamber, pressing a claim which had been finan-
cially discharged earlier, perhaps hastening thereby the author's
death. The upshot was that Peladan was barred from the master's
bedside and incurred the wrath of the remaining members of Barbey's
circle. This lead to a bitter exchange in <u>La Plume</u> in 1891. De-
spite his gross indiscretion, Peladan was, as we have seen, a sin-
cere admirer of Barbey d'Aurevilly. On Barbey's death he contrib-
uted an obituary to <u>Le Clairon</u> of April 26, 1889, as well as other
eulogies. <u>La Victoire du Mari</u> carried the commemoration. Anatole
France, in reviewing this novel for <u>Le Figaro</u> (January 5, 1890), saw
identical failings in the work of both men, especially in their
Catholic and occult poses.

In 1889, the most anglophile of French critics, Gabriel
Mourey, later French editor of <u>The London Studio</u>, published his
translations of the <u>Poèmes complets d'Edgar Allen Poe</u> to which Pela-
dan had contributed an introduction, also written during his Bayreuth
stay. The preface is a pretext to vilify the United States which
Peladan visualized in terms of his childhood in Nîmes.

Mourey was also Swinburne's translator (1891) as well as an
influential propagandist in France for later manifestations of the
Pre-Raphaelite Movement, such as the work of William Morris and
Walter Crane, whom he discussed in <u>Passé le Détroit</u>, <u>La Viet et l'Art
Londres</u>, ornamented with a lovely cover by Anning Bell (Paris:
Ollendorff, 1395), a taste shared by the contemporary Rose+Croix
Salons.

In March, 1890, Adrien père died, and Peladan included his

commemoration in the seventh volume of the Ethopée, Coeur en peine
which Dentu published in August.

In May Peladan's annual Salon appeared. The official Salon
(1889-90) itself had been the scene of an internecine struggle which
at last broke the throttle-hold of La Société des artistes français.
In 1890 the first Salon of the Société Nationale des Beaux-Arts,
headed by Puvis de Chavannes, Rodin and Carrière, took place. While
still "official," it was much more open to progressive works, par-
ticularly in the decorative arts.

The schism is echoed in Peladan's Salon, in a parody on the
"Salon Nationale" and the "Salon Jullian," the latter named after
the establishments in which students who had failed the entrance
examinations to the Ecole Nationale des Beaux-Arts polished up their
drawing. Peladan's evident distaste for the "Salon Jullian" is
predicated on his resistance to Synthesist and Divisionist princi-
ples which were first experimented with by certain students at the
Académie Julian. Out of this group emerged the prominent figures of
the Nabis and Pont-Aven artists--Bonnard, Vuillard, Denis, Valloton,
Ranson, Sérusier.[1] In addition to the expected praise of Puvis and
scattered compliments for other members of Joséphin's hierarchy,
Peladan devotes a long passage to the Spanish artist, Rogelio de
Egusquiza, still another worshipper at the shrine of Wagner. In all
likelihood they had met in Bayreuth in 1888. Egusquiza's preferred
Wagnerian subject matter was evidence enough for Peladan of a major

[1]John Rewald, Post-Impressionism from Van Gogh to Gauguin
(New York: Museum of Modern Art, 1956), pp. 271-275.

talent: "his work as a great painter was determined at Bayreuth as was mine as a tragic playwright."[1]

Other regulars of the Salons de la Rose+Croix discovered at the new Salon were the sculptors Marquest de Vasselot, James Vibert and Niederhäusern-Rodo, who later were to drag the Rosicrucian faction into the Balzac monument scandal. "What I admire in the work of this sculptor," Peladan wrote of Marquest de Vasselot, "is his superior gift for making visible the spark of flame which lies in an illustrious head. . . . Marquest de Vasselot has raised larger than life the Hercules of nineteenth-century letters, a floating dressing gown falls to his feet, bull-necked, the neck of cerebral fecundity, the four-square stance of an Atlas, realized without a lie, the reality of Balzac Imperator--here is a sculptor destined for a statue of B. Aurevilly if ever one is erected to him."[2]

The "Salon Jullian," held at the Palace of Industry on the Champs-Elysées, was treated by Peladan as a gross joke, a collusion from which only interested persons stood to gain. Peladan imagines an interchange between "Juli" ("Jullian," the head of the Académie Julian) and "Bougre" (Bouguereau, head of the Salon des Artistes français):

> Juli . . . Illustrious member of the Institute, I require that my schools be the shortest way from a daub to an exhibition wall. . . .
> Bougre . . . Illustrious vulgarizer of the arts, I am in

[1] Joséphin Peladan, La Décadence Esthétique (Hiérophanie), XIX. Le Salon de Joséphin Peladan (Neuvième année), Salon National et Salon Jullian. Suivis de trois mandements de la Rose+Croix Catholique à l'artiste (Paris: Dentu, 1890), p. 30.

[2] Ibid., pp. 55-56.

need--so despised is my painting by artists--to keep them in
check as an administrator. . . . If you would give your stu-
dents' voices over to me for me to vote in their stead I, in
turn, would be disposed to favor the students of the Academy
Jullian.
 Juli . . . Yes! Mine the exhibition space, mine and the
smears of my academy.
 Bouwre . . . Done! Mine the medals, to me and to those
without talent, my equals.[1]

But these aspects of the Salon of 1890 pale before a curious

appendage to the book, a Tiers-Ordre intellectuel de la Rose+Croix

Catholique. Syncelli Acta. These three bulls from Peladan's hand

proclaim aloud the schism within the Rosicrucian group. They are

the first public announcement of a new Rose+Croix, stripped of East-

ern impurities, reunited with the Mother Church. They proclaim the

formation of the Rose+Croix+Catholique under whose auspices the first

Salon de la Rose+Croix will be held in 1892. The Syncelli Acta marks

Peladan's self-elevation from the circle of Rosicrucian magi to the

glorified isolation of Sâr. They are signed Sâr Mérodack, the cen-

tral character of Le Vice suprême, the priest of Le Chemin de Damas

in Babylonian garb.

A new chapter of Peladan's career has begun. We have ar-

rived at the esoteric episode called The War of the Two Roses;[2] the

central event of the idealistic war will be Peladan's great crusade,

The Salons of the Rose+Croix.

[1]Ibid., pp. 61-62.

[2]Georges Vitoux, Les Coulisses de l'Au-delà (Paris: Chamuel,
1901), pp. 177-232.

CHAPTER III

SÂR

The Syncelli Acta are made up of three "open-letters," "Man-
dement à ceux des Arts du Dessin," "Lettre à l'Archevêque de Paris,"
and an "Excommunication de la femme Rothschild." The first informs
the community of artists that an agency headed by Peladan, the Rose+
Croix+Catholique, is at their disposal for criticism: "persuaded
that you are lacking both an immense reading and its assimilation,
it seems appropriate to our love of Art and our direction of the
Rose+Croix+Catholique to come before you as the delegate of Idea,
before you, Gentlemen of color and line--if you will agree to an
examination of your sketches and models."[1] The "Mandement" is dated
May 14, 1890.

The second letter addressed to the "Cardinal Archevêque de
Paris," is concerned with the erotic effects that the opening of a
bull-ring produced in the women of his congregation.

The third document is more interesting. It is an "Excommuni-
cation of the Rothschild Woman for the crime of sacrilege and icono-
clasm." Apparently a member of the Rothschild family tore down the
chapel of Saint Nicolas, "a curious specimen of the change in style

[1]Peladan, "Mandement à ceux des arts du dessin," Le Salon
(Neuvième année), p. 68.

78

from Louis XVI to that of the Empire,"[1] when she acquired the Chateau
de Beaujon. Worse still, "the Rothschild Woman razed from cellar to
eaves the house of the greatest writer of this century, Honoré de
Balzac. . . ." Peladan's tribunal, therefore, declared the Baroness
an iconoclast: "infamous this woman and infamous her name. . . ."
The Rochefoucaulds and Uzès were to give up her company, not to men-
tion other noble families; artists were to shun her. "If she enters
a church, a library, a museum, a concert, whomsoever has the right
to drive her away."[2] Artists employed by her, unless starving to
death, are renegades. Even the poor are to refuse her charity. The
last "Mandement" is one of the most curious anti-semitic documents
in a period marked by a high incidence of the genre.

To all intents and purposes the three "Mandements" represent-
ed Peladan's break with the rosicrucian circle of Stanislas de
Guaïta. A formal resignation appears in the June, 1890 issue of _Ini-
tiation_. Among the reasons Peladan gives for this act are his supe-
riority in occult matters to all rosicrucians except for the five
other known members of the Council of twelve, his scorn of Freemasonry
and of Buddhism. "You come from free thinking toward Faith, I leave
the Vatican toward the occult."[3] On May 24, 1890 Stanislas de Guaïta
had written to Peladan à propos the "Mandements." "I, Stanislas de
Guaïta, having received a mandate from the Supreme Council to speak

[1]"Excommunication de la femme Rothschild pour crime de sacri-
lège et d'iconoclastie," _ibid._, p. 73.

[2]_Ibid._ The MS of these "Mandements" are preserved in the
Fonds Peladan, Bib. de l'Arsenal, Paris, MS 13205.

[3]Vitoux, _op. cit._, p. 192.

in its name, appeal to your loyal friendship, begging you to public-
ly clarify the misunderstanding which cannot fail to ensue."[1]

Peladan clarified. In August, 1890 the Rose+Croix+Catholique
is officially announced in Initiation. Among the names of the gov-
erning council Peladan mentions Count Léonce de Larmandie and the
"Count of Tammuz," doubtless Antoine de La Rochefoucauld, patron of
numerous artists either openly committed to or on the fringes of
the rosicrucian circle. Papus, in consideration of his position as
editor of Initiation, was granted the privilege of sitting in on the
meetings of the dissident society.

The war of the Two Roses, conducted in the most obliging for-
mulas, soon began to have repercussions in the press. Maurice Bar-
rès, in a front page review of Le Figaro, June 27, 1890, called "Les
Mages," observed how modish the occult movement had become. Barrès
ridiculed Peladan's "satins and lace with mutton sleeves, his beard
of superb black." He paused briefly at the three "Mandements," sup-
posed incorrectly that "Sâr" derived from Sardanapulus,[2] invidiously
compared Peladan to Stanislas de Guaïta whose just published Seuil
de Mystère Barrès highly praised. Many of the jibes are justified,
despite the fact that Barrès and Guaïta were childhood friends.
In any event, the standard model for Peladan criticism is set; a

[1]Lettres inédites, p. 138.

[2]According to Doyon, op. cit., "Sâr" means chief and Méro-
dack equals Jupiter, p. 84. Praz (The Romantic Agony, 1933), be-
lieves the name to be a euphonic reference to Mérodack-Baladan, King
of Babylon, Isaiah xxxix, p. 316, an opinion corroborate by letter
69, Guaïta to Peladan, written under the sign of Jupiter and ad-
dressed to "Prince Rose+Croix Mérodack BALADAN." Lettres inédites,
p. 118.

deadening of repetition of remarks on his sartorial eccentricities
with slight accounting of the valuable aspects of Peladan's work.

Beginning in the October issue of La Plume, given over to
"Catholiques-Mystiques," particularly Charles Buet, a set of episto-
lary exchanges between Buet and Peladan are touched off. This marks
the beginning of Peladan's long wrangle with his former companions
of the Barbey circle. Angered by the publication of his reply to
Buet's letter on the death of his brother as well as to Buet's un-
flattering remarks on his career, Peladan protested, "Neither in
religion, nor in literature, will I accept M. Buet as a colleague."
On November 1, Buet replied that he was delighted at the news. The
November 15 issue carried Peladan's piqued response: "For a short
story and two articles on mystical art, I was paid in 1882 about a
hundred francs. Am I to be forever grateful to M. Buet for having
received in the place where usually he accepts foolishness the work
of a superior writer?"

The publication of l'Androgyne momentarily distracted Pela-
dan from these exchanges. It bore a cover by Séon and a frontis-
piece by Point. Séon's cover represents a head floating above a
rocky coast (Fig. 4). Reproduced again in the 1892 catalog of the
Salon de la Rose+Croix as well as in La Queste du Graal, it echoes
the ubiquitous decapitation theme notably taken up by Moreau in his
Salomés and by Redon in a multitude of fusains.[1] The Armand Point

[1] Sandström holds that Redon's use of the decapitation theme
derives from Gustave Moreau. Sven Sandström, Le Monde Imaginaire
d'Odilon Redon, étude iconologique (Lund, N.Y.: C. W. K. Gleerup,
Wittenborn, 1955), p. 48.

etching, if meant to be androgynous, did not succeed too well. A
lovely female nude is shown, her head bound in a fillet. Behind her
in the sky there vaguely emerges the figure of Aries the Ram. The
novel is dedicated to César Franck whose music Peladan admired.

L'Androgyne fancifully recounts Peladan's boyhood with the
Jesuit fathers. He calls himself Samas. While his companions are
at play, he manicures his fingernails. When called upon to trans-
late Caesar, he refuses on the grounds that Caesar was a murderer
and brigand. When rebuked for being insolent, he informs his precep-
tor that Jesuit merely means Joshua, that is prophet, whereas Samas
means the Sun.

Léon Deschamps published, in the March 1, 1891 issue of La
Plume, the Hymne à l'Androgyne, an eight-part Prose poem in extrava-
gantly bad taste, that forms the prelude to the novel. Deschamps
also continued to publish the denunciations of Peladan by the Barbey
circle.

On April 30, 1891, Peladan at last rose to the occasion. He
retorted with still another eulogy in praise of the master. He ful-
minated against Bloy who had refused to let him kneel beside Barbey's
deathbed. Bloy retaliated brilliantly in the May 15 issue, claiming
that he had taught Peladan, "that sidewalk Assyrian," everything he
knew. Bloy had introduced Peladan to Barbey; when Barbey came to
know Peladan better he, too, found him ridiculous; Peladan's meddling
during Barbey's final hours was nothing short of assassination.

On June 1 it was Peladan's turn. Cogently, personal letters
included, he refuted Bloy's assertions on all points. On June 27,

Peladan brought Bloy and Deschamps to court, asking five thousand francs damages for falsifying the role he had played during the events surrounding Barbey's death. _La Plume_ covered the hearings from July 15 on. The decision came in October. Peladan lost. The November 15 issue carried a crowing and well-turned letter from Bloy. Peladan's pride dashed, the affair left the pages of _La Plume_ not without sowing a campaign of ridicule of which Peladan would not live to see the end.[1]

Nor could Peladan turn to his former rosicrucian companions during this episode. On the contrary, he succeeded in further antagonizing them through a series of new "Mandements." On February 17 Peladan had issued a "Mandement" to Papus, which was published in the April issue of _Initiation_. Addressing him as brother, "Tres Cher Adelphe," Peladan informs Papus of the basis for his break with the rosicrucian circle.[2] For reasons having to do with pride, certainly, but also because "Catholic rigor . . . no longer permits me to remain the consort of a group in which Cakya-Mouni [i.e., Buddha] usurps the place of Jesus Christ. . . . You open the doors of the temple that I wish to close. . . . Henceforth I will give myself over entirely to my Rose+Croix+Catholique. . . . From this moment the Church possesses the occult as I bring it to her, in my person, one of the six gnostic lights of the hour. . . ."[3] The letter suggests

[1] Doyon, _op. cit._, pp. 109-111 esp.

[2] Calle "Rose+Croix Orthodoxes" by Vitoux, _op. cit._, p. 195.

[3] ʻonʼs Peladan, MS 13205$\frac{21}{}$; see, too, Vitoux, _op. cit._, pp. 196-197.

that Peladan had already decided upon his own Council of Six, and it is clearly evident that his Roman Catholicism would no longer tolerate Eastern occult intrusions. Peladan's break was none too early. In June, 1891, the "Groups des études ésotériques" and l'Initiation were placed on the Index. However much Peladan skirted heresy, his writings were never banned to Catholic readers. As he said, "today the Magus goes to mass, deems it an honor to hear it and to humbly confess to a priest whose conversation he could otherwise not stand for two minutes."[1]

Peladan only just got by ecclesiastic censure. In 1891 a provincial Catholic Congress meeting in Malines, Belgium, denounced Baudelaire, Barbey d'Aurevilly, Paul Verlaine and Joséphin Peladan as authors who dishonored the faith. The level of argument can be judged by their rejection of the study of the nude in the artist's training. This pathetic congress was the object of one of the acts of the Rose+Croix+Catholique, the "Exécration Vehmique du Congrès Catholique de Malines," in which Peladan, as Sâr, simply excommunicated all its participants.[2]

In May, Peladan's annual Salon review appeared. It was dedicated to the "Master Painter Marcellin Desboutin" and contained lengthy passages of lush praise of Desboutin's portrait of Peladan,

[1] Joséphin Peladan, "Instauration," La Décadence Esthétique (Hiérophanie) XX. Le Salon de Joséphin Peladan (Dixième Année), avec instauration de la Rose+Croix esthétique (Paris: Dentu, May 14, 1891), pp. 54-55.

[2] Included in Joséphin Peladan, Salon de la Rose+Croix, Règle et Monitoire (Paris: Dentu, 1891), pp. 303-305. In addition to the signature of "le Grand Maître" it is signed by "Le Grand Prieur, A. de La Rochefoucauld."

now in the Angers Museum (Fig. 3), which was shown in the 1893 Salon de la Rose+Croix. The following month Peladan's novel, Le Gynandre, was published and it, too, was dedicated to the "Marquis Marcellin Desboutin," a title as demonstrably mythic, as Peladan's "Sâr."[1]

For Peladan, the Salon of 1891 was dominated by his own image. The picture "seems to have come from the Louvre or the Pitti. . . . The Young Man in Black Satin [as Peladan's portrait was called] stands up to The Man with the Glove [i.e., Titian's portrait].[2] . . . only you [Desboutin] are able to console us with Titian's absence . . . I proclaim you to be the greatest living portraitist[3] . . . your brush has fashioned the plastic proof of my destiny: henceforth I belong twice-over to art, by my work and by yours."[4] And these observations come only from the dedication. The body of the text is even more rhapsodic. After four full pages of praise for the "pro-Peladano," ". . . a venetian-ritratto that comes down to us and not an icon dated 1891,"[5] Peladan at last moves on to Puvis de Chavannes, "the greatest artist of the day,"[6] who was exhibiting two panels for the Rouen decorations.

Peladan's Salon review of 1891 is most interesting because it is filled with passing remarks and praise for several artists who

[1] Noel-Clement Janin says that Desboutin was born at best to minor nobility of the provinces despite Peladan's and Armand Sylvestre's remarks. La Curieuse Vie de Marcellin Desboutin (Paris: Floury, 1922), p. 2.

[2] Peladan, Le Salon (Dixième Année), p. 5.

[3] Ibid., p. 6. [4] Ibid., p. 7.

[5] Ibid., pp. 18-19. [6] Ibid., pp. 20.

will have long associations with the Salons de la Rose+Croix as well as considerations on artists whose work is close in spirit.

Of foremost importance are Peladan's observations on Alphonse Osbert, a former student of Lehmann and a close friend of Aman-Jean and Seurat. Osbert had already passed out of his first, so-called "Spanish" period, perfected in Lehmann's studio, to his mature style, an arresting combination of Puvis de Chavannes' composition and the pointilism of Seurat. "OSBERT; his impression of dusk falling on a pond rises to a rare intensity; the shadowy part of the river flattens and metalizes the water, unsettling at this hour of the day; this approaches a beautiful thing."[1]

Khnopff is called "this so intense and subtle one."[2] Eugène Carrière, never to exhibit with the Rose+Croix, is admired for his "very excellent head of the desolate satyr, the portrait of the very exquisite poet of _Sagesse_: Paul Verlaine."[3] Alexandre Séon's "Le Désespoir de la Chimère" was seen "at the threshold of her cave, on a rock of lapis, the beast with the body of a woman tears at her paws and cries, the prey of an enigmatic despair."[4] The work was also shown at the 1893 Salon de la Rose+Croix.

"I will never forget my first emotion on seeing his Amfortas," Peladan wrote. "The Grand Master of the Grail" (Amfortas, not Peladan, though the Sâr was doubtless very sensitive to Amfortas's

[1]_Ibid._, p. 22. [2]_Ibid._, p. 23. [3]_Ibid._, p. 29.

[4]_Ibid._, p. 30. In June of the following year (1892), _La Plume_ (pp. 245-247) reproduced this work with a long prose poem by Alphonse Germain, one of the better known partisans of the Idealist movement. "Elle pleure ... Sur la passion des fils de l'Idéalité ... "

title), "seated on a knoll, moans an endless lament of moral pain; in his heart he carries the indignity which eats at him like the vulture who devoured the entrails of Prometheus. His Tristans are of an inexpressible intoxication and I can say no better of him than that he manifests the echo of Wagner as an artist and the reflection of Delacroix as a painter."[1] Rogelio de Egusquiza exhibited these and other works of Wagnerian inspiration at the Salons de la Rose+Croix of 1892-93 and 1896-97.

Of Armand Point, Peladan predicted that he "would be tomorrow a master as soon as he elevates his art to myth."[2]

Among the drawings that Peladan especially admired were Alexandre Séon's studies for the covers of the _Décadence Latine_. Of _L'Androgyne_: "Above the strange rocks of Bréhat, licked at by the waves, there rolls in the sky in place of the moon, the head of the androgyne Samas, stupefied by the sexual enigma."[3] Of _Gynandre_: "An angel descends full of grace and with a gesture rekindles hope within (the spirit of) the damned women of Baudelaire. . . ."[4] Needless to say, the lesbian theme closely related to that of the androgyne, will haunt the art of the Symbolist Movement. It is, for example, revived on numerous occasions by Rodin.

The last drawing is for an edition of _Le Vice suprême_. "From the terrace of Bas-Meudon one can make out the ruins of Paris; the Barbarians have come, the Yankee tower--a debris of scrap metal-- rises into the oppressive air. Alone, eternal priest, the cross on

[1] Peladan, _Le Salon (Dixième Année)_, p. 32-33.

[2] _Ibid._, p. 34. [3] _Ibid._, p. 40. [4] _Ibid._

which is nailed the head of the last Latin:"--a portrait of Pela-
dan--"on the ground engraved upon a stone, the epitaph of that which
was so great while it was Christian: **Finis latinorum**."[1] Huysmans
too detested the Eiffel Tower and vilified it in **Certains**. Peladan's
head, nailed to the cross elevated upon the detritus of western
civilization was republished in the 1892 catalog of the Salon de la
Rose+Croix and also of **La Queste du Graal**.

Hodler, called "Odler," caused a sensation at the Salon with
an early, tightly painted composition of nudes and a succubic night-
mare crouched on the chest of a terrorized sleeper. "If Hodler were
not lacking in taste," wrote Peladan, "or if he acquires some, I
guarantee his future in art. His various sleepers are marvellously
studied; the nightmare kneeling, black and vaguely formed upon a
chest, is really frightening; . . . the picture is unforgettable, a
work of art which bespeaks a great future."[2] In 1892, Antoine de La
Rochefoucauld travelled to Switzerland to ask Hodler to exhibit in
the first Salon de La Rose+Croix. He sent the famous "Ames Deçues."

Peladan's **Salon** is followed by an important document, the
Actae Rosae Crucis, which announces the formation of the **Rose+Croix**
du Temple directed by a **Rose+Croix Esthétique**, an act drawn up on
the Feast of the Ascension in "Roman Catholic Communion with Chris-
tian Rosenkreutz and Hugh of the Pagans." It is signed by Peladan,
Gary de Lacroze, Count Antoine de La Rochefoucauld and Léonce de
Larmandie, as well as three other secret persons, Sin, Adar and
Samas. These acts are composed of the **Instauration de la Rose-Croix**

[1] **Ibid.** [2] **Ibid.**, p. 41.

Esthétique, an address made by the Sâr to his peers whom he calls
"Ma nifiques," and "Les V Articles Publics [sic] de la règle des
Rose+Croix Esthétes." In his address Peladan explains the aims of
the new group.

> To insufflate theocratic essence into contemporary art, espe-
> cially esthetic culture, such is our new path.
> To ruin the notion attached to facile execution; to extin-
> guish methodological dilettantism, to subordinate the arts to
> Art, that is to say, to return to tradition which regards the
> ideal as the single aim of the architectonic, the pictorial or
> plastic effort.[1]

Peladan, in this address, proclaims the infallibility of the
Sâr. He calls upon Balzac, Wagner and Delacroix to intercede on his
behalf with God. The new "chevalerie" goes off to a new holy war,
Pour l'Idéal, under a new banner: Ad Rosam per crucem, ad crucem per
rosam, in ea, in eis gemmatus resurgam.[2]

Among the "V Articles Publics" one finds the following
points: In order to be admitted to the new confraternity an artist
must be vouchsafed for by two "god parents of talent." They in turn
may be driven from the circle if the artist whom they have presented
"forfeits honor" or "forfeits ideality." The Roman Catholic rite of
conversion, in which each new convert is supported by a witness, is
echoed in these first two articles. I know of no case in which an
artist ever joined the group in this way, unless one understands
simple recommendation or invitation in this hieratic light, nor of
any in which the "parrain" was hounded out of the group because of
his protégé's lack of ideality.

The third and fourth articles are also interesting. The

[1] Ibid., pp. 55-56. [2] Ibid., p. 58.

work which a member artist desires to exhibit must first be approved
in preparatory form by an "Esthetic-Consul." In case of a dispute,
the work will be brought before the Sâr who will arbitrate the ques-
tion, assisted by two peers. The artist, now referred to as "ar-
tiste R+C," echoing the "PRB" of an earlier brotherhood, is free to
show wherever and whenever he so desires, provided he annually exhib-
its a work especially created for the Salons de la Rose+Croix. This
is the first mention of an annual Salon de la Rose+Croix.

The fifth article reminds the associate artist that in any
conflict the authority of the Sâr is absolute.

The "V Articles Publics" concludes with the announcement that
all interested parties should contact the "Esthetic-Consul for 1891:
Gary de Lacroze."

A last step remained; to make public and legal the new schis-
matic rosicrucian group. Therefore, on August 23, 1891, Les Petites
Affiches carried under item 9256 the announcement that an Association
de l'Ordre du Temple de la Rose+Croix had been formed. Its stated
aim was "the organization of exhibitions of fine arts." The an-
nouncement was signed by Antoine de La Rochefoucauld who gave his
address in the rue d'Offémont as the headquarters of the society.
Unquestionably his was the basic capital behind the group. Five of
the Council of Six were also identified: Peladan, counts Antoine de
La Rochefoucauld and Léonce de Larmandie, Gary de Lacroze and Elémir
Bourges. The sixth member is unidentified.

Needless to say, the rosicrucian circle reacted strongly.
The August number of Initiation carried a sixteen-page supplement
covering the schism. Stanislas de Guaïta, Papus and Barlet felt

compelled to write "justice rendered to the novelist, the stylist,
the art critic; putting aside these very distinguished and precious
qualities that we will always be the first to applaud, what remains
of M. Peladan?--a good mystificator."[1] On August 31, 1891 Stanislas
de Guaïta wrote to Peladan: "I only reg et that the more or less in-
direct provocations of your R. C. C. oblige us to energetically pro-
test against it: it is important that occult students be made aware
that its doctrines are exactly opposite to all rosicrucian traditions
and that we have nothing to do with these acts of willful dementia--
let me get by with the word--that you have multiplied for a year now
under the label of Rose-Croix."[2]

The announcement of Les Petites Affiches aroused a storm of
interest, and, on September 2, 1891, Peladan published a lead arti-
cle in Le Figaro, explaining, in more popular terms, the aims of
this group. This article is called Le Manifeste de la Rose+Croix
(see Appendix I); the Manifesto will be republished on several occa-
sions: in the Règle et Monitoire of 1891 and as the supplement to
Le Panthée, the tenth novel of La Décadence Latine.

In the Manifesto, Peladan renders homage to his new col-
leagues, La Rochefoucauld, Larmandie, Bourges and Lactoze. He in-
vokes the benediction of Hugh of the Pagans and of Christian Rosen-
kreuze. He execrates the influence of the Realist and Naturalist
Movements, illustrating his apostrophe with a startling example, the
death words of Seurat, who on the edge of the grave (March 29, 1891)

[1] Vitoux, op. cit., p. 224.

[2] Lettres inédites, p. 138.

cried: "Huysmans led me astray!" If there is any truth in this recollection, then either Peladan or Seurat was in error, for at the time of Seurat's death Huysmans had begun to turn his back on Naturalism and was in the midst of a great spiritual crisis. In 1891 Boullan was denounced by the Rosicrucian circle, but e was also responsible for Huysmans' conversion, testified to in Là Bas, first published in serial form in 1891.

The Manifesto denounces the academy: "Whosoever is practitioner, whosoever is mystic, have nothing to hope for, neither from Carolus-Duran nor from Bouguereau. Officiall the Ideal is vanquished!" But, "The Salon de la Rose+Croix will be a temple dedicated to Art-God"; its opening date, March 10, 1892, is announced.

Then follows a most important passage: "Among the eighty artists already selected, practically all adherents at this hour, it suffices to name the following: the great Puvis de Chavannes, Dagnan-Bouveret, Merson, Henri Martin, Aman-Jean, Odilon Redon, Khnopff, Point, Séon, Filiger, de Egusquiza, Anquetin. The sculptors Dampt, Marquet de Vasselot, Pezieux, Astruc, the composer, Eric Satie.

"We will go to London to invite Burne-Jones, Watts and the five other Pre-Raphaelites; we will invite the Germans Lehnbart [sic] and Boeckling [sic]." By the latter two Peladan meant Lenbach and Boecklin. And for the other names, the typesetter, unduly harassed by the unfamiliar orthography and Peladan's spectacular handwriting, "Apian(Jean)," "Knopff,"--Peladan made this error constantly-- "Point-Séon," "Marquest de Vasselot." Eric Satie was called "Erick-Saties."

To these adherents--more or less, as we shall see in a mo-
ment--one must add the names that appear on the first manuscript
list of potential Rose+Croix exhibitors, dated August 1891, preserved
in the Fonds Peladan of the Bibliothèque de l'Arsenal:[1] William Lee,
Marcellin Desboutin, André Desboutin, Hodler, Osbert, Schwabe,
Fauché, Marcel Mangin, Monchablon, La Perche Boyer, Lapierre, La
Barre Duparc, Maurice Denis, Schuffenecker, Emile Bernard, Gary de
Lacroze and Antoine de La Rochefoucauld. Several of the artists are
of no consequence; some were recognized figures, others were of grow-
ing stature. Though these lists only mention a small portion of the
total number of exhibitors--according to my accounting 231 artists
over the 1892-1897 period--they cover the nucleus group either in
terms of collaboration or in terms of stylistic direction.

Peladan, however, was bragging. Many of the artists whose
names figure on the first lists never exhibited with the Rose+Croix.
the academicians Dagnan-Bouveret and Luc-Olivier Merson, who domi-
nated the market in academic religious art in the late nineteenth
century, never joined Peladan's group, doubtless because they felt
their positions would be jeopardized by an alignment with a flamboy-
ant critic who had for so long treated the Academy with contempt.
"But why address yourself to me," asked Dagnan-Bouveret on reading
in the rules that the Salon de la Rose+Croix excluded contemporary
subjects depicting workers and peasants, "I, who have practically
only painted contemporary themes. Logically I cannot, nor wish to,

[1]Reproduced Lethève, "Les Salons de la Rose+Croix," loc.
cit., pp. 363-374; p. 364.

follow you in this manifestation. I decline."[1] Nonetheless, the
Salons de la Rose+Croix are rife with the work of students and imi-
tators of both Dagnan-Bouveret and Luc-Olivier Merson. Certainly,
among the academicians, their religious painting greatly accords
with Rose+Croix precepts.

Puvis de Chavannes also declined the honor publicly. He
would not tolerate the use of his name as a means of enlisting
others. The evening issue of Le Figaro carried Puvis's rectifica-
tion: "I protest with all my strength against the mention that has
been made of me in this morning's article: Le Salon de la Rose+Croix.
I would be grateful if you would acknowledge my protest. . . ."[2]
But Puvis's influence remained strong in the Salons de la Rose+Croix,
particularly through the adherence of his pupils Alexandre Séon and
Alphonse Osbert.

The marked cooling of Peladan's criticism toward Puvis's
work in his subsequent writing can be traced to this date. In a
footnote to a later publication of the Manifesto, Peladan explained
that Puvis had to refuse his collaboration owing to his position as
President of the Salon du Champ de Mars.

Anquetin, the friend and associate of Gauguin, never exhib-
ited with the Rose+Croix[3] although he was a close friend of several

[1]La Défense, September 3, 1891.

[2]Le Figaro, September 2, 1891.

[3]Based on a review which appeared in Gil Blas, March 11,
1892, Gisèle Marie cites him as an exhibitor. Anquetin's name,
however, does not appear in any catalog listing. Gisèle Marie, Elé-
mir Bourges ou l'éloge de la grandeur, correspondance inédite avec
Armand Point (Paris: Mercure de France, 1962), p. 52.

artists who did, particularly Aman-Jean and Armand Point. Neither
did Maurice Denis send his work to the Rose+Croix despite his alli-
ance with the School of Pont-Aven, a group represented at the Rose+
Croix by Emile Bernard, Charles Filiger and, in several respects, by
the brothers Antoine and Hubert de La Rochefoucauld. "You will for-
give me," wrote Maurice Denis, ". . . while on one hand respecting
the religious convictions which exclusively attach me to the Roman
Church and on the other to esthetic theories which make it my duty
to repudiate all alliance between the allegory which is addressed to
the spirit by conventional signs and the symbol which suggests ideas
by beautiy alone . . ."[1] he declined an invitation to join an exhibi-
tion of idealist art that Antoine de La Rochefoucauld and Jules Bois
were planning for 1894.

Odilon Redon, too, kept his distance, although several con-
tribotors, such as George-Arthur Jacquemin, are obviously inspired
by his work.

André Desboutin contented himself with a frontispiece for
Peladan's novel, Le Gynandre, which represents a husky putto drag-
ging aside a curtain to reveal a landscape with Hecate's symbol in

[1] Maison Charavay. Bulletin d'Autographes, 112e année, No. 714
(March, 1964), Item 29646: Maurice Denis to Jules Bois and Antoine de
La Rochefoucauld. The letter is undated but it was written in 1894.
It expresses regret on Denis's part that he will abstain from collab-
orating in an idealist exhibition sponsored by Bois and Rochefoucauld:
"Monsieur de La Rochefoucauld cannot have forgotten that I made a
similar refusal two years ago for the Rose+Croix." This can only re-
fer to the first Salon de la Rose+Croix as Rochefoucauld broke with
Peladan during the first rosicrucian exhibition. Among the results
of this break was the foundation of the periodical Le Coeur, 1893,
backed by Rochefoucauld and edited by Bois.

the sky,[1] the negative pole of the Eternal Feminine, bats flying and a ghost-driven boat.

Schuffenecker, the great friend of Gauguin, never exhibited at the Salons de la Rose+Croix. Yet, of all the artists mentioned, Schuffenecker is perhaps the most suitable candidate. His career is deeply marked by occult leanings. He designed the cover of Mme Blavatsky's Le Lotus Bleu, which represents an oriental sage beneath a tree, evidently a recall of Chinese imagery. He also attempted to arrange an exhibition of esoteric art (Fig. 5). It is a variant of the catalog cover for the only exhibition of his work held during his life, in 1896 (Fig. 6). He later became a Theosophist, and among his manuscripts attesting to an extraordinary benevolence, there is a critique of one of Annie Besant's books which combines his solution of the world malaise--the abolition of inheritance-- with a profound respect for the work of Mme Blavatsky's successor.

Nor did the Germans or the Pre-Raphaelites ever show at the Rose+Croix Salons. Burne-Jones was content to send his canvases to the official Salons, beginning with the Exposition Universelle of 1889. However, several Rose+Croix artists were strongly influenced by his work, particularly the Danish artist Baron Arild Rosenkrantz.[2]

Surprisingly enough, neither Félicien Rops' nor Gustave Moreau's names appear in the first two lists.

[1] Lettres inédites, p. 166.

[2] Baron Rosenkrantz was, to my knowledge, the last surviving exhibitor of the Salons de la Rose+Croix. Born in 1870, he exhibited in the first Salon of 1892. He died in 1964. I had the great pleasure of visiting this artist who was still at work at the barony of Rosenholm, Denmark, in September, 1963.

The Manifesto was included in the <u>Salon de la Rose+Croix,</u> <u>Règle et Monitoire</u> which Dentu brought out in 1891 on the heels of Peladan's Salon review. Addressed "To all those of the Fine Arts" it was written "In the pure ether where beats no wing--beyond the nine choirs and the third heaven,--" that is, immediately following a performance of <u>Lohengrin</u> (doubtless in 1888). The address is followed by the <u>Rosae Crucis Templi, Sancta Ordinis, Charta Esthetica,</u> drawn up and signed the second Sunday after Pentecost, by Antoine de La Rochefoucauld and Peladan. They announced that "An annual exhibition of Fine Arts will take place in Paris commencing in 1892 under the title of Salon de la Rose+Croix." <u>The Règle du Salon de la Rose</u> <u>+Croix</u> then follows (see Appendix II).

The Rules are followed by an edited republication of the September Manifesto, the spelling errors more or less corrected. The last document of the <u>Règle et Monitoire</u> is the "Instauration de la Rose+Croix" which had already appeared in Peladan's May <u>Salon.</u>

Unquestionably, Peladan had a genius for organization and a great flair for publicity. The Manifesto, the Rules and the Inauguration echoed far. The supplement to the <u>Gazette des Beaux-Arts, La</u> <u>Chronique des arts et de la curiosite</u> of September 5, 1891, in a long column called "La Rose+Croix du Temple" "A. de L." (Antoine de Lostalot?) gave a more or less straightforward résumé of Peladan's theories.[1]

Moreover, this informed journal included a list of supposed exhibitors: Puvis de Chavannes, Charles Cazin, Odilon Redon, Desbou-

[1] Pp. 227-228.

tin, Blanche, Knopff (sic), Marquest de Vasselot, Constantin Meunier, Egusquiza, Osbert, Schuffenecker, Séon, Luc-Olivier Merson, Armand Point and Mme Antoinette de Guerre. Many of these names have been met on previous lists and the outcome of their so-called participation is already known. To set the record straight, however, Cazin, the respected Academician, famous for his religious work and stone-age reconstitutions, never exhibited with the Rose+Croix. Nor did Meunier, the great Belgian sculptor, whose stevedores are entirely too rugged and "unideal" for Peladan's manifestations. As for Mme Antoinette Guerre, we met her as an illustrator for the ornamental medallion that accompanied Peladan's memorial to Barbey d'Aurevilly. She, nonetheless, would have been refused in any case, since women were excluded from the Salons de la Rose+Croix.

Jacques-Emile Blanche is a reasonable and interesting error for the Gazette to make. At the turning of the last decade of the nineteenth century, Blanche succumbed to a transitory mystical yearning. He may have been invited to show with the Rose+Croix on the basis of his painting "l'Hôte," which caused a stir at the official Salon (Société Nationale, 1892) (Fig. 7). In his memoirs, La Pêche aux souvenirs, Blanche devotes a long passage to this work, now in the Rouen Museum. He calls it "the Pilgrims of Emmaus treated in a modern way . . . the setting is that which the group of the Revue Indépendante might have taken . . . Christ is Anquetin: draped in a robe of white linen with blue motifs--fishes . . . symbols of the name of Christ, and circles, symbols of Eternity. . . ."[1] Huysmans,

[1]Jacques-Emile Blanche, La Pêche aux souvenirs (Paris: Flammarion, 1949), pp. 192-193.

of recent a devout Catholic, referred to this painting when he complained, in the preface of Rémy de Gourmont's Le Latin Mystique, that ". . . the young literary set becomes mystical . . . a painter by the name of Blanche set the Redeemer up in a Japanese dressing-gown, in the midst of apostles in frock coats. Depicted after the apéritif, I believe, at dinner time, the Saviour regards the table-companions and breaks bread." Further along, Huysmans described certain kinds of painters such as "one will discover, at the exhibition of the Rose-Croix, who choose the religious article if it is in fashion, and who will draw worn characters encircled with iron wire after first having filled them with raw colors." Huysmans, of course, is jibing at the cloisonnisme of the Pont-Aven School, in which he recognized only "cold antics, false transfers from the Primitives. . . ."[1] Ironically, the cover of Le Latin Mystique bore a decoration by Filiger of the very kind that Huysmans described. Gourmont shared Filiger's ideal taste and Huysmans' preface was suppressed in subsequent editions.

The September issue of La Revue Indépendante carried an article highly praising Peladan's development of the Platonic theories expressed in the Symposium.[2] But in general the press was not so tolerant. On the front page of L'Evénement of November 2, 1891 the critic Gonzague-Privat ridiculed Peladan and his theories, describing

[1]J.-K. Huysmans, preface to Rémy de Gourmont, Le Latin Mystique, les poètes de l'antiphonaire et la symbolique au moyen-age (Paris: Mercure de France, 1892), pp. vii-xi.

[2]J. Aymé, "Tribune Libre, M. Joséphin Peladan, l'Amour platonicien en 1891," La Revue Indépendante, XXI (September, 1891), 311-344..

him as "the only Frenchman with the right of addressing the Ideal in
the familiar form. . . ." The November 15 issue of La Plume was
equally severe on the Sâr. In an article called "La Rose+Croix," E.
Museux expressed the sentiments of an outraged leftist:

> We equally mock the Thaumaturges as the Myths, the Myths as
> much as the Magi, the Magi as the Saints, the Saints as the
> Angels, the Angels as the elves, the elves as the sorcerers, the
> sorcerers as the alchemists, the alchemists as the occultists,
> the occultists as the Knights-Templar, the Knights-Templar as
> the Free-Masons, the Free-Masons as the illuminates, the illumi-
> nates as the convulsionaries, the convulsionaries as the Alexan-
> drians, the Alexandrians as the Orphists, and all the tricksters
> of all the centuries. . . . We have but one faith: The Revolu-
> tionary faith.

Yet it is evident that Peladan was responding to a deeply
rooted urge endemic in the period. Thus, in 1891 François Paulhan
published Le Nouveau mysticisme, a critical study that knew a consid-
erable vogue. He cited in literature Huysmans, Bourget and Peladan.
The latter two were especially linked by the critics of the period.

More strikingly, G. Albert-Aurier's brilliant assessment in
"Le Symbolisme en Peinture, Paul Gauguin" published in the Mercure
de France, a central document of the Symbolist Movement, lists five
qualifications for a Symbolist art, now the classical categories:

> 1) Ideological, because its sole ideal is the expression of
> the Idea;
> 2) Symbolistic, because it expresses this idea through forms;
> 3) Synthetic, because it presents these forms, these signs,
> in such a way that they can be generally understood;
> 4) Subjective, because the object presented is considered not
> merely an object, but as the sign of an idea suggested by the
> subject;
> 5) (And Therefore) decorative, since truly decorative paint-
> ing . . . is nothing but a manifestation of art which is at the
> same time subjective, synthetic, symbolistic, and ideological.[1]

[1]This translation appears in Rewald, op. cit., p. 482.

In examining this famous passage we recognize how much it corresponds with Peladan's art theories, though hardly with all of it. Therefore, Peladan's attitudes and actions demand reappraisal because, in theory, they relate to aspects of that which is most modern in their period. The crucial difference between Aurier and Peladan is that Aurier had the genius to recognize these principles in the art of Paul Gauguin whereas Peladan's were applied a priori to a host of less illustrious and, in many cases, inept artists.

With this lengthy examination of the antecedent documents of the Salons de la Rose+Croix, we are better equipped to appreciate the fascination they held for the artists and public of their period. Having extricated the supposed exhibitors from the list of artists who really did collaborate with the Salons de la Rose+Croix, we are at last able to examine the Salons themselves.

CHAPTER IV

MONT SALVAT

The Poster for the First Salon de la Rose+Croix of 1892: Carlos Schwabe (1866-1926)

Early in 1892 a haunting poster appeared in the streets of Paris. It depicted three female figures, one of them nude and sunk into the mire of daily life, slime dripping from her finger tips. The remaining two ascend a celestial staircase. Of these, one is darkly dressed and occupies the middle ground. She offers a lily to a near-transparent figure higher on the stairs who has left life's pollution far behind. This latter figure represents pure Idealism. In her hand she holds a smoldering heart. The steps are strewn with the flowers of Mary, roses and lillies. Masses of clouds and stars swarm about the mountain peaks at the top of the stairs. The picture is framed by a pattern of crucefied roses set on altars. Boxed in, at the lower left, necessary information is given—dates, place, price of admission—(Fig. 8)[1] concerning the first Salon de la Rose-Croix.

[1] Often reproduced, this poster is one of the best-known works associated with the Salons de la Rose+Croix. See Roger Marx, Les Maîtres de l'affiche, Vol. II, pl. 74; Vittorio Pica, Attraverso gli albi e le cartelle, I (Bergamo, 1902), 268; Ernest Maindron, Les Affiches Ilustées (1886-1895) (Paris, 1896), p. 154; Lethève, "Les Salons de la Rose+Croix," loc. cit. Recently Brian Reade identified this poster as an influence on the formation of the style of Alphonse Mucha. See Brian Reade, Art Nouveau and Alphonse Mucha (London: Victoria and Albert Museum, 1963), pp. 13-14.

Perhaps the most famous work associated with these <u>Salons</u>, the poster was executed by a young Swiss artist, Carlos Schwabe, whose willowy, ethereal females were characteristic of the Idealist revival. In January, 1892 Octave Uzanne began to publish a revue, <u>L'Art et L'Idée</u>, which in many respects expressed tendencies similar to those of the <u>Salons de la Rose+Croix</u>. Schwabe's frontispiece for the revue, an allegory of Art and Idea, was included among his entries in the first rosicrucian <u>Salon</u>. It represents two gothic women; one, enclosed in an almond-shaped mandorla, touches the forehead of the other, earthbound, creature. In effect the them of the poster and the frontispiece is the same: Initiation.

Among Schwabe's earlier work was a set of illustrations for <u>L'Evangile de l'enfance</u>, published by the <u>Revue Illustrée</u> in 1891.[1] Ten of the Botticellian illustrations were reproduced in the first <u>Rose+Croix</u> catalog. Schwabe employed the same manner for his illustrations of Zola's sentimental novel, <u>Le Rêve</u>, from the Rougon-Maquart series at the end of 1891 and 1892 (Fig. 9).

Although Schwabe was represented at the first <u>Salon</u> with sixteen works, most of them religious in nature, this was to be his only appearance. By the middle of the nineties his style had changed; still linear, it had grown more angular, and while remaining expressive, it no longer was English and ethereal but somewhat German and agonized (Fig. 10).

[1]Later published separately as <u>L'Evangile de l'enfance de N. S. Jésus-Christ selon Saint Pierre, mis en français par Catulle Mendès</u> (Paris: Colin, 1894).

The Opening of the First Salon de la Rose+Croix

On the heels of financial reverses,[1] Durand-Ruel consented to allow Peladan's group to exhibit in his gallery. While opposed to the general trends of his gallery, the exhibition nevertheless enjoyed a prodigiously successful opening. Two thousand press invitations were sent out as well as special invitations to private individuals (Fig. 11). The exhibition took three days and nights to hang. One ate as one could. "The real, the only food," Léonce de Larmandie recorded, "was an immense enthusiasm, an unshakeable faith in the certitude of an apotheosis, the deep-rooted belief that a new life opened for art and that we were the predestined workers of a regeneration without precedent."[2]

An enormous and curious crowd came. More than 22,600 visiting cards were left.[3] The afflux was so great--Larmandie counted 274 carriages--that the police were forced to stop traffic between the Opéra and the rue Montmartre until past five in the afternoon. The sardonic Jules Christophe, writing for Zo d'Axa's anarchic little review l'Endehors, could not resist punning on the number of "chars" and "Sârs" that slowed down the bus from Odéon to Clichy.[5]

Larmandie took especial pride in naming the tout-Paris who came: ". . . three La Rochefoucauld, two Gramont, two Mortmart, I

[1] Rewald, op. cit., p. 514.

[2] Larmandie, L'Entr'acte idéal, p. 18.

[3] Ibid. [4] Ibid., p. 19.

[5] Jules Christophe, "Le Salon de la Rose+Croix," L'Endehors, March 20, 1892, non-paginated.

select at random from the pile of noble visiting cards . . . the best two hundred names, the first of the French Armorial."[1] Larmandie also dwelt on the "signal honor" accorded Rose+Croix by the visits of Puvis de Chavannes, Gustave Moreau and, oddly enough, Emile Zola, who stayed an hour. Verlaine, too, came and made the sybelline observation, "Yes, yes, agreed, we are Catholics . . . but sinners."[2]

The visitors entered the gallery through a corridor in which was hanging a large Manet. "I leave it up to the reader," Larmandie wrote, "to guess with what jeers, what epigrams, this unfortunate canvas was riddled by the invasion of idealists, to such a point that one began to doubt the ambitious motto adopted by the famous painter: Manet et Manebit."[3]

The exhibition rooms were filled with flowers and a brass choir played the prelude to Parsifal. On opening day it cost twenty francs to see the exhibition and thirty people paid the exorbitant price of a gold Louis for the privilege of viewing it during the first two hours.

Two catalogs were published, one a simple list, the other an illustrated booklet. They were prefaced with Peladan's peroration: "Artist, you are priest . . . Artist, you are king . . . Artist, you are magus. . . ."[4]

[1] Larmandie, L'Entr'acte idéal, p. 24.

[2] Ibid., p. 25. [3] Ibid., p. 16.

[4] Catalogue du Salon de la Rose+Croix (lo mars au lo avril) à Paris. Galerie Durand-Ruel. 11 rue Le Peletier, 1892, pp. 7-11.

The diversity of the first <u>Salon de la Rose+Croix</u>--there were sixty-three exhibitors--makes it difficult to clarify certain homogeneous aspects. Yet several distinct and opposing factions were present. One was related to the italianate tradition fostered within official precincts, the other to tendencies nurtured by Impressionism. The linear, italianate group further subdivided into a branch derived from Puvis de Chavannes (Séon, Osbert, Point) and a branch related to Gustave Moreau (Khnopff, Rosenkrantz, Schwabe and Delville). Post-Impressionist trends were represented by Emile Bernard, Charles Filiger and Antoine de la Rochefoucauld among others. A body of uncommitted work, taking from both camps but exclusively adhering to neither (Aman-Jean, Henri Martin, the young Bourdelle) further complicates these distinctions.

Three artists particularly came to represent the hard-core Rosicrucian style, so to speak. They were Alexandre Séon, Alphonse Osbert and Armand Point. Present from the beginning, their work, for better or for worse, eventually was looked upon as the most characteristically <u>Rose+Croix</u>.

<u>Alexandre Séon (1855-1917)</u>

Of the nineteen works exhibited by Séon, largely frontispieces for Peladan's novels, the most important was a portrait of Joséphin Peladan now in the Musée de Lyon (Fig. 12). A drawing after this work appeared as the first illustration of the 1892 illustrated catalog.[1] The dedication of Peladan's <u>Le Panthée</u> (published

[1] Reproduced in Rewald, <u>op. cit.</u>, p. 516.

1892 but finished in August, 1891) honors the "monumental painter
Alexandre Séon." It mentions Séon's early adherence to the Salons
and compares his portrait with Marcellin Desboutin's earlier work.
"Desboutin realized the patrician in me. You have painted the Sâr,
not merely through your understanding of my Kaldean features, but
you have painted the soul of the Sâr!"[1]

A more typical work by Séon deserves comment. In "La Rivi-
ère" (Fig. 13) the Lyon-born Séon amply makes clear his debt to
Puvis de Chavannes with whom he briefly studied in 1880, prior to
entering Léon Lehmann's studio.[2] It is composed in mural-like flat
areas. Space is planar. The female figures are two dimensional.
The work is simplified and coordinated through firm rhythmic contours.

Among the committed partisans of this style was the critic
Alphonse Germain. In an illustrated article on Séon published in La
Plume (August 1, 1893) Germain distinguished between painting "which
is only addressed to the senses" and drawing which, being "always ab-
stract, seeks intellectual sensations." He then went on to describe
Séon's drawing. "His crayon, subservient instrument, in turn caresses,
accuses or evokes; here serpentine, almost affected, there fat and
firm, engraved; in other places vaporous, fluid, dying in a light
smudge; in many ways elegant, always pure."[3]

[1] Joséphin Peladan, Le Panthée. La Décadence latine X (Paris:
Dentu, 1892), p. xiv.

[2] Ex. Cat. Puvis de Chavannes et la peinture lyonnaise au
XIXe siècle. Musée de Lyon, 1937, p. 122.

[3] Alphonse Germain, "Le Salon de 'La Plume,' Les mal connus,
Alexandre Séon," La Plume, August, 1893, pp. 336-340. Germain had

Shortly before, Germain had contributed a note on Séon to a special issue of La Plume on "Peintres Novateurs (Chromo-luminaristes, néo-traditionnistes, indépendants)" (September 1, 1891) in which the painter had been described as an "enthusiastic disciple of Puvis de Chavannes," a "Rose-Croix artist . . . [who] lives like a hermit and [who] works like a Benedictine monk." Séon's chiromantical and astrological merits were also cited.[1]

At the time of the first Rose+Croix exhibition, Germain contributed a review for L'Art et L'Idée in which Séon, Khnopff and Schwabe were called "Idealists."

> To idealise esthetically translates as seeing with the eyes of the spirit and in painterly terms: to work toward synthesis while seeking unity: to annihilate all anatomical detail harmful to the ensemble and useless to the movement of a figure: to correct all ugliness, suppress all triviality, all vulgarity: above all else to choose beautiful lines and beautiful forms according to the laws of nature (the empty balanced by the filled), and never to copy, always to interpret.[2]

The most important study on Séon is Peladan's "Les Grands Méconnus: Séon." It appeared in 1902, after the demise of the Salons de la Rose+Croix, as a tribute to Séon's unflagging support. Like Germain, Peladan also spoke of the strong dosage of Puvis in Séon's work, but whereas Puvis had Amiens, Poitiers, "le Bois Sacré" and the Sorbonne, Peladan regretted that "the student could never give proof of his measure"[3] other than in a decoration for the

written earlier of Séon in "Un peintre-idéiste, Alexandre Séon," L'Art et l'idée, I (January-June, 1892), 107-112.

[1] Alphonse Germain, La Plume, September 1, 1891, p. 303.

[2] Alphonse Germain, "L'Idéal et l'idéalisme, Salon de la Rose+Croix," L'Art et l'idée, I (January-June, 1892), 176-180; 177.

[3] Joséphin Peladan, "Les Grands méconnus: Séon," La Revue Forézienne illustrée, No. 49 (January, 1902), pp. 7-20.

Mairie de Courbevoie (1884?) or as an assistant to Puvis during the execution of the Panthéon murals in Paris.

Peladan remembered a work called "Douleur," shown at the first Rosicrucian exhibition, which represented a female nude weeping against a tree. While the virgins of Burne-Jones appear to have been raped in their sleep, Peladan continues, and those of Greuze ready to swoon, "those of Séon carry their pitchers intact. They are all sisters and all twins; their difference is in the rhythm of their movements. . . .[1]

Peladan recalled that Séon was present at all the Rose-Croix exhibitions--in fact, he did not exhibit with the group in 1894-- showing a body of work that "realized Rose+Croix doctrine in the highest degree in terms of respect for tradition and probity of drawing."[2] Moreover, Peladan went on, "owing to his idealism, Alexandre Séon belongs to the School of Lyon," linking his name with those of Chenavard, Janmot and Puvis de Chavannes. "He belongs to the mysticism of art by a truly touching cult of the human form that he interprets scrupulously and with unction."[3] Peladan concluded his remarks on Séon with the conceit that he dared predict nothing for "the mystic and chaste painter except immortality."[4]

Alphonse Osbert (1857-1939)

Alphonse Osbert's debt to Puvis de Chavannes--incidentally the artist's best man at Osbert's marriage in 1894--is evident from

[1] Ibid., p. 13

[2] Ibid., p. 16.

[3] Ibid., pp. 16-17.

[4] Ibid., p. 20.

his entry in the first Rose+Croix Salon, "Hymne à la Mer." Osbert's relations with the Indépendants was close as he began to exhibit with them in 1889. In 1893 the "Hymne à la Mer" was shown at the Salon des Indépendants. In fact many artists associated with the Rose+Croix are also to be found among the Indépendants, notably Bernard, Filiger and Séon. Gustave Coquiot, in his history of the Indépendant exhibitions, devotes a long passage to Osbert, whose work he rightly esteems more highly than that of Séon, placing this "painter of evenings" in a group he called the Nostalgiques which also included Séon, Roussel and Trachsel.[1]

Osbert sensitively combined the bucolically desolate arrangements of Puvis with the refined color adapted from the palette of his friend Seurat with whom he had been associated since student days in Lehmann's studio, a circle that also included Séon and Aman-Jean.

In April, 1899, Félicien Fagus, in an article in La Revue Blanche, compared Osbert to Puvis de Chavannes and took Osbert to account for his supposedly literary painting. Osbert was hurt by this criticism; a first draft of his reply to Fagus is preserved among Osbert's papers. This letter contains many clues to the kind of art aimed at by the idealists, art as a cult of evocative natural beauty. Its similarity to the critical values of Peladan and Germain is self-evident.

> I regard art as a religion of beauty and the evocator of the high and serene thoughts open to mankind's intelligence faced with the splendors of nature, the mystery of the woods, waters, heavens.

[1] Gustave Coquiot, Les Indépendants, 1884-1920 (Paris: Ollendorff, n.d.), p. 125.

From this principle the painter must, in order to achieve
the heights of Evocation, and not merely give a servile transla-
tion of nature (as in a study which is only a document), free
his work of everything which is useless and which therefore di-
minishes the initially experienced emotion. From this it fol-
lows then that the artist requires a grandeur of lines and a
harmony based on the dominant color of the hour--a work thus
conceived with elements of nature will have a more exact resem-
blance to nature as it will make nature's own great impression.
The naturalist school which hopes to find truth in a so-called
exactitude always only gives the notation of a document. Corot
is not the exact verity of a morning, but an emotion of marvel-
ous resemblance.

Art only lives by harmonies. . . . It must be the evocator
of the mystery, a solitary repose in life, like prayer . . . in
silence. The silence which contains all harmonies. . . . Art
is therefore necessarily literary, according to the nature of
the emotions experienced.[1]

Armand Point (1861-1932)

Owing largely to a correspondence with Elémir Bourges, the
French novelist, Armand Point's career is possibly better known than
that of most artists connected with the Rose+Croix. The correspond-
ence, spanning 1890 to 1920, forms the basis for Gisèle Marie's
study of Elémir Bourges and recounts the gestation of his novel,
La Nef.[2]

Point's painting and handicrafts, in the wake of the Pre-
Raphaelites and Ruskin's writing, often displays a tightness and

[1] With the kind consent of Mlle Yolande Osbert, daughter of
Alphonse Osbert, who permitted me to study his private papers at
length.

[2] While Bourges's letters were preserved by Point, passing
into the hands of Aristide Marie, Symbolist historian (La Forêt sym-
boliste) and father of Gisèle Marie, Bourges's biographer, Point's
share of the letters appears to have been lost. Mlle Gisèle Marie
expressed the opinion to me that they may have been burned by Mme
Bourges possibly owing to certain slighting remarks about her which
may have appeared in the correspondence. Mlle Marie's study takes
great pains to clarify the milieu of the Idealists both in Paris
and at their summer retreat, the artists' colony of Samois near
Marlotte.

over-elaboration, particularly in his furniture and Victorian Gothic
frames (Fig. 14). This tendency is counterbalanced by a suave feminin-
ity, close in spirit to the work of Khnopff and Schwabe, but which,
more than any other, approximates Peladan's Leonardesque, androgynous
ideal. Work of this sphinxic nature were a particular feature of his
contribution to the second Salon de la Rose+Croix.

Like many artists of his generation, Point believed that he
was assuming a progressive position by renouncing contemporary life
and adopting the ornamental appearance of late medieval painting
(using formulae based on medieval working recipes). In 1896 he
founded Hauteclaire, an artist-worker community at Marlotte, where,
under his supervision and after his designs, a large body of enamels,
bronzes and works of applied design were executed.

An erstwhile author, Point's contributions to L'Ermitage and
the Mercure de France throughout the 1890's reveal a petty envy of
Impressionism and a sentimentalized picture of quattrocento Florence.
In his revivalism, Point reminds one of his contemporary Emile Ber-
nard who had turned his back on Pont-Aven in favor of Baroque Venice,
or even of Filiger whose sensitive religious yearning continued to
manifest itself in his work in the form of mystic Byzantine patterns
long after he had renounced his cloisonnist manner of painting devel-
oped alongside Gauguin at Pont-Aven.

Point contributed five works to the first Salon de la Rose+
Croix, among them a "Perversity," a "Pubery" and the frontispiece
for Peladan's novel L'Androgyne.

Fernand Khnopff (1858-1921)

Fernand Khnopff is perhaps the most original artist to have exhibited with the Rose+Croix. Khnopff's apologists dwell on his marked anglophilia (doubtless intensified by his English parentage) and his fixation with his sister's beauty,[1] which in his work is translated into a kind of sexless angelicism. Dumont-Wilden, Khnopff's biographer, when writing of the artist's "Englishness," focused on Khnopff's Des Esseintes-like withdrawal from the world in the house he had constructed in Brussels. Among its features was an altar dedicated to Hypnos decorated with Tiffany glass plaques. The exquisite introversion of this altar surmounted by a winged head--a personification of Athena which occurs throughout Khnopff's work as it does, incidentally, throughout Mallarme's poetry--is re-enforced by the inscription "On Ne A Que Soi [sic]," Khnopff's motto, to be found equally on his bookplates.[2]

Nestor Eemans rightly stressed Khnopff's debt to Gustave Moreau to whom Khnopff's poem Jason et Médée was dedicated.[3] Like Moreau, Khnopff's preferred themes included sexless women, svelte animals and jewelled over-adornment. These other-worldly compositions are generally understood to signify a spiritual exhaustion. Actually, it was

[1] Nestor Eemans, Fernand Khnopff (Anvers: de Sikkel, 1950), p. 8.

[2] The altar is described by Louis Dumont-Wilden, Fernand Khnopff (Bruxelles: Van Oest, 1907), p. 26. It is reproduced in part in Francine-Claire Legrand, "Fernand Khnopff--Perfect Symbolist," Apollo, April, 1967, pp. 278-287; p. 282. The bookplate is reproduced in Robert Schmutzler, Art Nouveau (New York: Abrams, 1962), p. 14.

[3] Eemans, op. cit., p. 9.

probably an attempt to describe a curious emotion peculiar to the late nineteenth century and to Rosicrucian art. In this admittedly generous light, the meticulous jewel-like work of this period may be seen as a kind of new form, possibly an adjunct of poetry, and not exclusively the residue of a reheated Pre-Raphaelism.

Among Fernand Khnopff's three catalog entries for 1892 are the three frontispieces for Peladan's novels from the Ethopée, as well as "Sphinx." This might have been the work now in the Brussels Cabinet des Estampes which represents a Knight and Sphinx with the features of Khnopff's sister (Fig. 15). Remy de Gourmont was particularly struck by the sexual connotation of this painting[1] but Felix Fénéon wrote:

> One will never make Mr. FERNAND KHNOPFF understand, nor a number of his co-exhibitors, that a picture must first seduce by its rhythms, and that a painter gives proof of an excessive modesty in choosing a subject already rich in literary significations, that three pears on a table cloth by Paul Cézanne are moving and at times mystical, and that all the Wagnerian Valhalla is as uninteresting as the Chambre des Députés when they paint it.[2]

Without impugning Fénéon's excellence as a critic, it may be worth noting that Fénéon, a crucial defender of the Divisionists, in this brilliant dismissal, was writing for Rodolphe Salis's periodical, Le Chat Noir, one of the quarters most antagonistic to Peladan.

Jean Delville (1867-1953)

Khnopff's smoldering eroticism was exploited in a more aca-

[1] Remy de Gourmont, "Les Premiers salons," Mercure de France, May, 1892, p. 63.

[2] Felix Fénéon, "Pont-Neuf, Vêtements sur mesure, R+C (Galeries Durand-Ruel, mars-avril)," Le Chat Noir, March 19, 1892, pp. 1924-26; p. 1926.

demic way by Jean Delville. A much respected teacher and recipient
of numerous public commissions in Belgium, Delville popularized Pela-
dan's cause in Brussels and well-nigh asphyxiated it at the same
stroke. In 1892 a schism developed within Les XX which led to the
formation of a group called Pour l'Art, headed by Delville and joined
by Fabry and Ottevaere, all of whom sent work to the Salons de la
Rose+Croix in Paris. Pour l'Art, like the Rose+Croix, owing to its
taste for escapist symbolism, felt itself to be at variance with the
fundamentally Naturalistic and Impressionistic tendencies of the
"Vingtistes," who, despite their basic preference, had nevertheless
invited Peladan to lecture in 1889.[1] Delville ultimately became the
spokesman and theorist of the new Belgian idealist group.

In La Mission de l'art: Etude d'esthétique idéaliste, Del-
ville, without identifying Peladan, reasserted the latter's predilec-
tions for the PRB, Wagner, the occultist circle, Leonardo. The
book drowns in high-minded generalities, endless lists of culture
heroes and swollen sentences hollow for all their flourish of names.[2]

Of the three works Delville sent to the 1892 exhibition, one
was reproduced as a drawing which reappears as well in the catalog
for the following year. The ymbolisation de la chair et de l'es-
prit" (Fig. 16), represents a male figure--Spirit--fleeing the embrace
of a serpent-tailed female--the Flesh. The scene is enacted under

[1]Peladan was planning to lecture on Istar, ou la victoire du
mari, a novel from the Ethopée. He stipulated that the audience was
to be entirely female. The proposed lecture never took place. Maus,
op. cit., p. 88.

[2]Jean Delville, La Mission de l'art. Etude d'esthétique
idéaliste (Bruxelles: Balat, 1900).

water and Spirit, as he attempts to rise to the light is caught up in a tangle of weeds and sea plants. One imagines the work to be colored in the swampy sea-green cherished by the Symbolist poets.

Arild Rosenkrantz (1870-1964)

Like Fernand Khnopff, the Danish Baron Arild Rosenkrantz attempted to infuse his early work, painted in a pre-Raphaelite manner, with a nervous and neurotic flavor. Like Khnopff, too, he was strongly attached to England, marrying an English cousin and eventually settling in London.

Heir to one of Denmark's most ancient baronial houses, Arild's participation in the first three <u>Salons de la Rose+Croix</u> was largely the result of his mother's intervention, the latter being a Swedish aristocrat and occultist. Through her energies Arild was accepted. A small scrapbook of Arild's Rosicrucian episode[1] dates from the first years of the <u>Salons de la Rose+Croix</u>. Antoine de La Rochefoucauld's letters to Arild's mother are preserved in this scrapbook. Decorous missives, they rephrase Peladan's familiar injunctions: "Above all else we favor the Traditional-Ideal. . . . We are attempting to rally all artists who are partisans of noble and aristocratic art, great art in a word, artists who are enemies of

[1]This scrapbook is preserved among Arild's effects at Rosenholm, the family seat, a castle in the Danish Renaissance style, now a museum. A section of the castle is given over to a permanent installation of Arild's painting. Arild's Rosicrucian style was superceded in 1912 by a "modern" imagery colored according to prismatic-like sequences. The change was made on the advice of Rudolph Steiner under whose influence Arild fell at this moment.

hard-core Realism, Realism without past, without tradition and without future. . . ."[1]

Moved by La Rochefoucauld's appeals, the Baroness reciprocated by first sending a silver rose and then an original musical composition. While thanking her for "the sequence of divinely symphonic chords imagined by angels and seraphs" La Rochefoucauld informed the Baroness that Arild's pastel, "La Sainte Vierge enfant," would be accepted by the Rose+Croix because of its "exquisite delicacy and pure profile."[2]

Arild was less moved by the Count's Rosicrucian appeals. Beside the line drawing of Séon's portrait of Peladan in the first catalog, Arild struck out the title "Sâr" replacing the word with "sale"--filthy or miserable--and esteemed the portrait "daarlig," that is, dreadful in Danish.

Rogelio de Egusquiza (1845-1914)

Rogelio de Egusquiza was a Spanish aristocrat who worked in Paris, of whom Peladan had already written well in his reviews of the official Salons of 1890 and 1891 and whose name appears among the first adherents in the Figaro Manifesto. Egusquiza's work concentrates heavily on Wagnerian themes, recalling in this respect Fantin-Latour, but without the latter's redeeming lightness or inventiveness.

In all likelihood, Peladan had met Egusquiza in Bayreuth in

[1] Arild's Rose+Croix scrapbook, letter dated December 6, 1891.

[2] Ibid., undated letter.

1888. Both had been driven there by their consuming passion for the master's music. Wagner had died in 1883 but his widow, Cosima, lived in retreat at the great musical shrine sponsored by "Mad" King Ludwig the Second of Bavaria whose portrait figures among Egusquiza's plates and was shown at the last Salon de la Rose+Croix in 1897. The young Spaniard had made repeated attempts to come into contact with Cosima, but they proved to no avail, Peladan laments in the Théâtre Complet.[1]

Wagnerian portraits (Figs. 17, 18) by Egusquiza were included in the 1892 and 1893 Salons. "Amfortas," the priest of the Holy Grail in Wagner's Parsifal (Fig. 19) had been published earlier in the Bayreuther Festblätter of 1884 and was shown again with the Rose+ Croix in 1892 and 1897. Other listings for 1892 include a "Sigmund and Sieglinde," and a "Floramine" (Fig. 20), for which a drawing appears in the catalog.

Italianate into English: The Rose+Croix and the PRB

The artists we have been discussing are related in varying degress to two streams of italianate taste: Séon, Osbert and Point deriving from Puvis de Chavannes, and Schwabe, Khnopff, Rosenkrantz, Egusquiza and Delville related to Gustave Moreau. In France during the 1890's these currents are united a taste which may be called English, a taste which, at its core, is a popularization of Pre-Raphaelite values.

[1]Thieme-Becker reports to the contrary: that Rogelic de Egusquiza began visiting Bayreuth in 1877 and that he was in fact a friend of Wagner. Perhaps this is correct as a large body of Egusquiza's work is developed to Wagnerian portraiture, both etched and sculptured.

This English character, vaunted in Peladan's writing, was
the central issue of an important review of the first Salon de la
Rose+Croix written by Robert de la Sizeranne called "Rose+Croix, Pré-
Raphaélites et esthètes, la renaissance esthétique des deux côtés de
la Manche."[1] Despite Sizeranne's special pleading in favor of the
Pre-Raphaelites whose history he made accessible to Frenchmen of his
generation,[2] he nonetheless seized on many similarities and discrep-
ancies between the PRB and the Rose+Croix. The very letters "R+C"
following the names of certain artists appeared to him to be a re-
minder of the once cryptic "PRB," Pre-Raphaelite Brotherhood, of mid-
century. The intense observation in the flowers, those for example,
of Schwabe and Séon, seemed to him a reflection of Ruskin's love of
verisimilitude. Both groups, he held, virtually banished anecdotal
genre, at least in principle, and they both believed that they sought
"the soul of the least animated things, the symbol behind the appear-
ance, the eternal idea beneath the form--even those complicated, or
mannered, fleeting or ungraspable."[3] He observed that Puvis de Cha-
vannes, the Rosicrucian hero, was often referred to as "the French
Burne-Jones."

Sizeranne admitted that the Rose+Croix acknowledged their
debt to the Pre-Raphaelites, but he seriously questioned whether the
occult group would ever play as decisive a role in French art as it

[1] In Le Correspondant, March 25, 1892, pp. 1127-1140.

[2] Robert de la Sizeranne, La Peinture anglaise (Paris:
Hachette, 1895).

[3] As in note 1, above, p. 1133.

was the lot of the PRB to play in English. He gave as his reason the observation that the program of the PRB represented an esthetic and technical innovation while the Rose+Croix had not the slightest interest in revealing a new method. Moreover, Sizeranne observed that "the poetry of Rossetti and Swinburne . . . the Decadents and the Symbolists preceded that of the Rose+Croix by a long while. The esthetic attempt in this case is merely the tail end of a whole literary movement. It corresponds to no painter's need but meets only the wishes of men of letters."[1] The PRB, Sizeranne went on, was also sustained by its fervor whereas "our era hardly lends itself, outside the religious domain, to voluntary immolations for an idea."[2] Sizeranne's sharp critique concluded with a parable concerning Oscar Wilde and the Esthetic Movement in England. In the end the fashion passed, but "our Rose+Croix want to be Pre-Raphaelites; they will only be Esthetes."[3]

Pont-Aven in Anglo-Italy

The Italianate-cum-English tendency of the first Salon de la Rose-Croix, although representative of Peladan's aims, is superceded in importance by another group gravitating around Paul Gauguin and the School of Pont-Aven, as his circle of Brittany followers had come to be called. This group included Emile Bernard, Filiger and related figures such as Antoine and Hubert de la Rochefoucauld and Félix Vallotton. Despite the fact that the work of these artists would be considered subversive by Rosicrucian standards--for a lack of itali-

[1] Ibid., p. 1138. [2] Ibid., p. 1139. [3] Ibid., p. 1140.

anate values, for a formal rather than literary emphasis, for an open
descendance from Impressionism--these artists, too, yielding to
Antoine de La Rochefoucauld's presence in Peladan's circle--responded
to the Sâr's call, or at least that portion of it that preached a
kind of primitive Christianity and a rejection of official middle-
class art. They joined Peladan as Christians and intellectuals and
their transient allignment, for by the following year they had been
expunged, if nothing else makes the <u>Salons de la Rose+Croix</u> events of
cardinal importance in the history of Symbolism. Had Peladan not
been blindly bound to this theoretical superstructure, had he been
capable of valuing experience as highly as he valued polemics, he
would have recognized immediately that the artists he rejected were
precisely those who would bring the greatest posthumous honor to his
"gestes idéals" and who, in certain measure, would become the finest
representatives--e.g., Filiger and Bernard--of his occult theory.
It took the first <u>Salon de la Rose+Croix</u> for Peladan to realize
exactly what the proper Rosicrucian "look" was, after which he was
honor bound to choose the second rate in favor of the first.

Emile Bernard (1868-1941)

Of all the artists shown at the <u>Salons de la Rose+Croix</u>,
Emile Bernard is the best known. In addition to a respectable body
of painting and an early compassionate appraisal of the then un-
known Van Gogh, a fair amount of writing is attached to his name,
not a little of it feeding the academic argument over whether he or
Gauguin invented Cloisonnism. On one hand, deeply embittered by the
increasing fame, importance and popularity of Gauguin, and on the

other, frustrated by his own vitiating idealism which carried him to
his later Venetian manner, Bernard's moral pessimism and religiosity
were in many respects close to Peladan. It is certainly revealing
that at the beginning of the twentieth century Bernard still clung
to the notion of revitalizing art--giving it the religious and ideal-
istic content he, like Peladan, felt it so manifestly lacked--that he
turned to the equally undaunted Elémir Bourges and Armand Point for
support and with them founded La Rénovation Esthétique whose very name
conjures up Peladan.

At the time of the first Salon de la Rose+Croix, Bernard was
an occasional contributor to the then newly organized Symbolist or-
gan, Le Mercure de France. In 1893 he withdrew to Cairo, not return-
ing to Paris until 1901. Excepting his early sympathy for Van Gogh,
Bernard's articles throughout the nineties betray, like those of
Armand Point, a flat mystical preciosity bordering on the insipid
and an excess of synthesising formulae. "Notes à propos de Flan-
drin" (November, 1894), "Ce que c'est l'art mystique" (January,
1895), and the books Reflexions d'un témoin de la décadence du beau
(1902), and Les Cendres de la gloire et le sable du temps (1906) all
recount a spiritual yearning and a decorous mysticism of a kind that
Peladan more fantastically and robustly expressed.

Bernard sent to the 1892 exhibition a "Christ portant sa
croix," an "Annonciation,"[1] and a "Christ au jardin des oliviers."
The "Annonciation" (Fig. 21), reproduced in the illustrated catalog,

[1]Dated 1888. See also, Ex. Cat., Cinquantenaire du Symbol-
isme, entry 1096.

is drawn in lyrically curved lines. Gabriel and Mary are set on a
flat heraldic ground. Perceptual space is given up in favor of dec-
orative space-fillers--garlands, scrolls, fluttering drapery and con-
ventionalized flowers, grass and trees. Like Gauguin, Filiger and
Sérusier, Bernard believed that this "naïve" pattern-like organiza-
tion was a direct transcription of the spiritual values inherent in
nature, a "cri de l'âme sans type,"[1] akin to those expressed in the
folk arts of Brittany where this group had been repairing since 1888.
In so far as the "archaic" appearance became associated with a body
of late nineteenth-century religious art, Bernard and the others were
correct in this intuition.

In an article by Francis Jourdain, "Notes on the Painter
Emile Bernard,"[2] a trace of the remaining works sent by Bernard to
the first Salon is recorded. A drawing, "Christ," is reproduced in
the article. It depicts a figure supporting a huge cross. This can
only be the conjectural Rose+Croix "Christ" as Jourdain notes that
Bernard had already painted "several curious Christs." Indeed, from
earliest school days, Jourdain recalls, Bernard's notebooks were
"scratched over with Calvaries, with Christs nailed to the Cross,
with Virgins and saints in the middle of caricatures and character
sketches." Jourdain took these to be an early manifestation of
Bernard's "constant research for simple formulae."[3]

[1] Emile Bernard, "De l'Art naïf et de l'art savant," Mercure
de France, April, 1895, pp. 86-91; p. 91.

[2] In La Plume, September 15, 1896, pp. 390-397.

[3] Ibid., p. 394.

Granting the importance of the article--it was published il-lustrated in La Plume--Jourdain tends to read too much into the work and, like that of so many other critics of the day, his writing is marred by an excessive synaesthetic metaphor. Van Gogh saw the mat-ter more directly. He knew the "Christ Carrying the Cross" and the "Christ in the Garden of Olives" from photographs Bernard had sent him. Writing from Saint-Rémy in early December, 1889, he considered one "atrocious" and the other a "nightmare." "I won't forgive you," Van Gogh wrote of "Christ portant la croix," "for the banality--in-deed banality--of the composition."[1]

Charles Filiger (1863-1928)

"Dear Sir," wrote Emile Bernard to Léon Deschamps, the editor of La Plume, "In your issues on innovating painters [September 1, 1891] you overlooked, and I apologize for not noticing it immediately, a young artist of great talent, genius, whose art, essentially of the soul, brings to this century a wholly unexpected and mysterious note; not only in its essence but in its form too. Charles Filliger [sic] (the name of the forgotten artist) is essentially an innovator: above all mystic, always rare and also strong."[2]

This letter, one of the earliest traces we have of the art of Charles Filiger, sketchily relates Filiger's arrival in Paris, his occasional appearances at the studio of Colarossi (where Gauguin

[1] Quoted in Rewald, op. cit., p. 364. On the preceding page Rewald reproduces "Christ in the Garden of Olives."

[2] Emile Bernard, "Critique d'art," La Plume, December 15, 1891, p. 441.

worked), his poverty and describes certain of Filiger's pictures composed like Italian primitives. The work of Bernard and Filiger at this time was deeply related, and, like Bernard, Filiger had exhibited with the Indépendants before joining the roster of the Rose-Croix.

Obliged to leave Paris in 1890 because of an "affaire de moeurs," Filiger settled in Le Pouldu, Finistère, remaining in Brittany for the duration of his life. Deeply religious, Filiger's first artistic solutions focussed on a kind of angelic perfection clearly felt in his sensitive drawings of adolescent boys. His later watercolors, like Byzantine diagrams of a divine and mystical rationale, relate to visual patterns devised by the expatriated German brotherhood, the Benedictine Colony at Beuron.

Filiger sent six works to the Salon de la Rose+Croix. These were in large part loaned by Antoine de La Rochefoucauld, both a patron and an apologist (as he was also for Sérusier) from whom the painter had been receiving a stipend since 1890. The Count's pictures included "Christ aux anges" and the "Sainte Famille."[1] Another work, "La Prière," was loaned by Schuffenecker; three remaining works, "Saint," "La Vierge," and "Saint Jean" completed Filiger's entry.

Antoine de La Rochefoucauld's enthusiasm for Filiger's work can be measured in terms other than the influence it had on the Count's painting. In 1893, after a noisy break with Peladan during the concluding days of the first Salon de la Rose+Croix, La Rochefou-

[1]They are presently in the collection of Arthur Altschul, New York City. See Ex. Cat., Neo-Impressionists and Nabis in the Collection of Arthur Altschul (New Haven: Yale University, 1965), pp. 72-80, where they are reproduced.

cauld founded one of the fascinating, typographically beautiful re-
views of the period, Le Coeur, settling its editorship on Jules Bois,
a historian of magic and satanism.[1] The periodical, which supported
artists of idealistic or mystical tendencies, carried in the July-
August issue of 1893 a long study on Filiger by La Rochefoucauld, as
well as a full-page reproduction of the "Holy Family" (ig. 22).

> Filiger finally has known how "to find" an original Virgin.
> She raises the soul to the paroxysm of faith, so good is her
> face, so devoid of all materiality.
> Let us congratulate Filiger on his pious audacity. He has
> innovated an entirely original form of the Virgin. . . .
> She is: not the Virgin of Byzantine mosaics
> not the Virgin of the old Florentines
> not the Virgin of Raphael
> not the Virgin of Flanders
> Less awesome than the Virgin of the East, less angelic than
> the Virgin of Giovanni da Fiesole, less human than the Virgin
> of Raphael. Nor is she the "Mother" par excellence achieved by
> Memling. She is "the Queen of Bounty." Her form is more ab-
> stract than that of the Virgins by past masters and she recalls
> them in no way.[2]

La Rochefoucauld's alembicated literary manner indicates his
shortcomings as a critic. His piece on Schuffenecker in Le Coeur is
also quite creditable,[3] even though his pedantically ostentatious
lists reveal the influence of Peladan.

"Prayer," Schuffenecker's loan, was reproduced in the Rose+
Croix catalog and is quite possibly its finest illustration (Fig. 23).
It depicts a nude boy seen in profile, another example of the ephebic
beauty emphasized in Filiger's early work. The boy is enclosed in a

[1] See Jules Bois, Le Satanisme et la magis, intro. J.-K. Huys-
mans (Paris: Chailley, 1895).

[2] Antoine de La Rochefoucauld, "Charles Filiger," Le Coeur,
Nos. 4-5 (July-August, 1893), pp. 3-6; p. 3.

[3] Antoine de La Rochefoucauld, "Emile Schuffenecker," Le
Coeur, No. 3 (March, 1894), pp. 3-8.

kind of phallus-shaped frame which, in a general way, echoes the con-
tours of his simple linear figure. This drawing is related to a gou-
ache "Prière" which may have been the work shown under that title at
the first _Salon_ (Fig. 24).[1] A "Sainte en prière" was reproduced in
the _Revue Encyclopedique_ of 1892 but this figure is much more stiffly
doll-like and is indicative of a new tendency in Filiger's art at
this moment (Fig. 25). La Rochefoucauld reports in his article that
Gauguin laughed when he first saw Filiger's early pictures, among
them "Prayer," though it was on Gauguin's advice that Filiger began
to exhibit with the _Indépendants_ in 1889.

In addition to the support of Antoine de La Rochefoucauld,
Filiger was also championed by two influential writers of his day,
Remy de Gourmont and Alfred Jarry. Filiger's design for the cover
of Gourmont's _Le Latin Mystique_ of 1892 has already been noted in
connection with Huysmans and Jacques-Emile Blanche. The cover deco-
ration places two haloed heads, one a red-bearded Christ, the other
a female with blue-gray hair, in an eccentric quadrilateral. Fili-
ger's frontispiece for Gourmont's _L'Idéalisme_ (Paris: Mercure de
France, 1893) depicts a reclining female in a flat amorphic land-
scape.

[1]Included in a small Filiger retrospective exhibition, Paris,,
1962. See Ex. Cat., _Charles Filiger, 1863-1928_ (Paris: Le Bateau
Lavoir, 1962), intro. Charles Chassé. See entry 45 to Ex. Cat., _Les
Etapes de l'art contemporain, II, Gauguin et ses amis, L'Ecole de
Pont-Aven et l'Académie Julian_ (Paris: Wildenstein Galleries, Febru-
ary-March, 1934), organized by Raymond Cogniat; see entry 226, Ex.
Cat., _Eugène Carrière et le Symbolisme_ (Paris: Orangerie des Tuile-
ries, December, 1949-January, 1950), cat. by Michel Floorisoone.
Reproduced in Charles Chassé, _Le Mouvement symboliste dans l'art du
XIXe siècle_ (Paris: Floury, 1947), facing p. 96.

Remy de Gourmont breathlessly enthused over Filiger's entries at the Salon de la Rose+Croix:

> More finished, more "final" Cimabues: The soul of the Primi-
> tives; the faith of Angelico; a Love of eyes which are all in-
> tellectually sensitive man; his heads, like that of Christ and
> his Angels inscribed forever in the eyelashes; like that of
> this "Virgin and Child," Breton, idealized, in a wonder of
> naïve sweetness; at the side, a willful and severe head; then a
> naked child praying--adorably innocent; a Saint John the Bap-
> tist preaching, of great faith!--a "Virgin with Angels," angels
> so consciously pure, these are incoherently a few of the im-
> pressions that Filiger's miniatures afford. He is an authentic
> mystic, and not a fac-simile of the temperament--a man of char-
> ity as well as a rare and knowing theoretical artist. The
> "Christ with Angels" is a masterpiece and the Breton Virgin,
> the most worthy of Ave Maria since those painted by the last
> Flemish idealists for their beloved churches.[1]

L'Ymagier, begun under the joint editorship of Gourmont-Jarry in 1894 and later continued under Jarry alone, was dedicated to reviv-ing interest in folk art such as Epinal prints. In the first issue, Jarry associated Filiger's work with the folk prints of Epinal.[2] The handsome review carried numerous illustrations by Filiger and Bernard and published an occasional spot by Gourmont himself, recalling those of another critic, Camille Mauclair, for La Plume. These illustra-were all conceived according to the hieratic conventions peculiar to the Pont-Aven circle. To spur the purchase of L'Ymagier, the review offered a hand-colored reproduction of Filiger's Virgin and Child, "Ora Pro Nobis," published in an edition of twenty.

[1] Remy de Gourmont, "Les Premiers Salons," loc. cit., p. 64.

[2] Alfred Jarry, "Filiger et les images d'Epinal," L'Ymagier, No. 1 (October, 1894), p. 65.

129

Antoine de La Rochefoucauld (1862-1962?)[1]

It seems certain that many of the figures who consented to
appear at the first Salon de la Rose+Croix did so owing to the sup-
port which La Rochefoucauld gave to the movement. No other Rosicru-
cian figure dealt as closely with the artists as he did, sharing
with them--particularly those associated with the circle of Pont-
Aven--their artistic aims and, with Filiger and Bernard, a common
religious passion. A catalytic figure, his fortune permitted him to
support Filiger, Sérusier and Bois, and his family name added consid-
erable luster and social appeal to the Rosicrucian movement. He was
himself a painter of merit and his writings characteristically ex-
press the syncretic religious notions of the day.

"The Good Goddess Isis,"[2] one of the more singular works ever
to be shown at the Indépendants, was preceded by La Rochefoucauld's
envoi to the first Rosicrucian Salon, "The Angel of the Rose+Croix."
La Rochefoucauld's angel, to judge from the catalog illustration, was
a brusquely drawn female head whose halo is decorated with arcane,
Christian and Rosicrucian symbols (Fig. 26). Gourmont described her
as "truculent, violent, bizarre, barbarian and yet, of all the works
at this salon, perhaps the only one that is really painted. . . .

[1]In Robert Herbert's catalog, Neo-Impressionists and Nabis in
the Collection of Arthur G. Altschul (New Haven: Yale University Art
Gallery, 1965), p. 73. La Rochefoucauld's death date is given as
1900. I believe this to be incorrect. It is my impression that An-
toine de La Rochefoucauld died in the early 1960's, having spent the
concluding portion of his life sequestered in a religious institu-
tion. It is possible that the "error" in dating given in the Yale
catalog is based on information given in an exhibition catalog,
Charles Filiger (London: Reid Gallery, October 3-November 2, 1963),
p. 9.

[2]Reproduced Le Coeur, No. 1 (April, 1893).

M. de la Rochefoucauld possesses a solid artistic temperament; with it one can be sure of oneself."[1] The idealistic Alphonse Germain qualified her merely as "an attempt at broken color unsuccessful in the flesh parts. . . ."[2]

Félix Vallotton (1865-1925)

The Swiss painter Félix Vallotton, whose reputation as a painter is enlarged by his important woodcuts,[3] was, of all the artists connected with the Nabis circle, the most enthusiastic supporter of the first Salon de la Rose+Croix. He sent four entries, but three of these were framed groupings of prints so that he was quite heavily represented: "sept sujets originaux gravé sur bois," "deux sujets originaux sur bois: Le Beau Soir et l'Enterrement," still another "deux sujets originaux sur bois," and a work dedicated "A Baudelaire."

Like so many others, Vallotton felt that Realism had had its day and was about to be replaced by a return to the Primitive and the Symbolistic: "Now one is, or believes oneself to be, mystic or symbolist; in any event, one affects saying so. The robustness of yesteryear is succeeded by pale enigmatic works, phantom-like cataleptical works, and the need to "quintessentialize" grows more and

[1]As in footnote 1, p. 128.

[2]Germain, "L'Idéal et l'idéalisme," loc.cit., p. 179.

[3]The most admired being fifty-three spot portraits of Symbolist figures for Remy de Gourmont, Le Livre de Masques (2 vols.; Paris: Mercure de France, 1896, 1898). Peladan is glaringly absent from these short critical essays. Vallotton's portrait cuts were used occasionally as illustrations in La Revue Blanche.

more general."[1] Prior to the exhibition, Vallotton anticipated very little from Peladan's effort. "Not much good is to be expected from Peladan and his crusade" he wrote. "The Sâr already has amply proved that he only knows how to be dangerous to the causes he represents."[2] But after the opening of the _Salon_, Vallotton radically changed his opinion.

> Instead of the anticipated mystification, the open-minded visitor was astonished to find a well-arranged hall, nicely composed, wherein very good work appeared with dignity with no other showing-off that their extreme flavor of art . . . a breath of youth and life, so that, whether one wanted to or not, sympathy was won; all the works shown, even beginner's works, denoted audaciousness and sincerity. The air that one breathed on entering there bore witness to so much faith and loyal effort that we were impressed as by a bravura melody.
> One can be utterly indifferent to the Sâr, the sweet inoffensive Sâr, for his manias, his costumes, and his ridiculousness, but after the smiles one nevertheless owes him a debt of gratitude for having put before the public the chance of judging so much valiant and tangible work. The famous program of necessity had to be attenuated. Of the original rigors there remained scarcely more than the exclusion of works relating to the theme of contemporary life—as well as portraits—with the exception of course of one of the Sâr in a violet toga, displayed in full light and so bad as to arouse pity.[3]

Henri Martin (1860-1943) and Giovanni Previati (1852-1920)

Other figures in debt to Impressionism while remaining rooted in later nineteenth-century academic tendencies were Henri Martin and Giovanni Previatti both of whom exhibited with the Rose+Croix in 1892. In several respects, Martin's work at the beginning of the nineties is similar to that of Aman-Jean (who will be spoken of in connection with the second _Salon de la Rose+Croix_). Both were attracted by

[1] Vallotton, quoted in Hahnloser-Bühler, _op. cit._, pp. 177-178.

[2] _Ibid._

[3] _Ibid._, pp. 178-179.

dainty, feminine themes such as "Une Femme à la Rose," shown by Martin in 1892 and Aman-Jean in 1893. In contrast with the gentility of these theme, Martin's Ropsian "Vers l'abîme" achieved a certain renown in the early nineties. In this work a batwinged female leads a horde of conquered admirers to the brink of destruction (Fig. 27).

Martin's contribution to the Salon of 1892, eight works in all, suggests easel paintings of modest proportions and a heavy dosage of Puvis-like nostalgia. A "Femme a la rose (etude)," "Tristesse," "Solitude" and "Mélancholie Cerépuscule" are representative themes. They barely conjure up the scale of his subsequent work, huge decorations for the City Hall of Paris, or the Capitole of Toulouse, works which consecrated this now-obscure painter whose timid impressionism once epitomized official public taste through the 1920's.

Giovanni Previati, a kind of Italian Henri Martin, sent tight Impressionistically derivative canvases from Italy. Like Martin he might easily today be overlooked were it not for the fact that among his admirers figured the young Futurists, notably Boccioni. Lake Martin, Previati combined a shy broken color with a penchant for literary symbolism, typical of certain late nineteenth--century trends in Italy related to Segantini or to the schiacciato modelling of the funerary sculptor of pure Rose+Croix sensibility, Leonardo Bistolfi. Previati was represented at the Rose+Croix in 1892 with a "Maternity."

Ferdinand Hodler (1853-1914)

One last group remains to be spoken of in connection with

the first Salon de la Rose+Croix. They are a heterogeneous group,
bound together neither by common method nor style, but are figures
of interest because of their undeniable artistic merit (such as
Hodler), because they buttressed the otherwise questionable produc-
tion with fascinating theoretical scaffoldings (such as Albert Trach-
sel and Charles Maurin) or because they are related to the decorative
arts and the nascent Art Nouveau style (such as Tooroop and Grasset).

Hodler's contribution to the 1892 Salon[1] was his "Enttäuschte
Seelen," called "Ames décues" in the illustrated catalog. A drawing
of a single sorrowing patriarch, one of the five who divide the pic-
ture plane along vertical axes in the final version, ranks with
Filiger's work among the finest illustrations in the book (Fig. 28).
This important canvas bridges Hodler's earlier Naturalist--albeit
symbolical--style, that of his "unforgettable"[2] "Sleep" and the
plangent eurhythmic canvases associated with his later production.
Vallotton was deeply stirred by the "Ames décues" saying that one
had to go back to the 'ancient frescoes of Orcagna and Signorelli to
find this strength of line and a like grandeur."[3]

Albert Trachsel (1863-1929)

An intimate friend of Hodler,[4] Albert Trachsel also appeared

[1]Presumably Hodler exhibited only once with the Rose+Croix
(1892). Yet in a review of the Rosicrucian Salon of 1893 Yvanhoë
Rambosson paused before a "kneeling child" by Hodler. See Y. Ram-
bosson, "Le Mois artistique," Mercure de France, June, 1893, pp.
178-180. There is, however, no listing for Hodler in the 1893 cata-
log.

[2]Joséphin Peladan, Le Salon de . . . 1891, p. 41.

[3]Vallotton quoted in Hahnloser-Bühler, op. cit., p. 180.

[4]Hodler's affection for Trachsel is testified to by a large

in the first <u>Salon de la Rose+Croix</u>. A curious Swiss artist, Trachsel had made an earlier single appearance at the <u>Indépendants</u> in 1891, where his work so impressed Coquiot that he devoted a long passage to Trachsel in his history of <u>Les Indépendants</u>, classifying him among the "Nostalgiques."[1]

According to Stuart Merrill, the American-born French Symbolist poet, Trachsel's work at the beginning of the 1890's divided into three units. The first, "Fêtes Réelles," was a set of fantastic architectural drawings which may have been shown in its entirety at the <u>Rose+Croix Salon</u>. In 1897 the <u>Société du Mercure de France</u> published fifty heliotypes under this title. The second and third groups were still in progress and were probably executed in watercolor, to judge from "Le Regard dans l'infini" which is reproduced with Merrill's article for <u>La Plume</u> and which is included in Trachsel's catalog listing. These groups were assembled under the titles of "Le Chant de l'Ocean" and "Vision"; both were sets of imaginary themes.

Trachsel's listing, thirty-two works in all, was probably even larger since one of the entries reads "Vision (aquarelles)," suggesting the cycle mentioned by Merrill. One of Trachsel's architectural fantasies included in the <u>Rose+Croix</u> exhibition was reproduced in the <u>Revue Encyclopédique</u> of 1892 (Fig. 29). Entitled "Exécution d'une symphonie et retraite joyeuse," it clearly favors a dramatic conceptualized architecture recalling the work of Boullé

number of drawings, paintings and caricatures of Trachsel. In one, Hodler calls Trachsel "our sympathetic grasshopper." See Ex. Cat., <u>Hodler Gecächtnis-Austellung</u> (Berne, 1921), item 803.

[1]Coquiot, <u>op. cit.</u>, pp. 126-127.

and Ledoux of a century earlier. A monumental figure broods over a huge and desolate amphitheatre approached by a towered double viaduct.

"Le Regard dans l'infini" (Fig. 30), scarcely visible in Merrill's article, depicts a kind of anthropomorphic locomotive crouching upon a tall arcade hidden in a hazy atmosphere through which a beam of light illuminates all manner of comets and asteroids. First comparing this work to the images of such "feverish visionaries" as Blake and Redon, Merrill continues:

> On a colossal pedestal whose base rests on one knows not what Rock of Ages, crouches an indescribable monster with an aureolated head, from whose single eye projects a beam of divergent rays into the infinite. At the base of the pedestal there swell like bubbles the domes of churches, and in the half-light of this sight, enormous ringed stars, like Saturn, circle about. As to this monster made of curves and circles, is he not the sign of Horror before the Mystery?[1]

Merrill also lengthily described a "Monument de la Maternité" which is probably the "Fête de la Maternité" of the Rose+Croix listing, basically a huge dome in the form of a female breast.

While Vallotton considered Trachsel "The Edgar Allen Poe of architecture,"[2] a dissident opinion was put forth by Durand-Tahier, writing in La Plume, who was hard put to admit the good faith of the artist of "these awkwardly executed watercolors. . . ."[3]

A last aspect of Trachsel's talent: he was what might be described as a proto-Futurist poet, possibly influenced by the pure

[1]Stuart Merrill, "Le Salon de la Plume: Albert Trachsel," La Plume, February 1, 1893, pp. 53-57; pp. 56-57.

[2]Vallotton quoted in Hahnloser-Bühler, op. cit., p. 180.

[3]H. Durand-Tahier, "Le Salon de la Rose+Croix," La Plume, March 15, 1892, pp. 131-132.

sound theories realized in Maeterlinck. Trachsel's poem, "The Cyclem" contained numerous passages of "literary music" such as "Hou Hôôô," "clic clac ché," and "Hou Heïe, Heïe."[1]

Charles Maurin (1856-1914)

Charles Maurin, a friend of Vallotton and Toulouse-Lautrec,[2] was, at his best, a pleasant graphic-artist and illustrator employing familiar themes of the late nineteenth century: Japan and Maternity.[3] Like Trachsel, Maurin's ideas are perhaps more striking than their execution.

Of a practical nature, in 1891 Maurin patented a system of colorprinting from a single plate, a method particularly suitable to the reproduction of watercolors.[4] He also devised a means of coloring theatrical costumes in an aerated gauzy manner that was used both by Sarah Bernhardt and by the Théâtre de l'Oeuvre. Inspired by Pointilism, Maurin attempted to soften its occasionally chromatically saturated effect by spraying paint through vaporizers, emphasizing the ambiguous possibilities of colors and devising an early air-brush technique. Paintings done in this method were exhibited by Vollard in 1895.[5] In 1892 Maurin sent an "Aurore" to the Rose+Croix, and he

[1] Albert Trachsel, Le Cycle (Genève, Paris: A. Charles, n.d.), reviewed by Remy de Gourmont, Mercure de France, May, 1894, p. 83.

[2] Intro. by Arsène Alexandre to Ulysse Rouchon, Charles Maurin, 1856-1914 (Le Puy en Velay, 1922), p. 5.

[3] For example his sets of colored drypoints, Education Sentimentale and Education Sentimentale nouvelle which centered around maternal themes of bathing children, caressing them, feeding them, etc.

[4] Rouchon, op. cit., p. 27.

[5] Commented on by Richard Ranft, Courrier du Soir, September 2, 1895, repro. Rouchon, op. cit., p. 4, and by Henry Nocq, repro.

would appear with the Rosicrucians again in 1895 and 1897.

Eugène Grasset (1841-1917) and Jan Tooroop (1858-1928)

The outstanding figures connected with the emerging _Art Nou-veau_ style, represented at the first _Salon de la Rose+Croix_, were Eugène Grasset and Jan Tooroop. Grasset's work is of particular im-portance as he both taught at his own school and published several large texts to implement his teaching. These books, in turn, served to disseminate further the style. His role in popularizing the large commercial poster is central, and he was one of the founders of the "Salon des Cent," inaugurated in 1893 by _La Plume_ to foster the art of the poster.

Grasset's contribution to the _Salon de la Rose+Croix_ of 1892, the only one in which he appeared, was a "Thoura-Mazda," which strikes an unfamiliar note in the thematic range of this artist whom we asso-ciate with Gothic or Insular patterns.[1]

The art of the Java-born Dutchman, Tooroop, whose early fan-tastic style led to some of _Art Nouveau_'s most personal works, is of quite another order than Grasset's fundamentally polite and natural-istic style. The eccentric and highly elaborate patterns character-istic of Dutch _Art Nouveau_ were already visible in Tooroop's work of the early 1890's, for example, in the famous "Three Brides." His contribution to the 1892 _Salon de la Rose+Croix_, his only appearance

ibid., p. 42. Nocq describes the technical procedures of Maurin at length.

[1] E.g., Eugène Grasset, _Ornaments Typographiques, lettres ornées, têtes de pages et fins de chapitres publiées en 1880 pour les Fêtes chrétiennes de l'Abbé Drioux_ (Paris: Sagot, 1898).

with the group, was "l'Hétaire" and "Une generation nouvelle" (Boy-
mans Museum). In 1893 the Revue Encyclopédique published one of
Tooroop's designs from this period, "L'Annonciation du nouveau mysti-
cisme" (Fig. 31) which was also executed in this highly personal and
obsessive manner.

Nantes in Paris: Pierre-Emile Cornillier (1863- ?) and Maurice Chabas (1862 or 3-1947)

Pierre-Emile Cornillier and Maurice Chabas began their long
association with the Salons de la Rose+Croix in 1892, and were pres-
ent at all the succeeding ones. Both artists were born in Nantes;
Emile Maillard looks on them with local pride and in his L'Art à
Nantes au XIXᵉ siècle (Paris: Librairie des Imprimeries réunies,
n.d.).

Cornillier's work is associated with that of his teacher,
Luc-Olivier Merson, an academic painter of popular religious paint-
ings, whom he assisted in many large commissions. Of the numerous
works shown by Cornillier at the Rose+Croix--which one mentions more
out of respect for his doggedness than for any intrinsic worth--per-
haps the orthographic oddity "Two Drawings" by "Philgrimé Progress"
(sic), shown in 1892, leaps most at the eye. In 1893, to rectify
the misspelling, two illustrations to Pilgrim's Progress by "Bunyam"
(sic) were shown. In addition to numerous religious works, classi-
cal and historical themes also were included among Cornillier's
entries.

Maurice Chabas, brother of Paul Chabas, the painter of the
famous "September Morn," is scarcely more interesting than his compa-

triot. A "Révélation" and an "Erraticité" were reproduced in the
1892 catalog, works that are exotic only by virtue of their names.
"Awena," "Aechea (Incarnation de la volopté pure et du commandement)"
and "Celsa (Phase exstatique)" were sent with several other pieces to
the Salon of 1894. The titles of his entries bear out the Edouard-
Joseph description of Maurice Chabas as an artist drawn to landscapes
of a spiritual order (Fig. 32).[1] Parisians could judge of the spiritu-
ality at the Mairie of the Fourteenth Arrondissement and at the Gare
de Lyon where some of his landscape decorations are still to be seen.

The Sculptors: Antoine Bourdelle (1861-1929), Georges Minne (1866-1941), Jean Dampt (1853[4]-1946) and Auguste de Niederhausern-Rodo (1863-1914)

Antoine Bourdelle, then still known as Emile Bourdelle, sent
"Fourteen Drawings" and a statue, "Saintly Woman at the Foot of a
Cross," as yet a still unidentified entry, to the first Salon de la
Rose+Croix. The illustrated catalog reproduces the unlisted "l'Amour
agonies." Since Bourdelle's entries to the Salon of 1893 constitute
its most prominent feature, I will postpone my discussion of his en-
tries to the Rose+Croix until I consider the second Salon de la Rose+
Croix.

The widely admired Belgian sculptor, Georges Minne, remembered
for his lean and adolescent Gothic figures, was scarcely visible in
1892, contributing a single unidentified "Dessin."

Jean Dampt, follower of the "Florentine" sculptor, Paul Dubois,
sent three works, "Virginité," "Tête d'enfant" and "Le Baiser des

[1] René Edouard-Joseph, Dictionnaire Biographique des Artistes contemporains. 1910-1930, Vol. I (Paris: Art et edition, 1930), p. 260.

anges." In an article on Dampt by Fernand Weyl, published in 1895:

> At the Salon de la Rose+Croix, of which he was a fervent adept, Dampt undertook new research in the combinations of materials. He showed a low relief, "The Kiss of the Angels," in which the Cherubim with the heads of extremely young children, purse their lips. The heads were carved out of wood.
> It was in Ivory, however, that he executed Virginity--symbolized by a young girl stretched out on the ground, looking at heaven, holding a Lily in her hand.[1]

In 1893, while reviewing the official Salon, Peladan was struck by Dampt's "Au seuil de mystère." Referring to the sculptor as "Dampt (R+C)" he praised the work for its "research in androgynous plasticity . . . the bodies merit appreciation for the understanding of bi-sexual hesitation which is the ideal of art."[2]

The last sculptor of more than routine interest was the Swiss artist Auguste de Niederhäusern-Rodo. Remembered because of his association with Rodin, Niederhausern-Rodo was the sculptor of the Verlaine Memorial raised in the Luxembourg Gardens by public subscription inaugurated by La Plume in 1896. In 1892 Niederhäusern-Rodo exhibited five works, including a portrait of the "desolate satyr,"[3] Verlaine, of which a robust drawing appeared in the illustrated catalog (Fig. 33).

The Peladan-La Rochefoucauld Break

The first Salon de la Rose+Croix was, in many respects, a

[1] Fernand Weyl, "Les Artistes de l'âme: Jean Dampt," L'Ermitage, I (1895), 129-137; 134.

[2] Joséphin Peladan, "Salon du Champ de Mars, Règle pour la geste esthétique de 1893," La Rose+Croix. Organe trimestriel de l'ordre (Paris: Commanderie de Tiphereth, n.d. [1893?], p. 18.

[3] Joséphin Peladan, Le Salon de . . . 1891, p. 29.

triumph for Peladan, but a galling one, since it was scarred by a droll and irreparable rift, the break between Antoine de La Rochefoucauld and the Sâr.

It has been amply demonstrated that from the very outset two Symbolist tendencies were represented. One group related to expanding Nabis sympathies, that is, it stemmed from "Materialistic" Impressionism. The other, the "English" stream, derived from Moreau and Puvis de Chavannes. Larmandie reluctantly states in L'Entracte Idéal that "Several discussions arose with regard to the two tendencies juxtaposed at the Salon . . . one, the majority, opted for an exclusively classical tradition while others favored modern Impressionism . . . these differences of view and appreciation led to a schism in the Order: The Archonte [i.e., Antoine de La Rochefoucauld] separated from the Grand Master and the Commanders."[1]

La Rochefoucauld's break with the Rose+Croix led to serious financial problems for the brotherhood. Durand-Ruel at this time equally disappointed the Rose+Croix in their hope of having another exhibition in his gallery the following year. He preferred, said Larmandie, "his ordinary little buzzing of ten to fifteen visitors a day to the veritable human flow that we unleased in his rooms. . . ."[2]

While La Rochefoucauld's artistic affiliations obviously compromised his association with the Rose+Croix from its very inception, there were personal reasons which are perhaps more painfully amusing.

The Salons de la Rose+Croix were festivals of the arts in addition to being merely painting and sculpture exhibitions. The evenings

[1]Larmandie, L'Entr'acte idéal, p. 37. [2]Ibid.

were given over to plays and musical performances. The first event was held on March 17, 1892. After a performance of Palestrina's "Mass for Pope Marcello," Peladan's "Wagnérie Kaldéene," Le Fils des Etoiles--a three-act play with incidental music by Eric Satie--was given and very badly received. As a result, La Rochefoucauld refused to meet the exorbitant costs of the scheduled two remaining performances which Peladan claimed he had promised to do. In addition, it was discovered that the Gallery had been lease in La Rochefoucauld's name, not in the name of Peladan or the Rose+Croix, so that La Rochefoucauld became the legal artistic director of the Salons.

For an evening devoted to Wagner's music, La Rochefoucauld had obtained the services of Lamoureux as guest conductor, although, according to Peladan, the performance was to have been conducted by a certain Benedictus who had been forced out by La Rochefoucauld. The Count insisted that this was not the case, and that Benedictus had left of his own free will. Other issues arose and Peladan, taking umbrage at the events, had recourse to legal representation--to no avail. During the playing of the "Siegfried Idyll" at the aforementioned evening, a heavily bearded man asked for Commander Larmandie. Larmandie, however, was not present as the Sâr had ordered him "to retire immediately and definitively from Durand-Ruel, traitorously rented in the name of La Rochefoucauld."[1] The bearded man then caught

[1] Arild clipped many accounts of the contretemps which he pasted, undated, into his scrapbook; among them "Les Funérailles de la Rose+Croix," Echo de Paris; "Chez l'Archonte," Le Figaro; "Wagner chez l'Archonte," Le Temps, all from April, 1892.

sight of La Rochefoucauld and, hurling insults at him, shouted "La Rochefoucauld, you are a felon, a coward, a thief." The intruder was pushed out a glass door, which shattered with a great noise, interrupting the orchestra. The music stopped and the audience was on its feet. During the scuffle the intruder's beard was pulled off, revealing Peladan's associate Gary de Lacroze, who was dragged off to a nearby police station.

This episode is wittily retold in a letter by the so-called "Ouvreuse du Cirque d'Eté," who mentions some of the famous figures of the Symbolist art world who were present at the performance:

> Willette slept with a sweet smile, Descaves pinched his thighs to stay awake, and René Ghil, instrumentalist poet and anti-mystic, paraded his Eyes (with a capital E) wide with astonishment, across the diagrams of Trachsel, the architect of Charenton-of-the Ecstacies. . . . "You are a coward, a felon, a li." The "ar" was not heard, shoved back into the mouth of the ex-magus by a vigorous punch by Mr. Paul Fort, director of a tottering art theatre—that the Archonte can no longer dispense from shoring up by means of a grateful silent partnership. The Larochfouconoclast was dragged to the station-house; then the tempest subsides (music by Chausson who enjoyed himself like a little madwoman) and when the pertubators of the violin had gone—to you Dubus!—the Archonte himself reassured the faithful: ""Ladies and Gentlemen, that was a friend that Sir—not Sâr— Peladan sent over to interrupt the performance."[1]

In the column, "Dissolution of Societies" of the _Affiches Parisiennes_ for April, 1892, one finds La Rochefoucauld's legal announcement of his break with Peladan. Dated March 24, it reads:

> Deeds under private signature.
> Order of the _Rose+Croix du Temple_
> Peladan and La Rochefoucauld
> Annual Salon of esthetic manifestations
> Seat: Rue d'Offémont, 19.

[1]From Arild's scrapbook. It was probably written by Willy [Henry Gauthier-Villars] who published his _Lettres de l'Ouvreuse. Voyage autour de la musique_ (Paris: Vanier) in 1890, a collection of humorous critiques of the _Concerts Lamoureux_ of the 1889-1890 seasons.

The first Salon de la Rose+Croix was over. "If Paris has seen an attempt at esthetic renewal," Peladan announced," similar to the Pre-Raphaelite Movement of Ruskin, Rossetti, Burne-Jones, in spite of intruding canvases shown through treason, the honor belongs to the Rose+Croix."[1]

Peladan Evangelist: 1892-1893

The first Salon de la Rose+Croix concluded on a greatly publicized note. The public who followed the gossip of the daily press came to associate the issues over which Peladan and La Rochefoucauld parted exclusively with the Salons de la Rose+Croix. Idealism became, in effect, the popular conception of the Symbolism. Taking into consideration the attrition of styles, this fact also explains in great measure the gradual trend away from Rosicrucian taste among young artists who held in horror all that was common and familiar.

The break between the Sâr and Archonte was by Peladan's accounting a call to further action. Above all else, there was to be no retrenching. A reasonable man might have capitulated at the loss of the count's backing, but Peladan was Sâr, and the whole of 1892 is marked by an intense activity in favor of the Rose+Croix platform, climaxed by Peladan's tour of the low countries in November. In Belgium he was greeted by the Idealists of "Pour l'Art" and Raymond Nyst, a Belgian occultist who later dedicated his book Un Prophète (Paris: Chamuel, 1895) to the Sâr. Peladan lectured in Bruges, Ghent,

[1] Ex. Cat., Catalogue Officiel illustré de 160 dessins du second Salon de la Rose+Croix (Paris: Champ de Mars, Librairie Nilsson, 1893), p. xl.

Antwerp, Louvain. In Malines, however, Cardinal Goosens, Archbishop of Malines, would not let him speak owing to Peladan's earlier "Exécration vehmique" of the Malines Congress.[1]

During the year, Dentu brought out Le Panthée,[2] the tenth novel of the Ethopée. In addition to the catalogs of the Salon de la Rose+Croix, La Queste du Graal, composed of the most lyrical passages of the novels of the Décadence Latine, illustrated with their covers and frontispieces, was offered for sale. At the end of the year, Dentu published the eleventh novel, Typhonia, which included the "Regle Esthétique du second salon de la Rose+Croix."

Chamuel also brought out the first of Peladan's seven works which comprise the "Amphithéâtre des sciences mortes," Comment on Devient Mage. This esoteric treatise elicited abuse from the expected quarters. La Plume saw that "the butt (megot) is only a burned-out cigarette, but the "Magot" must constantly be lit up by the occult."[3] The young bohemians of the Chat Noir were singing the ditty, "Les pieds du Sâr Peladan (aux pied du Mufle)."[4] Amidst the din, Maurice Bazalgette's high praise of Peladan in the Revue Indé-

[1] Peladan's reply to the Cardinal formed the supplement to the Belgian periodical Le Mouvement Littéraire, No. 20 (November 23, 1892), a special issue devoted to Peladan.

[2] The edition bore a cover by Séon, contained a frontispiece by Khnopff, and reproduced a page of Eric Satie's "Leit-Motif du Panthée."

[3] Anon., La Plume, March 1, 1892, p. 111.

[4] F. A. Cazals, La Plume, July 15, 1892, p. 338. See also Pierre Trocy, "Comment on devient Mage," La Plume, March 15, 1892.

pendante--here the Sâr was compared with Homer, Dante, Shakespeare, and Balzac--was lost.[1]

Fifteen Days in Holland (Peladan and Verlaine)
Philippe Zilcken (1857-1930)

On his November lecture tour, Peladan was accompanied by Paul Verlaine who recorded the events of this journey in his Quinze Jours en Hollande. In these recollections, Verlaine paints an understanding picture of Peladan, pitting the decorative, empty trappings of his dress and erudition against the Sâr's essentially intellectual and even comic gifts:

> In Joséphin Péladan I have always made the distinction between the man of considerable, eloquent and profound talent,-- which all who are capable of understanding and appreciating must acknowledge lest they be charged with signal bad faith,--and the systematic, the doubtless very sincere but certainly too encumbering sectary that he calls Sâr or Magus. . . .[2]

Verlaine and Peladan were received in The Hague by Philippe Zilcken, a Dutch artist working in the manner of Israels and Mauve who, at the Salon de la Rose+Croix of 1893, exhibited a dry-point portrait of Paul Verlaine after a sketch made by Tooroop, as well as a study for the poster announcing Peladan's lectures in Holland. This study, a portrait of the Sâr, was reproduced in the illustrated catalog of the second Rosicrucian exhibition.

The Death of Boullan

In January, 1893 the occult circle in Paris was shaken by a

[1] La Revue Indépendante, No. 65 (March, 1892), 340-360.

[2] Paul Verlaine, Oeuvres Complètes (Paris: Vanier, 1900), esp. pp. 274-279; p. 275.

new scandal ignited by the death of Boullan in Lyon where he had suc-
ceeded Vintras. Boullan had died on January 3. On January 9, Jules
Bois, on information secured from Huysmans, accused in the Gil Blas
the Rosicrucian group, notably Stanislas de Guaïta but also Wirth and
Peladan, of having killed Boullan by "casting spells" (envoûtement).
The following day Bois reasserted his allegation of murder at a dis-
tance in the Gil Blas, and Huysmans published an interview in Le
Figaro which substantiated Bois' claims. When challenged to a pistol
duel by Stanislas de Guaïta both Bois and Huysmans retracted their
remarks in print, although the former remained convinced that Boullan
had actually been murdered by magic.

Bois reopened the issue in an attack on Guaïta in April in
L'Evénement which led to an indecisive duel between Bois and Guaïta.[1]
It is unlikely that the Bois-Huysmans accusations against the Rose+
Croix brought Guaïta and Peladan together again. Bertholet states
categorically that the friendship ended in 1891, the year the let-
ters ceased." Peladan's books, published after the War of the Two
Roses, found in Guaïta's library, no longer carry personal inscrip-
tions on the fly-leafs. Over-scrupulous pride had stood in the way
of a reconciliation. Peladan admits as much in his touching dedica-
tion to "Catholic Occult," published immediately after Guaïta's death
by drugs in 1898.

[1] For information concerning Boullan's death see Bricaud, op.
cit., p. xx; Baldick, op. cit., pp. 209-211; Boutet, op. cit., pp.
228-232.

[2] Letters of Guaïta to Peladan, Lettres inédites, intro., p. 9.

The Salon de la Rose+Croix of 1893

A signal honor was granted to the Rose+Croix. It was allowed
to exhibit in the Palais du Champ de Mars, the seat of the official
Salon, owing to the intervention of a certain M. Quentin-Bauchart.
Many details had to be cleared away before this concession could be
granted, and only after forty-three visits to the Prefectury, the
Secretary General, the Foremen, the Directors of the Promenades, the
Chiefs of Finances, could Peladan secure the last aisle of the Cen-
tral Dome. Peladan had to agree personally to defray the costs of
the exhibition.[1]

Among the maddening details to which the Rosicrucians had to
agree was that they would not drive a nail into the wall, thereby
necessitating the facing of their allotted space with wooden panels.
The meagerness of funds spurred their self-reliance, and a group of
workers enlisted from the ranks of devoted Rosicrucian intellectuals
worked around the clock to complete the hanging in time. Henceforth
this group was known by the "pythagorian appelation, the 45."[2]

The exhibition ran from March 28 through April 30. Again it
was to be a great festival and Peladan's four-act tragedy, Babylon,
was performed five times during the run of the Salon. The cast in-
cluded the celebrated actor of the Comédie Française, Mounet-Sully.

The Illustrated Catalog of 1893

An illustrated catalog was published listing 378 works and
containing 160 reproductions. A considerable body of these illustra-

[1]Larmandie, L'Entr'acte idéal, pp. 42-43. [2]Ibid.

tions are after works of old masters, largely French and Italian,
such as Robert de la Fage or Pordenone. The old masters are unlisted.
Peladan's essay,"La Règle esthétique et les Constitutions de l'Ordre,"
had been written in 1892 and had appeared earlier in Typhonia.

The introduction is a Peladanian litany of immortal names,
Hosannah and congregational responses. "Artist, if you believe in
the Parthenon and in the Saint-Ouen, in Leonardo and in the Winged
Victory of Samothrace, in Beethoven and in Parsifal, you will be ad-
mitted to the Rose+Croix."[1] Following the Introduction, a "Constitu-
tiones Rosae Cruci Templii et spiritus sancti ordinis" provides
thirty-seven esoteric propositions. There follow eleven questions
of initiation and some of the potential beneficent results of the
Rose+Croix. Under point XXXV we read:

It will manifest annually in March-April by
1. A Salon of all the arts of drawing.
2. An Idealist theatre while waiting for it to become Hieratic.
3. Performances of sublime music.
4. and lectures designed to awaken the ideality of the worldly.
The Rose+Croix holding beauty for orthodoxy has created a
corporation called the
 Militia of the Past
This body will establish an esthetician in each city whose
job it will be to inform it of the condition of all its monu-
ments and to be the surveillant of all things relating to art.
 . . .
The Militia and the Consul must work together to inform the
brotherhood of citizens with artistic or scientific inclinations,
especially among the poor and working class, in order that the
brotherhood may take an interest in their welfare.[2]

A section called "refused subjects and acceptable subjects"

[1] Ex. Cat., Joséphin Peladan, Catalogue Officiel illustré de
160 dessins du second Salon de la Rose+Croix (Paris: Champ de Mars,
Librairie Nilsson, 1893), p. xxvii.

[2] Ibid., p. xxxvii.

in the "Rules" rephrases the "Regle et Monitoire of the Salon of 1891."

Aman-Jean (1860-1935): The Poster for the Salon de la Rose+Croix of 1893

The poster for the second Rosicrucian Salon represented a simple Italian arcade--similar to the one Puvis employs in the decoration of the Boston Public Library--through which a floating Beatrice is led away by a winged angel. She turns her back on an unseen figure, obviously Dante, and hands him a quaint outsize lyre. The theme is inspiration (Fig. 34).

One of the best-known figures connected with the Rosicrucians, Aman-Jean, showed both in 1892 and 1893. His contributions to the first exhibition were largely of a religious nature, focussed principally on Joan of Arc. His work in 1893 included not only religious subjects such as an "Etude pour le Christ Mort," but also his more popular work along feminine themes, in this instance a "Femme à la rose." It depicts the artistic female type of the period derived from Pre-Raphaelism, hair drawn back into a bun and deeply inhaling the perfume of a large cabbage rose.

Shortly afterwards, when the Champ de Mars was occupied by the official Salon, Peladan was to write of a portrait of Verlaine painted by "Aman-Jean (R+C)" that the artist was "the idealist painter as the Rose+Croix conceives him . . . his art embodies chastity."[2]

[1] Joséphin Peladan, "Salon du Champ de Mars, Règle pour la geste esthétique de 1893," La Rose+Croix, organe trimestriel de l'Ordre (Paris: Commanderie de Tiphereth, n.d. [1893?]), p. 11.

Point, Séon and Osbert in 1893

Each of these indefatigable regulars was given a much larger representation in 1893. Catalog illustrations of Point indicate that he had moved closer to Peladan's Leonardesque and androgynous ideal (Fig. 35). Camille Mauclair observed that "M. Armand Point paints women lost in the frosts of desire, contemplating the feverish birds of their voluptuousness silently die in sad flights, and their gazes are sweet, knowing and cool."[1]

Alexandre Séon showed thirty-five works, many of them drawings connected with literary efforts such as his frontispiece, "Sin," the hero of Peladan's Typhonia, "Le Désespoir de la Chimère" which inspired Alphonse Germain's poem, and "La Fin des Dieux," the frontispieces of Henri Maazel's "Crépuscule des Dieux."

Osbert sent a huge "Vision," perhaps his masterpiece[2] (Fig. 36). In a granulated atmosphere of highly acid tints, Sainte Geneviève, her head illuminated by a halo, her eyes irradiating light, stands transfixed as if by a vision. A small panel, a study for the large work, dedicated to Osbert's fiancée, is painted in a soft pointilist manner related to the work of his former companion in Lehmann's studio, Seurat, who had recently died (Fig. 37).

An affinity between Osbert's and Aman-Jean's work can also be seen in a marked preference for pale colors and large planar shapes.

[1] Camille Mauclair, "Armand Point," Mercure de France, December, 1893, pp. 331-336; p. 332.

[2] Although listed as item 104 in the Ex. Cat., Cinquantenaire du Symbolisme, its size proved too cumbersome for moving and it was not exhibited at that iem. It was transported to London this year for the First Retrospective Exhibition of the Salons de la Rose+Croix, the Piccadilly Gallery, London, 1968. It is reproduced in the catalog for this event as item 83.

Despite Aman-Jean's often difficult personality--he was guardedly shy, a sensitivity perhaps magnified by a slight physical deformation, he stiffly held his head tilted to the right--Osbert and Aman-Jean were to remain lifelong friends.

Fernand Khnopff in 1893

The Belgian constituency was particularly strong in 1893. In addition to Delville, Fabry and Khnopff (Fig. 38), Henri Ottevaere, one of the central figures of Pour l'Art and one of its poster-makers (Fig. 39), sent work to the Rosicrucian Salon.

The group was dominated by Khnopff. Among his five offerings were two major works, "L'Offrande" (Fig. 40) and "I Lock My Door Upon Myself" (Fig. 41). The latter takes its name from a poem by Christina Rossetti. Overwhelmed by the painting, also known as "The Recluse," Yvanhoë Rambosson wrote at length and affectedly on the painting in the Mercure de France, seeing enacted in the background the past, present and future of "La Lady." "It is certainly the past, this painting; a young widow in an abandoned alleyway,--this past that she lived so alone with the grief of so many immolated things, so many unrealized ambitions, and which leaves her devoid of hope in the poignant melancholy of a wasted existence, in the irremediable. It certainly is the present, this head of Pallas lacking a wing; and the Future is symbolized by small round and square windows opening onto an infinity the color of absinthe, an infinity of fog without light. The work of M. Khnopff is complex, complete, one; it is beautiful."[1]

[1]Rambosson, loc. cit., pp. 178-179.

Peladan, too, was extremely moved by Khnopff's Mallarméan art and dedicated his review of the official <u>Salon</u> of 1893 "To the Idealist," Fernand Khnopff. "You have been, among many admirable figures, the great argument of my thesis, in this defense of the Ideal, which last year was called the First <u>Salon de La Rose+Croix</u>. . . . Receive, as a reparation for the imperfect reception which took place at that time despite my efforts, the dedication of this study. I consider you the equal of Gustave Moreau, or Burne-Jones, of Chavannes and of Rops. I consider you an admirable master. . . . I pray to friendly angels that you will be faithful to the Order of the Rose+Croix, and proclaim you, by my voice, Admirable and Immortal Master."[1]

Anatole Marquest de Vasselot (1840-1904)

Possibly the most interesting figure of the 1893 exhibition centered around sculpture. In addition to Bourdelle's large participation, Anatole Marquest de Vasselot, one of the central figures in the dispute between Rodin and the <u>Société des Gens de Lettres</u> over the Balzac memorial, began his association with the <u>Rose+Croix</u>.[2]

Peladan's admiration for Marquest de Vasselot had already been expressed in his review of the official Salon of 1890; extensive remarks on the sculptor's work--the most familiar being the marble Balzac of the <u>Théâtre Français</u> (executed in 1863 and shown with the <u>Rose+Croix</u> in 1893), and the Balzac Monument in the Avenue de Fried-

[1] Peladan, "Salon du Champ de Mars ... 1893," <u>loc. cit.</u>, p. 4.

[2] See Jacques de Caso, "Rodin and the Cult of Balzac," <u>The Burlington Magazine</u>, June, 1964, pp. 279-284.

land--appear again in Peladan's criticism of the official <u>Salon</u> published in the <u>Bulletin Mensuel de la Rose+Croix</u>, May, 1895.

In 1893, Marquest de Vasselot sent twelve works, five of them connected with Balzac. Among these figures "La Comédie humaine," a shallow relief depicting 103 characters from Balzac's novel. In 1895 Marquest de Vasselot's four entries again emphasized the Balzac theme and a "Comédie Humaine" was shown, possibly the piece exhibited two years earlier or a pendant work.

By 1895 the scandal of the Balzac commission reached its height. The <u>Société des Gens de Lettres</u>, which Larmandie served in the capacity of Secretary General under the Presidency of no less a man than Zola, had in 1878, commissioned a Balzac monument from Chapu. Chapu died before the statue was finished, and in 1891 the commission was given to Rodin. His famous figure of Balzac striding, half-heartedly called by Larmandie "a powerful plastic suggestion," was refused by the Society. Larmandie claimed the work could not be appreciated by the general public--a feeble remonstration from an occult idealist.[1]

Falguière was then asked to attempt a Balzac monument, but he too died prior to completing the work, whose finishing touches were added by his students. The Society accepted Falguière's "icône."[2] With all this in mind, Larmandie wrote of Marquest de Vasselot's Balzac work that

> . . . the low reliefs . . . representing the characters of The Human Comedy with their postures, their costumes, their psychol-

[1] Larmandie, <u>L'Entr'acte idéal</u>, p. 139. [2] <u>Ibid</u>.

ogy could not find, until this moment, a place of public exhibition. Marquest de Vasselot is the artist who has most studied Balzac and his bas-reliefs which make the three hundred characters by this great cerebral act and swarm with intense life in a picturesque mêlée so to speak. They constitute a unique work, thrilling, original, synthetic, that I would like to bring to the attention of the Minister of Fine-Arts.[1]

Peladan added vituperative abuse to the situation:

Recently there has been a bit of noise over the statue of Balzac ordered from M. Rodin, the sculptor of primates, the plastician of Borneo! M. Marquest de Vasselot has undertaken several projects for a statue of Balzac. . . . That one preferred M. Rodin, is not only unjust, it is absurd: Witness . . . the highly interesting model of a low relief in which one sees all the protagonists of the Human Comedy from Vautrin to Marsay, from Mme de la Chanterie to Mme Marneffe.[2]

Antoine Bourdelle (1861-1929)

More important by far than Marquest de Vasselot's association with the Salons de la Rose+Croix--he appeared for a third and last time in 1897--was the participation of Antoine Bourdelle in the first two rosicrucian exhibitions. The prestige lent by Bourdelle's presence had not been fully realized, as Bourdelle's entries were not completely known. They were listed on a separate broadside, an addendum to the second catalog which had been lost prior to the present research.

At the time of the first Salon, Bourdelle was throwing off the influences of the tight training he received at the Ecole des Beaux-Arts in Toulouse, in the process of moving from a restrained carving to a looser modelling in which the influence of Rodin was just beginning to be discernible. In 1892 Bourdelle, who still was known by his

[1]The number of figures indicated in Larmandie suggests that there were a pair of pendant bas-reliefs. The catalog listing of 1893 states that the relief contains 103 characters. Ibid., p. 140.

[2]Peladan, Bulletin Mensuel ..., No. 2 (May, 1895), pp. 40-41.

first name Emile, sent fourteen drawings and a statue of a "Holy Woman at the Foot of a Cross." The catalog published an additional drawing, unlisted, called "L'Amour agonise" (Fig. 42). This drawing represents a shrouded figure stretched out in death, like a mortuary effigy. This theme also occurs in an early drawing, called "The Agony of Love," which represents an ephebic angel, laid out horizontally across a field. The angel is a winged nude, his mouth slightly open, and the sun is setting Fig. 43). In this drawing the theme appears pagan or mythically classical although it is certain that Bourdelle equally regarded the theme of the Agony of Love in Christian terms. Two small sketches pasted in Bourdelle's scrapbooks, inscribed "Paris début 1886" depict two vertical figures representing Christ crucified.

The catalog supplement of 1893 lists thirty-one items (see Appendix IV). Of these, fourteen are definitely labelled as drawings. Four works by Bourdelle were reproduced in the illustrated catalog of 1893, but three of these do not appear on the supplementary list, thereby raising his total selection to thirty-four works, one of the largest single entries ever to be shown at the Salons de la Rose+Croix. Many of the drawings come from a projected edition of Pouvillon's Césette, a realist novel concerning a love triangle among farm laborers, published by Lemerre in 1881. The "Fourteen Drawings" of the 1892 catalog and 1893 supplementary list were probably comprised of Bourdelle's illustrations to this novel.

The set of illustrations resulted from a long friendship and debt that Bourdelle felt toward the novelist. Pouvillon, amazed at

the precocious carvings of the thirteen-year-old Emile (who, having left school out of boredom, had begun to assist his father, a cabinet maker in Montauban), and a banker named Lacaze subsidized the boy. Through their efforts the young Bourdelle entered the Ecole des Beaux-Arts de Toulouse at the age of fifteen.[1]

When Bourdelle received his copy of Césette, inscribed with the sincere affection of the author, he was fired by the book and even made a drawing on the novel's title page (Fig. 44). Several drawings, kept in the reserves of the Bourdelle Museum, correspond to the 1893 supplement. Among these are an "Enterrement en forêt." Another drawing of a farmer spading a desolate field thinking, "Ah, to belong to one and to love another, what misery," may be reasonably attached to the drawing called "Amertume" or "Douleureuses Pensées." These drawings exist in variant forms, either in a crisp, tight manner or as freely brushed sketches.

Still another work for the Césette project might be the "Prière des Blès," which represents a field-hand scything wheat. At least four variant drawings exist of this theme. They carry slightly differing inscriptions which roughly suggest the same idea: "I kiss the blond chaff of my grain." The drawing called "l'Innocent," which depicts a child leading ducks to a pond, and "Le Rêve du Pastoure" (Fig. 45) in which a shepherd sleeps in a nocturnal landscape, his flock close by, are equally from the Césette project. The supplement listing "Le Rêve" may be the drawing of a crouched figure seated in a

[1] See note by Michel Dufet, Curator of the Bourdelle Museum, and son-in-law of the sculptor in André Suarès--Antoine Bourdelle, Correspondance (Paris: Plon, 1961), p. 168.

barren landscape for which there are two characteristic studies, one tightly drawn, the other rapidly. Considering the Rose+Croix provisions, it is more than likely that the tight drawings were sent to the exhibition, the rapidly handled works being sketches for them. It may well be that Bourdelle, disappointed at the shelving of the Césette project, was determined to reap some benefit for his hard labors instead of completely burying them in his portfolios.

The "Michel-Ange Buonarotti" is a pastel in which Bourdelle doubtless cast the features of one of his friends, Chauliac, onto those of the Renaissance sculptor (Fig. 46). Bourdelle described this picture in an undated letter:

> And here a man's head comes to life! with intense thought within the tormented brow! head inclined forward over the right shoulder. Only the forehead is brightly lit. The eyes are closed the better to retain the thought! This is no flat portrait. . . . There's soul this time. Its the head of Michelangelo! As he could have been during the effort of sublime labor. A plastercast of his Slave is there. I'll place it to the left in shadow, the tragic marble head tipped backwards. That's a picture in which thought will find delight.[1]

Of Bourdelle's sculptural entries in the 1893 exhibition, three works may be pointed to with some degree of certainty. "Femme Riant aux caresses de la mer" may be the high relief head of a woman known in stained and unstained plaster versions as well as in glazed terra-cotta. The work is inscribed "La Mer roule les gemmes et les perles." The head is completely modelled but the ground is roughly treated as if a fragment of a still larger work (Fig. 47). In a related style "Le Rire" may be "La Rieuse," catalogued in the Bourdelle

[1]From an unpublished letter, Bourdelle to "Marie" ca. 1892, courtesy M. Michel Dufet.

Museum as "early work, probably around 1889." As the preceding head, "La Rieuse" is also a high relief with versions both in plaster and terra-cotta (see Fig. 48). The head is boldly modelled with full tresses, thickly worked into agitated undulations. In this instance, the hair serves to frame the head eccentrically, similar in its effect to the fragmented ground of "Femme Riant aux caresses de la mer."

One last work, a small bronze, may have been the "Bacchus endormi" of the supplementary list. This extremely free study of a reclining male nude is so passionately modelled that comparison with Rodin or even Matisse would seem inevitable (Fig. 49).

Despite Bourdelle's substantial showing at the Rose+Croix exhibition of 1893--practically a one-man show within the confines of the larger manifestation--criticism did not focus on him. This is hardly surprising in view of the large number of rather staid drawings for Césette. Moreover, our amazement at the silence surrounding Bourdelle's entry is based on a growing appreciation of his work today. It is not until the "Herakles" of the Salon of 1909 that Bourdelle became a well-known figure. At the time of the Salons de la Rose+Croix Bourdelle was scarcely thirty, and if he was known at all, it was only as a sculptor on the periphery of Rodin--like Niederhäusern-Rodo in the 1892 exhibition and as James Vibert was to be in the 1895 exhibition. Even granting the expressionist tendency of the "Sleeping Bacchus," the general impression of Bourdelle's work must have been somewhat plodding. Bourdelle would have to wait for the crystallization of his archaic Greek style, well on into the twentieth century, before the full measure of his worth would become self-evident.

However, Peladan, in his review of the official Salon of 1893, said that only seven sculptors of interest were present there, four of whom had shown with the Rose+Croix: Dampt, Walgren, Alexandre Charpentier and Bourdelle. He regarded these sculptors as the equals of Bartolommé, Carriès, then widely known academic sculptors, and, most important, Constantin Meunier. The last had been invited to exhibit with the Rose+Croix despite Peladan's innate revulsion to Realism.[1]

The Decorative Arts

As in 1892, when Georges-Arthur Jacquin (1851- ?) was represented by, among other works, several colored ceramics, and Rupert Carabin (1862-1932) was admired for his fantastic furniture which combined structural elements with human forms (Fig. 50), in 1893, several decorative artists of distinction began their association with the Salons de la Rose+Croix. Foremost of these were Edmé Couty (? -1917), Georges de Feure (1868-1928) and Andhré de Gachons (1871- ?).

Couty, a decorator and graphic designer in the manner of Grasset, was to exhibit annually with the Rose+Croix during its remaining years. He was generally represented by works labelled "Panneau Décoratif." In all likelihood "La Photographic, composition pour une revue de Paris" refers to his poster "Exposition d'Art photographique" (Fig. 51).

Although a less ardent contributor to the Rose+Croix than

[1]Peladan, La Rose+Croix. Organe trimestriel l'Ordre, pp. 17-19.

Couty--he was only to appear in 1893 and 1894--Georges de Feurs is one of the central figures in the decorative arts ranging from <u>Art Nouveau</u> to "art déco," in this respect recalling Rene Lalique. From the 1890's to the 1920's, Georges de Feure was responsible for certain of the period's characteristic solutions from the posters for the <u>Salon des Cent</u> to the showrooms of Madeleine Vionnet, the great dress <u>couturière</u> of the 1920's.

Like Georges de Feure, Andhré des Gachons would also be part of the group sponsored by <u>La Plume</u>. A regular illustrator for this Symbolist mouthpiece, he also figured among the participants of the <u>Salon des Cent</u> organized by the review, Gachons was present at the magazine's testimonial dinners and found his career forwarded by an occasional article on its pages. Lastly, he enjoyed the distinction of having a whole issue devoted to his work,(No. 159).

Compared to the neglected de Feure, Gachons is a rank mediocrity whose Gothic mannerism did little to disguise feeble drawing (Fig. 52). He affected the title "L'Imagier" and pretentiously added an "h" to the spelling of his first name. He nevertheless carried off this gothicism with an amusing flair. The sign at his studio in the <u>rue de Rennes</u> read: "You have the right to smoke a pipe and to profanely or mystically sing. Those are your rights. But by the Magi's beard, you will be banished if you make noise during the office, if you spit on the mosaics, tap your feet, speak badly of the poor. . . . If you are drunk kindly leave this castle! . . . signed: The Quasi-Magus, ANDHREUS."[1]

[1]Leon Maillard, <u>Notes pour demain I. l'Imagier Andhré des Gachons</u> (Paris: La Plume, 1892), p. 10.

J. L. Croze reports that among the decorations of his studio there was a portrait "of the young practical-joker . . . Sâr Peladan on a gold ground."[1] Like Peladan, Gachons affected an Assyrian beard which resulted in his sobriquet, "Peladan II."[2]

Brother of the novelist, Jacques des Gachons, Andhré collaborated in 1895 in the production of the play "Le Prince naïf" for which he produced thirty-two sets and costumes. "One particularly applauded," wrote Rachilde in the Mercure de France, "the princess with the light eyes, and those of the seven deadly sins (anger was very originally conceived as a livid woman hanging by her feet in a pool of blood)."[3]

The art of Gachons was seen at the Rose+Croix in heavy doses from 1893 to 1897. The Medieval cast is patent in the 1893 offering of "La Guillaneu (croquis pour l'illustration d'une vielle chanson poitevine)" or "Ma Mie Jehanne (pour illustrer une prose de Jacques des Gachons)."

Marcellin Desboutin (1823-1902)

The second exhibition was dominated by a familiar work, Marcellin Desboutin's "Portrait du Sâr Peladan, grand-maître de l'Ordre laïgue de la Rose+Croix du Temple et du Graal," the painting which Peladan had praised so effusively in his Salon review of 1891. At the first exhibition, Desboutin had shown two innocuous pieces of a

[1] Ibid.; J.-L. Croze, "Chez l'Imagier," reproduced ibid., p. 10.

[2] Ibid., p. 13.

[3] Rachilde, "Le Prince naïf," Mercure de France, pp. 234-35; p. 235.

Florentine boy and girl. The Sâr's portrait at the second exhibition
concluded Desboutin's association. According to Jean Regnier (Le
Gaulois, March 29, 1893), Desboutin also showed a drypoint portrait
of Verlaine, a work not listed in the catalog.

Effects of the Second Salon de la Rose+Croix

The second Salon was greeted with a growing sense of disap-
pointment and futility. From our standpoint its saving feature must
have been Bourdelle's section despite its many mediocre drawings.
Larmandie's assurances that "The second Gesture closed as triumphantly
as the first, with a notable increase of bravos and hissing, of love
and hate, of applause and contradictions"[1] notwithstanding, the general
impression gathered from the reviews is one of growing lassitude. From
this moment on, one can easily predict who the recipients of praise
will be. Certainly Séon, Osbert and Point. If the critic is a trifle
more discerning, the Belgian Idealists will be cited. After the sec-
ond Salon, nothing seriously distinguished one exhibition from another,
until, of course, the last in 1897, when an important section was
filled by the students of Gustave Moreau, notably Georges Ronault.

The lean years of the Salons de la Rose+Croix had begun. At
the conclusion of the second exhibition, Peladan was saddled with a
considerable deficit. The third exhibition needed to be housed.
Durand-Ruel was too expensive and the central dome of the Palais du
Champ de Mars too troublesome, nor had it been offered to the Rose+
Croix again.[2] A commercial gallery which rented exhibition space

[1]Larmandie, L'Entr'acte idéal, p. 70. [2]Ibid., p. 78.

the "Galerie des artistes contemporains" in the rue de la Paix, along-side the great fashion house of Worth, became the site of the next two exhibitions. Peladan borrowed money to cover rental costs for the 1894 Salon. The irony of the situation was that, although the Rose+ Croix had fallen on lean times, Peladan and his Salons, to the layman, had become synonymous with Symbolism.

Continued Publicity: Gustave Geffroy and Max Nordau

Throughout the remainder of 1893 and into 1894 Peladan con-tinued to publish heavily. The occult tracts and novels were pub-lished unabated. His efforts became the subject of numerous arti-cles by some of the period's outstanding figures. Gustave Geffroy brought out the second volume of La Vie Artistique and, speculating on the possible benefits to be derived from Peladan's undertakings, found them deficient. Of the artists, he added, that "with the greatest good will it is impossible to attest to anything but compe-tency, finesse in the largest number. The Primitives, the Byzantines, the miniaturists and the sculptors of the middle ages, the English Pre-Raphaelites are the models imitated. Add the influence of Rops among the moderns to the influences stemming from the past. A few, here and there, attain erotic mysticism."[1]

Max Nordau's much maligned study, Degeneration, was also pub-lished in 1893. Nordau, who considered mysticism "a cardinal mark of degeneration,"[2] did not realize that his attack on the Symbolist Move-

[1] Gustave Geffroy, La Vie Artistique, II (Paris: Dentu, 1893), 377.

[2] Max Nordau, Degeneration, trans. anon. from 2d German ed. (New York: Appleton, 1895), p. 22.

ment was to become one of the fullest contemporary descriptions we have of the phenomenon. For this reason the book remains important despite its petty bourgeois sectarianism--Verlaine is discredited for his homosexuality, Wagner for his anti-semitism, etc. Peladan fared better than many. Nordeau considered him a "higher degenerate" and treated him as a kind of schizophrenic:

> . . . prey to a strange conflict. His [Peladan's] unconscious nature is quite transfused with the rôle of a Sar, a magus, a Knight of the Holy Grail, Grand-Master of the Order . . . which he has invented. The conscious factor in him knows it is all nonsense, but he finds artistic pleasure in it and permits the unconscious life to do as it pleases. . . .
> Peladan's judgment has no power over his unconscious impulses. It is not in his power to renounce the part of Sar. . . . He cannot abstain from perpetually returning to his "Androgynous" absurdity. All these aberations, as well as the invention of neologisms and the predilection for symbols, for prolix titles, and the casket-series of prefaces, so characteristic of the "higher degenerates," proceed from the depths of his organic temperament, and evade the influence of his higher centres. On its conscious side Péladan's cerebral activity is rich and beautiful. In his novels there are pages which rank among the most splendid productions of a contemporary pen. His moral ideal is high and noble. He pursues with ardent hatred all that is base and vulgar . . . his characters are thoroughly aristocratic souls, whose thoughts are concerned with only the worthiest, if somewhat exclusively artistic interests of humanity.[1]

Nordau's daughters recall that Peladan met the Zionist through Léonce de Larmandie during the Salon de la Rose+Croix of 1895.[2] Not only did Peladan eventually become a friend of Nordau's, he may even have been a patient. Nordau was, at that time, what we would term today a lay analyst, in addition to being a physician.

Peladan's acquaintance with Nordau lasted until World War I

[1] Ibid., pp. 223-224.

[2] Anna and Maxa Nordau, Max Nordau, a Biography (New York: Nordau Committee, 1943), p. 88.

when anti-German racism got the better of him. "Although his princi-
ples were practically in all matters different from ours," wrote Lar-
mandie, "we have always considered Nordau as an honorary Rosicrucian."[1]

In addition to the considerations of Nordau and Geffroy, an
endless flow of satire from La Plume continued unabated. In April,
Laurent Tailhade's "Ballade sur les avantages kabbalistiques de M.
Joséphin Peladan" appeared (April 15, 1894). In the same month, An-
toine de La Rochefoucauld and Jules Bois published the first issue of
Le Coeur, a new, elegant organ of esoterism.

How to Become an Artist, and Idealistic and Mystical Art

Peladan in turn brought out two works of importance at the
outset of 1894.[2] Comment on Devient Artiste (Esthétique), part of
the "Amphithéâtre des sciences mortes," was warmly dedicated to the
then recently deceased Armand Hayem, although Peladan, even in these
circumstances, was unable to refrain from referring to the incident
of the Barbey portrait, belonging to Armand's brother, that he had
hoped to display between the portraits of Dante and Wagner at the
entrance to the second Salon de la Rose+Croix.

In a brilliantly written satire, "Ad Rosam per crucam," which

[1] Larmandie, L'Entr'acte idéal, p. 109.

[2] Peladan also published the hermetic Les XI Chapitres mysté-
rieux du Sepher Bereschit du Kaldéen Mosché revé par le Sar Peladan
pour ceux de la Rose+Croix du Temple et du Graal, l'an 1894 de J.-C.
VIIe de la rénovation de l'ordre (Bruges: Daveluy Frères, 1894).
The cover also carries "Chez Bailly, rue de la Chausée-Dantin." This
is the only Rosicrucian document bearing the name of Bailly, the
well-known esoteric book publisher and dealer, who published, among
other things, L'Art indépendant, les publications théosophiques, la
Bibliothèque de la haute science, etc.

opens the book, Peladan fulminated against Belgian customs officials.
He had been detained in Belgium in November, 1893, where he had gone
to lecture, because still unopened French tobacco was discovered
among his linen. The result of the detention was that all hopes for
an abbey, supposedly to be provided for the Rosicrucian order by a
rich American sympathizer, went by the board. Mont Salvat lost be-
cause the Sâr's fur hat, suède boots, and great cloak had antagonized
the customs officials. Unable to placate them, Peladan had been in-
carcerated overnight and thereby missed his benefactor.

In addition, a black-bordered "Commemoration de Firmin Bois-
sin [Simon Brugal]"--Peladan's former tutor who in 1858 had initiated
Adrien fils into the Rosicrucian mysteries--preceded the body of the
text of Comment on devient artiste. This arcane work, a "Method of
sensibility and idealization after the ascesis of antique initiation,"[1]
emphasized once more the priestly nature of the artist's role, the
sanctity of his creation. The three sections of the book are sub-
divided into prolix litanies, obscure references and lapidary maxims.
Peladan thoughtfully added a page of publicity at the end of the book
which states that if the present work was not entirely clear, the
reader would have recourse to his L'Art idéaliste et mystique, then
still in press.

Expressing once more the sacerdotal nature of artistic crea-
tion, the latter work reiterates Peladan's familiar passions: Puvis
de Chavannes, the italianate tradition, the supremacy of drawing,

[1] Joséphin Peladan, Comment on devient artiste (esthétique),
Amphithéâtre des sciences mortes (Paris: Chamuel, 1894), p. 385.

the idealistic hierarchy, the Impressionist myopia, the rules and
regulations of the Rosicrucian salons, the trinity of Balzac, Barbey
and Wagner, the androgynous preoccupations, in short the esthetic
standards Peladan had established in his art criticism of the 1880's
and brought into sharper focus during the period of the first two
"Esthetic Gestures." All of these elements are touched upon in this
general essay, perhaps the single most readable and comprehensive
Rosicrucian work on the arts.

The Third Salon de la Rose+Croix: 1894

Owing to the confraternity's straightened circumstances, the
catalog for the third exhibition was merely a booklet containing, in
addition to the exhibitors' list, the "Commemoration de Firmin Bois-
sin," as well as that of Pierre Rambaud, a sculptor who died in 1893.
The booklet begins with a "Leitmotif de la Joconde" and a "Leitmotif
du Précurseur," two lengthy incantations in praise of Da Vinci's
paintings (recalling Pater's famous pages on the Mona Lisa from The
Renaissance, of 1873). These paeans were followed by the exhibition
restrictions which we know from earlier catalogs.

A certain Gabriel Albinet supposedly designed a poster for
this exhibition although no trace of this poster has been found.
Albinet's catalog listing reads "Composition for the poster of the
Third Salon de la Rose+Croix: Joseph of Arithmathea, first Grand-
Master, in the features of Leonardo da Vinci, and Hugh of the Pagans,
first Master of the Temple, in the mask of Dante, form the escort to
the Roman Angel holding the chalice of the crucified rose."[1]

[1]No. 1 in the catalog.

Although extremely diminished in number (only some seventy
odd works were shown), "the holy canons of art were more or less re-
spected, tachism and pointilism were almost entirely excluded."[1]
Still, owing to the fame of the Rose+Croix, more than ten thousand
visitors, by Larmandie's account, flocked to the exhibition gallery
and traffic again was interrupted. The crowds were relegated to the
vestibule of the small gallery to await their turn.[2]

Peladan had hoped to be able to mount his reconstitution of
the Eschylus trilogy, The Promethiad (first refused by Jules Claré-
tie, then head of the selections committee for the Comédie Française,
even though it had been praised by Emil Bournouf, then head of the
French School in Athens), but it was never played. Babylon was re-
vived, however, at the Théâtre de l'Ambigu.[3]

To judge from the catalog listing, the third exhibition dis-
played nothing of particular interest with the exception of Jean
Delville's "Head of Orpheus" (Fig. 53). In honoring Gustave Moreau--
the work alludes to Moreau's celebrated canvas, Jeune fille thrace
portant la tête d'Orphée, 1865--Delville is also following the Sâr's
androgynous dicta, since Orpheus is given the features of Mme Del-
ville. Henri Nocq, in the Journal des Artistes, found it "very Orphic."

Works related to Berlioz by Pierre Rambaud (1852-1893), eulo-
gized in both Idealist and Mystical Art and in the 1894 catalog were
posthumously shown. A "Berlioz mourant" reproduced in the Revue

[1] Larmandie, L'Entr'acte idéal, p. 79.

[2] Ibid. [3] Ibid., p. 83.

Encyclopedique (Fig. 54), might possibly have been shown with the Rose+Croix.

Louis-Welden Hawkins (? -1910), a painter of British ancestry, made the first of two appearances (1894, 1895) at the third Salon. He painted country girls in full, pretty forms. Edward Lockspeiser has resuscitated Hawkins in connection with the young Debussy.[1]

The Rose+Croix at the Salon: The Disavowal of Puvis de Chavannes

At the same time that the Rose+Croix was installed in the rue de la Paix, the official Salon was set up in the Champ de Mars. Peladan, sensing an advantage in the situation, reviewed the official Salon for La Presse. His articles ran for four days, from April 24 through April 27. The last two days he focussed on "La Rose+Croix au Salon." This review is startling because it marks Peladan's denial of Puvis de Chavannes:

> If I employ the epithet of enemy in speaking of the committee of the Champ de Mars, I will prove it by citing that Marcius-Simmons, Hodler, Séon, des Gachons, Couty, Osbert, de Feure, are placed in the worst spot, in shadow, while opposite them is displayed the senility of Puvis de Chavannes. . . .[2]

Understandably, Peladan never forgave Puvis de Chavannes for his public denial of association with the Rose+Croix when his name

[1] Edward Lockspeiser, Debussy: His Life and Work, Vol. I: 1862-1902 (London: Cassell, 1962), p. 140.

[2] Joséphin Peladan, "La Rose+Croix au Salon, III," La Presse, April 25, 1894. Pinky Marcius-Simmons is the only American to have exhibited with the Salons de la Rose+Croix. Like Egusquiza, his work is Wagnerian in inspiration. Born in New York City, he died in Bayreuth where he had been employed as a set designer.

appeared among the adherents to the _Figaro_ manifesto. Pointing to
the master's painting, Peladan heaped abuse on Puvis's head. "Look
at _Fantasy_; some seated female glancing into a mirror. Opulent Sym-
bolism. Look at _Intrepidity_ which consists in pulling someone out
of the water without getting wet yourself."[1] But the source of dis-
content cannot be veiled. Peladan goes on:

> Certainly, for ten years . . . I sang his praises. My es-
> thetic has not changed and it is that which will survive. In
> losing his genre he pushes the Rosicrucians to the dark corners
> that he should have aided and behaves shabbily. Immortal owing
> to his past works; today derisory, I vote for his bust because
> his real career seems over to me.[2]

The review closes with an invitation to the artists of the
official Salon whose work rose out of the mediocre to join the ranks
of the _Rose+Croix_. Whistler, Ary Renan, son of the historian, and
Le Sidaner, an accomplished painter of erstwhile pointillist sensi-
bility were asked to no avail.

Results of the Third Salon de la Rose+Croix

In May, a review of _Salons_ ranging from Brussels to Paris ap-
peared in the _Mercure de France_.[3] Jean Delville had organized the
first of his own Rosicrucian Idealist exhibitions in Belgium based on
Peladan's precepts. _Comment on devient artiste_ and _l'Art idéaliste
et mystique_ had appeared, and a concentrated third _Salon de la Rose+
Croix_ had taken place. On the basis of this evidence, Julien Leclerq,

[1] _Ibid._, passage entitled "De L'Allégorie et de M. Puvis de
Chavannes. De l'art religieux et de M. James Tissot," April 27, 1894.

[2] _Ibid._

[3] Julien Leclerq, "Sur la peinture de Bruxelles à Paris,"
Mercure de France, March, 1894, pp. 71-77.

a friend of Gauguin, concluded that the Ideal, that Tradition and Beauty were all very well and good, but within Peladan's sphere merely constricting. "The Rose+Croix . . . have hardly done more than was done at the time of Republican allegories to the mythologies of David, of Girodet-Trioson and of Baron Gérard. This too was in art, an epoch of the Ideal(?), of Tradition(?) and of Beauty(?). What a mediocre souvenir it left. . . . When art is awaiting its fully liberated renaissance, Mr. Peladan wants to jail the artists."[1] Leclerq saw that art for Peladan was "an auxiliary of his neo-Catholicism and a means of propaganda." Unfortunately, he continued, despite Peladan's "eloquence, his activity, the agreeableness of his sympathetic person," the results of the Sâr's campaign can only be measured in superficial manifestations of style, in mannerism, in dress, in "woman's hairdressing. Society women, dancers, models, to our damnation, have adopted the flat fillets of martyrs and very Christian princesses."[2]

Despite the Sar's wizard-trappings, the novelty of his exhibitions was growing thin. The publicized break with Antoine de La Rochefoucauld was last season's gossip. True, Peladan had been able to continue without the Archonte's financial support. The third Rosicrucian exhibition had been dull, but it was also admitted that it had been "a severe and methodical selection,"[3] and of a piece. Even La Plume was won over. Albert Fleury felt honor-bound to admit that, magical decoration aside, a creditable body of literature and

[1]Ibid. [2]Ibid., pp. 76-77.

[3]Guimandeau, La Justice, April 9, 1894.

criticism had been written and a regular salon of value had been established, all things considered, no mean feat. In the end, "the contemporaries of the sâr will be severely judged for their indifference."[1]

Jules Huret included Peladan's response to Enquête sur l'évolution littéraire (Paris: Charpentier, 1894) in a chapter on "The Magi" by whom he meant Peladan, Paul Adam, Jules Bois and Papus:

> What is "Magism?"--you ask, sir. It is supreme culture, the synthesis which takes all analysis into account, the highest result combined of hypothesis united with experimentation, the Patrician class of Intelligence and the crowning of science and art mixed together.[2]

The 1894 Salon de la Rose+Croix provides still another example of the paradox that, within the arts, the moment of acceptance often marks the moment of decline. "Rose+Croix" had become a common term of reference. Henri Evenepoel, a Belgian studying in Paris with Gustave Moreau, wrote home to his father that the master, when criticizing one of his paintings, found it "a little Rose+Croix, decadent, symbolic (not too). . . ."[3]

At this time also, when he first opened his gallery, Vollard, still far from his fame as a twentieth century art dealer, solicited

[1] Albert Fleury, "Le Sâr Peladan," La Plume, November 1, 1894, pp. 445-447, with full page photograph of Peladan.

[2] P. 39. Huret's book is a republication of a questionnaire replied to by 64 prominent literary figures and published in the Echo de Paris, March 3-July 15, 1891.

[3] Henri Evenepoel, "Gustave Moreau et ses élèves, lettres d'Henri Evenepoel à son père," intro. Edouard Michel, Mercure de France; this article was bound separately as a brochure at the Cabinet des Estampes, Bibliothèque Nationale, Paris and bore the inscription Mercure de France, 1/XV-1-MCMXIII. However, no such article was published in the Mercure de France during 1913.

as an "obscure admirer" an interview with the Sâr.[1] Perhaps it was in reference to this meeting that Larmandie recalled during the 1895 Salon de la Rose+Croix that it was distinguished by "a quite especially interesting type of visitor . . . the painting dealers."[2] More likely he was referring to Georges Petit, who shortly came to be the dealer of such Rose+Croix regulars as Osbert, Séon and Dampt, the so-called "Artists of the Soul," and in whose gallery the last Rosicrucian exhibition took place.

The Fourth Salon de la Rose+Croix: 1895

The marginal finances of the Brotherhood resulted in the rehiring of the "Galerie des artistes contemporains," from March 20 to April 20, 1895. No poster was issued nor was any catalog published. The list of exhibitors was included in the Bulletin Mensuel de la Rose+Croix du Temple et du Graal for April, 1895. The list was preceded by a "Mandement" in which the Sâr lamented the fact that the Rose+Croix, "destined to confederate all the elite . . . to conquer fame and our spirits . . ."[3] had fallen short of this ideal. To rectify the situation, Peladan called upon Rosicrucian thought to broaden its scope, to encompass Humanism, "since Humanism is the synonym

[1] Ambroise Vollard, Recollections of a Picture Dealer, trans. Violet M. MacDonald (Boston: Little, Brown, 1936), pp. 230-233. Although a translation, this is nonetheless the first publication of this work.

[2] Larmandie, L'Entr'acte idéal, p. 97.

[3] Joséphin Peladan, Bulletin Mensuel de la Rose+Croix du Temple et du Graal contenant le catalog du IV salon. ouvert du 20 mars au 20 avril. de 10. h. à 6. H.. 5 rue de la Paix, IIIe année, série exotérique, No. 1 (April, 1895), p. 12.

of Synthesis."[1] The responsibilities of the Militia of the Past were again enumerated for the Rosicrucians, now referred to as "Nabis."

The ranks of exhibitors were still thin, a hundred-odd works distributed among thirty-six participants. The exhibition had fallen to its nadir. Chabas, Cornillier, Couty, Osbert, Point and Séon naturally were present, the last again showing his "Désespoir de la chimère." The inevitable portrait of the Sâr was by Delville who depicted "Le Grand-Maître de la Rose+Croix en habit de choeur." Marquest de Vasselot showed "The Human Comedy" and a bust of Balzac. Edgard Maxence (1871-1954), one of Moreau's better-known students, joined the ranks this year and remained on until the end.

Jean Vibert (1872-1942)

The single new figure of interest in the Salon of 1895 (show-ing only this once) was James Vibert, a French-born, Swiss-trained sculptor. He showed "Vita in Morte, Fragment d'un rétable symbolique représentant le cycle de l'existence mortelle." Although fallen into oblivion, Vibert was an artist of merit in the train of Rodin. In 1893 "Vita in Morte" had already been shown at the official Salon in the Champ de Mars. Part of a huge altar group dedicated to Nature, the whole project was conceived as an immense architectural edifice, recalling Bartholomé's "Monument to the Dead" in the Père Lachaise Cemetery. The work aimed at a dialectical synthesis of seventeen[2]

[1]Ibid., p. 14.

[2]André Ibels, Critiques Sentimentales. James Vibert (Paris: Bibliothèque d'Art et de la critique, 1898), p. 5.

life-scale groups including, among others, "Spiritual Love," "Physical Love," "Genesis of the Idea," "Revolt against the Infinite," "Moral Suffering," "The Struggle with Matter," "Pride," "The Downfall," "The Dying Race," "The Degenerates," "The Future Race," "Piety," "Atheism," etc. According to Jean de Fontanes, only "Vita in morte" was ever completed.[1] André Ibels contends, nonetheless, that it was superior to Rodin's "Gates of Hell."[2]

Fontanes recalls that Vibert's piece, depicting a figure attempting to tear himself from brute matter in which he is buried to the waist (Fig. 55), was threatened with crumbling because of the bitter cold in the artist's studio. Staying with the clay during New Year's Eve, 1892, Vibert was able to reanimate each fragment as it fell away from the core.[3] Vibert shared a studio with his brother, the respectable graphics artist Pierre-Eugène Vibert, well-known for his handsome wood cuts of leading contemporary figures.

Owing to the success of "Vita in morte" at the official Salon, with amateurs of Symbolist persuasion at least, Vibert came to be a friend of Paul Verlaine and Léon Deschamps, editor of La Plume. On the cover of the May 1, 1896 issue of La Plume there appeared a drawing by Vibert--"Les Visions"--showing the head of an emaciated poet. This work was included in Vibert's entries for 1895.

In 1894 (although Ibels says in 1891), Vibert entered Rodin's studio and remained for fourteen months. "The atmosphere," according

[1] Jean de Fontanes, La Vie et l'oeuvre de James Vibert (Genève: Perret-Gentil, 1942), p. 29.

[2] Ibels, op. cit., p. 15. [3] Fontanes, op. cit., p. 29.

to Ibels, "quickly grew stifling."[1] While there, Vibert came to
know Neiderhäusern-Rodo. Several anecdotes relating to Rodin date
from this period. Vibert, it seems, aided Rodin in the execution of
"Eternal Springtime," "Orpheus and Eurydice" and the "Balzac Monu-
ment."[2]

At the time of the showing of Rodin's Balzac--at the offi-
cial Salon of 1889--a group of young artists conspired to vandalize
it. Vibert's enthusiasm for the master had cooled, but his respect
for the work continued unabated. Accordingly he stationed himself
before the "Balzac," successfully defending it against the cabal.

In the Wake of the Salon de la Rose+Croix of 1895

If the Salon de la Rose+Croix of 1895 was drab, the year it-
self was nonetheless productive for Peladan. He added a Politics
to the "Amphithéâtre des sciences mortes," the fourth in the series
called Le Livre du Sceptre (Paris: Chamuel, 1895). He published a
novel, modelled heavily on his father's life, called Le Dernier
Bourbon (Paris: Chamuel, 1895), the twelfth in the Ethopée de la
décadence Latine, and a kind of sub-novel which bridged the Ethopée
and the Amphithéâtre called Mélusine, the first in the series of the

[1] Ibels, op. cit., p. 4.

[2] Rodin had only recently acquired the Hôtel Biron and it was
Vibert's task to transport the clay of "The Man Who Walks" from the
Meudon Studio to Paris. Assisted by the animal sculptor Pompon, the
work was carted but the transfer proved so treacherous that Vibert
had to cut the clay in two in order to protect it from entirely
smashing, and later reassembled the two halves. Rodin, on hearing
of the event, was at first furious, but on better understanding the
situation, relented and forgave his assistant. Ibid., pp. 39-42.

Septénaire des Fées.[1] This last work bore a cover by Séon representing a knight peering at a mermaid through bosky shrubbery.

Continuing his battle against scientific materialism, Peladan brought out La Science, La Religion, et La Conscience: Réponse à Messieurs Bethelot, Brunetière, Poincaré, Perrier, Brisson, de Rosny, etc. (Paris: Chamuel, 1895), a wildly censurious, inconclusive disavowal of celebrated intellectuals of the day.

Babylon, a four-act tragedy, was at last published (Paris: Chamuel, 1895) after it had already played two Rosicrucian seasons, and Le Théâtre complet de Wagner, les XI Opéras scène par scène (Paris: Chamuel, 1895) as well. Dedicated to Judith Gautier, daughter of the poet Théophile Gautier, the work digresses into lengthy descriptions of ideal and fatal women. As one might expect, it execrates the French public for their indifference to the first Paris performance of Tannhäuser and insists that Wagner, above all else, was a great dramatist. "I don't hesitate to say it: the poet crushes the musician, the drama surpasses and drowns the score: by moments, only passages, the harmony equals the writing" (p. 57). Written prior to the publication of Wagner's autobiography, Peladan recognized something that Wagner makes tediously clear; that he did, in fact, write the text before the music and that the poems were conceived of as separate and finished works prior to their scoring.

[1] Joséphin Peladan, Diathèse de Décadence, Psychiatrie, le Septénaire des Fées, I, Mélusine (Paris: Ollendorff, 1895).

The Denial of Gustave Moreau; Chenavard; the Three Salons

Add to these works, and their reviews by other writers, three important pieces of art criticism by Peladan, and it is easy to imagine how much Peladan's name remained before the public. In January, L'Ermitage published his "Gustave Moreau." The article opened with an outline of Peladan's unflagging devotion to the master, the unstinting praise, the "Saluts aux absent" that interspaced the criticism of the 1880's. Peladan purportedly quotes Moreau verbatim on his method: ". . . my dream is to create iconostases rather than paintings, properly speaking. Year after year I add augmentative details to my two hundred "posthumous" works as the idea strikes me because I want my art to suddenly appear, in its entirety, a moment after my death."[1]

But then the article swiftly turned against Moreau. How was it possible, Peladan wondered, that an artist should be both a recluse, should abstain from showing his work, while accepting a Professorship at the Ecole Nationale des Beaux-Arts? "Evidently there is something illogical in the conduct of an artist who refuses to exhibit his work while accepting to teach his art officially, who seems to disdain the suffrage of his equals in order to accept the banal distinction of the Institut."[2] Although Peladan had for so long championed Moreau, along with Puvis de Chavannes and Rops, Moreau was, "at the present hour, no one's friend," Rops "a criminal

[1] Joséphin Peladan, "Gustave Moreau," L'Ermitage, January, 1895, pp. 29-34; p. 30.

[2] Ibid.

genius" and Puvis "had become the <u>Luca fa presto</u> of Municipal Allegory."[1]

While, of the three, Moreau still remained the "most realizing of <u>Rose+Croix</u> theory," Peladan nevertheless felt bound to address Moreau in the following terms:

> Your interest lies in producing your effort publically, if not you will only be known after your imitators.
> Moreover, since you are a public painter, patented, decorated, official, national professor and an artist certified "good," a member of the house of Mazarin, . . . behave like a public painter, decorated, patented, official, national professor, guaranteed by the state, and show you work so that young artists won't go amiss in imitating you without knowing you; or else, if you are the character, a little unbalanced and Hoffmanesque that I saw, die quickly, die immediately, for the greater good of art, for your own glory.[2]

In May, <u>L'Artiste</u> published Peladan's "Paul Chenavard" with a portrait of the artist by Braquemond. In the course of this appraisal, Peladan referred to the <u>Rose+Croix</u> exhibitions, and in particular to Point, Chabas, Séon, Maurin, Cornillier, Couty, Rosenkrantz and Maxence, indicating that the group "presents all the elements of a French Pre-Raphaelitism; famous French patriotism has a great chance to demonstrate against the invasion of Burne-Jones' taste which is manifest not only in painting but in prints, furniture, fashion, and fabrics."[3]

In the same month Peladan's review of "The Three Salons" also appeared in <u>Le Bulletin Mensuel de la Rose+Croix de Temple et du Graal</u>. He meant by these, the two official <u>Salons</u>, one in the <u>Champ de Mars</u>,

[1]<u>Ibid</u>., p. 34. [2]<u>Ibid</u>.

[3]Joséphin Peladan, "Paul Chenavard," <u>L'Artiste</u>, May, 1895, pp. 356-362; p. 360.

the other in the Champs Elysées, and the Salon de la Rose+Croix. In
the first he found only vulgarity, "insolent and multiple or else
sick vulgarity. There are also some things from Médan [referring to
Zola's country home, symbol of the Naturalist movement in literature]
and some from Charenton [the famed mental institution]." Puvis de
Chavannes' figures were now "without suppleness, all trivially hold-
ing the same heavy lyre except one who got knotted up in her violet
gauze . . . one no longer finds the artist of Le Bois Sacré."[1]

At the Champ Elysées, Peladan concluded that "the Salon-
Bazaars, the eclectic Salons" were dead and that "in the near future
one will only see doctrinaire Salons like the Rose+Croix or other-
wise simply exhibitionistic Salons like the Indépendants."[2]

Apart from some interesting side-lights on Marquest de Vas-
selot and the Rodin "Balzac," which have already been mentioned,
Peladan's review of the Rose+Croix merely holds firm to the belief
that Rosicrucian truth is on the way to conquering the whole artis-
tic future in the name of Pre-Raphaelitism, Idealism, Symbolism" and
that its apostolate consists in loving an idea "even when it carries
a by-gone name."[3]

André Mellerio. Victor Charbonnel. Joris-Karl Huysmans

In February, 1895, the articles which make up Le Mouvement
idéaliste en peinture began in the Nouvelle Revue Européenne. In
this series, one of the earliest and most important descriptions of

[1]Peladan, Bulletin Mensuel, No. 2 (May, 1895), p. 41.
[2]Ibid., p. 48. [3]Ibid., pp. 42-43.

the Symbolist Movement, André Mellerio successfully attempted to clarify and subdivide the several stylistic tendencies of the 1890's.[1] His estimation of the Salons de la Rose+Croix, largely based on his recollections of the first exhibition, was extremely cool:

> Finally, a manifestation capable of bringing great harm to the new sensibility [i.e., the Idealist Revival], nevertheless affirmed in an indirect fashion its existence which responded greatly to an aspiration of the public--I speak of the Rose+ Croix.
> What was this exhibition at heart--in which there appeared no contemporary master, few or none of the artists with whom we will deal during the course of this study? With several honor- able exceptions . . . it was a very ordinary ensemble which ef- fected no innovation. However, a huge crowd passed through comprising in part that section of Paris which prides itself on its artistic curiosity. The disappointment was great. If, on one hand, one did not find at this exhibition the number of exaggerated and aborted attempts that one feared, on the other, one did not meet the precursors of a revelatory dawn that one had hoped for either. The experiment was nonetheless instruc- tive in the sense that it demonstrated that a numerous public was anticipatorily awaiting an attempt at a new art.
> The Rose+Croix continues but without reawakening the dis- abused curiosity.[2]

To Peladan's early view as to who most influenced the Ideal- ist Movement, namely Puvis de Chavannes and Gustave Moreau, Mallerio appended the names of Redon and Gauguin, artists who scarcely existed for Peladan. Mellerio's work remains fundamental for its early iden- tification of the circle of Paul Gauguin as a separate school, whom he called, as we still do, "Synthetists." In addition, Mellerio de- scribed another set of Symbolists, designated as "Idealists," which included Denis, Bernard, Filiger and Verkade[3] to which he appended

[1] André Mellerio may have exhibited at the Salons de la Rose+ Croix. Larmandie's list of Rose+Croix exhibitors (see Appendix III) includes an unidentified "Mellerio." I have never found his name in the catalogs.

[2] André Mellerio, Le Mouvement Idealiste en peinture (Paris: Floury, 1896), p. 12.

[3] Ibid., p. 56.

other figures familiar from the Rose+Croix milieu: Séon, Point, Trachsel, Andhré des Gachons, de Feure, Maurin, Jeanne Jacquemin, Schwabe, Osbert, etc.

In the final analysis, Mellerio's description of the Idealist Movement covered the same ground that Peladan had partly covered since the movement itself was measured by "the predominance of the idea that the intelligence imposes on the reproduction, willy-nilly, of the world in flux."[1] The great difference lies in the fact that Mellerio selected his representatives from the genial figures of the period and Peladan from the pedestrian.

In December, 1895 the Mercure de France began to publish the important set of articles which comprise Victor Charbonnel's "Les Mystiques dans la littérature présente." Charbonnel expressed mixed feelings for Peladan. While admiring his high purpose, he was chary, as so many critics before had been, of the Sâr's artistic snobbishness and self-advertising. As for the Salons de la Rose+Croix:

> It is undeniable that they mark a sincere idealistic renovation in art. Under the sign of the Crucified Rose, it is true that several impotents and several "intentionists" [the Nabis faction?], lacking in technique, managed to attract the attention of a band of snobs who would not have noticed them other than at the "esthetic gestures" of the Sâr. However, it must be admitted that true and great artists--Dampt, Walgren, Pierre Rambaud, Alexandre Séon, Aman-Jean, Armand Point, Jean Delville, Carlos Schwabe, Marcius-Simmons, Maurice Chabas, Alphonse Osbert, and many others--affirm by the incontestable superiority of their talent, in the Temple of the Rose+Croix, this renewal of idealism which has so rapidly and powerfully, these past years, transformed our art and spread a youthful life around the glorious and sacred work of Puvis de Chavannes.[2]

[1] Ibid., p. 71.

[2] Victor Charbonnel, "Les Mystiques dans la littérature présente," Mercure de France, December, 1896, p. 77.

Charbonnel's viewpoint is at once conservative and patronizing. He was, however, sensitive to the expansion of Idealist taste which he saw in the growing popularity of Burne-Jonesian Pre-Raphaelitism, Liberty paisleys, "anemia, the Virgin, stained glass windows, Edgar Poe, the primitives, slimness, Mr. Peladan, dresses without waists, and the last books of Mr. Huysmans. This capharnaum furnishes the arsenal of mysticism.[1]

Mellerio, too, had cited Huysmans as a characteristic expression of the Idealist Movement. And we already know Huysmans' opinion about the _Salons de la Rose+Croix_. They were once more made clear in a letter he wrote to Gabriel Mourey to thank him for a copy of _Passé le Détroit. La Vie et l'Art à Londres_:[2] "If your book could convince the Pre-Raphaelites to organize an exhibition in Paris--that would be a real service rendered to all--except to the foetus of the Rose+Croix--and its about time!"[3]

The Wedding of the Sâr

On January 11, 1896, a social event which was directly to affect the _Salons de la Rose+Croix_ took place in the Church of Saint Thomas d'Aquin in Paris; Peladan married the niece of Léonce de Larmandie, Constance-Joséphine de Malet-Roquefort, a widow, a mother and the Countess Le Roy de Barde.

[1]_Ibid._, p. 79.

[2]Gabriel Mourey, _Passé le Détroit. La Vie et l'Art à Londres_ (Paris: Ollendorff, 1895).

[3]Quoted in Robert Baldick, "J.-K. Huysmans et Gabriel Mourey: Correspondance inédite," _Bulletin de la Société J.-K. Huysmans_, No. 2 (1953), pp. 27-38; p. 33.

At the end of 1895, when the engagement was announced, La Plume could not resist ridiculing the Sâr and a page of "Objects of Art for Wedding Gifts" designed by F. A. Cazals appeared in the December 15 issue. One of them represented an object in the form of a rose called "La Rose Croît" (the rose grows), in which the Sâr's hair formed the petals and his beard the leaves (Fig. 56).

A revealing document comes down to us from this moment, the visiting card of "The Sar and Princess Peladan" (Fig. 57), an even more glorious title than her legal one, conferred by Peladan on his bride.

The wedding was a sensation. Larmandie states that some three thousand newspaper articles appeared as a result.[1] During the service, the Curé referred to Peladan by his Rosicrucian titles thereby alienating a number of his devout Faubourg Saint Germain congregation.[2]

The marriage shortly proved unhappy and did not last. Doyon hints that Peladan may have been impotent. Doyon's picture of the marriage is that of a man endowed with tremendous literary powers rather than with physical prowess. He suggests, too, that the Countess felt she had been used, and that financial and social snobbery may have been the circumstances which prompted the marriage. It must be added that these piquant details were used by Doyon as a means of turning a painful situation to comic advantage. We know that Larmandie never held the failure of the marriage against Peladan. By 1900, the break was definitive. At about this time Peladan

[1]Larmandie, L'Entr'acte idéal, p. 115. [2]Ibid.

fell in love with an Englishwoman, Christiane Taylor. Peladan wrote a set of love poems to her, later published as Le Livre Secret (Paris: La Connaissance, 1920), with illustrations by Henry de Groux. (De Groux in large measure shared artistic sympathies with the Rose+Croix and had been asked to exhibit with them but never did, possibly because of his close friendship with Léon Bloy). Christiane Taylor was a divorced woman at the time she met Peladan, and in 1901 Peladan married her in Nîmes, a union which was not recognized by the church for obvious reasons. Shortly thereafter, Peladan's first wife, the Countess le Roy de Barde, died thereby regularizing Peladan's awkward situation. Beginning in 1904, Peladan directed much of his energies into tracts for Catholic divorce reforms as for example his Supplique à S.S. Le Pape Pie X pour la réforme des canons en matières de divorce (Paris: Mercure de France, 1904).[1]

Based on a circumstantial reading of Peladan's writings—particularly those passages concerned with the Androgyne and Saint John—it would be easy to imagine that Peladan was homosexual. He was, in fact, comically nicknamed "La Sâr Pédalant." However, no trace of active homosexual activity has been found in Peladan's career.

The Fifth Salon de la Rose+Croix, 1896: The Poster and the Catalog

Since Peladan's marriage provoked so much curiosity, the Galerie des artistes contemporains would have been too confining for the next exhibition and so the Galerie des Arts Réunis, 28 rue de l'Opéra, was engaged, both for its spaciousness and for the novelty

[1] See Doyon, op. cit., chap. on "Marche pour fiançailles." Doyon was wrong when he states that Peladan's first marriage took place in 1893, but the error may easily have resulted from a typographical mistake.

of its daytime electrical illumination. "The effect of a fairytale light and of a dream on the works shown," Larmandie wrote, "proved to be extremely favorable and thrilling."[1]

The Salon opened without the presence of Peladan. The Sâr was honeymooning in Venice, and so the responsibility of defending the exhibition fell on Larmandie. Owing to the marriage and the comparative elegance of the surroundings, the Fifth Salon was beseiged, eight thousand visitors alone on opening day.[2]

The fortunes of the Rose+Croix were for the moment eased, and the new prosperity was seen in the publication of both a poster and a catalog. The poster was designed by two artists, Armand Point and his disciple, a precocious Dutchman, Léonard Sarluys. The poster depicted a kind of Rosicrucian hero, at once Perseus and Saint George, who holds aloft in one hand the severed head of Emile Zola; in the other, he clutches the avenging sword. Upon the hero's breastplate is chased an eagle dangling a rose from its talons. Inscribed on the entrails dripping from the slashed throat are the familiar titles of Zola's novels--The Earth, Nana, etc. A new day dawns on the horizon (Fig. 58). Armand Point drew the hero, and Léonard Sarluys the head of Zola.

A scandalized cry rose up against the poster, but Camille Mauclair, generally unsympathetic to the Naturalist School, nonetheless took a calm view of the affair: "I only see there," he wrote in the Mercure de France, "an inoffensive fantasy, after all is said and done, gaily signifying the general tendency of young artists. A

[1]Larmandie, L'Entr'acte idéal, p. 116.　[2]Ibid., p. 119.

poster doesn't kill anybody, and one has to laugh at the pedantic
irritation of some of our colleagues."[1] In addition to the poster,
a pretty catalog was published. The pendant-winged Assyrian beasts
flanking a gothic arch crowned by a crucified rose, designed by Séon
in 1892 (and employed throughout the Rosicrucian publications) was
given up in favor of another illustration by Séon, called "Vers
l'Idéal" which depicted a winged female angel seen in profile hold-
ing flowers (Figs. 59, 60). Séon's drawing for the cover was in-
cluded in the exhibition.

Armand Point (1861-1932), Léonard Sarluys (1874- ?), Jean de Caldain (? - ?)

Repeating again the sacerdotal nature of art, Peladan intro-
duced the catalog with the exhortation: "Artist you are a Priest."
The listing of 110 works then followed. As always, the press re-
ceived the works of Osbert, Point and Séon favorably. Two of Point's
six listings for 1896 are indicative of his ever increasing commitment
to Florentinism: "Ecce Ancilla Domini (peinture à l'oeuf reconstituée
selon la tradition des primitifs italiens)" and "Sirène des Lacs
(peinture à fresque reconstituée selon la tradition des primitifs
italiens." The echoes of Dante Gabriel Rossetti are obvious. Point
had just celebrated the beauties of "Florence, Botticelli, La Prima-
vera" in the January issue of the Mercure de France. His fragile
prose bears traces of Peladan's androgynous theories and a rationaliz-
ing hatred of Impressionism.

[1]Camille Mauclair, "Art, Exposition de la Rose+Croix," Mer-
cure de France, May, 1896, pp. 314-316; pp. 315-316.

Léonard Sarluys (or Saluis), one of the few unknowns dis-
closed at the fifth _Salon_ (his unique appearance), was from a family
of Dutch antique dealers. A handsome young man, he arrived in Paris
at the age of twenty-one, after having completed a chapel in Rotter-
dam representing the Miracle of Saint Anthony at Padua.[1]

Jean Lorrain, that most dandy of critics, was smitten with
Sarluys, and in the April 2 issue of _Le Journal_ proceeded to speak
of him as "nearly another Sâr Peladan" because of Sarluys' fanciful
manner of dress.

> This Batavian artist, a living Giotto, if one believes the
> hear-say, has turned the Esthetic camp on its heels . . . the
> smile of a da Vinci, the eyes of Donna Liggeia, the throat of
> Dante Gabriel Rossetti's Beatrice, the talent of Michelangelo,
> and with all this still virgin . . . [Sarluys] ambulates in
> life in a doublet of black velvet, in long suède gloves em-
> bossed with golden embroidery, and falling on the shoulders
> the curly and too heavy hair of Florentine pages.[2]

Sarluys' listings in the catalog make amply clear his at-
tachment to Armand Point. Number 93 reads: "Jeune Florentine
(peinture à l'oeuf selon le procedé retrouvé par Armand Point)."

One last figure from the little history of the Symbolist
movement enlivened the proceedings of the fifth _Salon_, Jean de Cal-
dain, Huysmans' erstwhile secretary. Largely lithographic, Caldain's
work suggests the influence of Redon's _fusains_ combined with the
clumsy imagery of Trachsel--a kind of undersea and molecular fantasy.
Among his contributions was an "Hallucination" and a work amusingly
titled "?."

[1]Marie, _op. cit._, pp. 135-136. [2]_Ibid._, p. 107.

Results of the Fifth Salon

Baude de Marceley's satirical review attempted to capture some of the transient excitement generated by the Salon: "It all acted, walked, chatted, asking for news of the Sâr; one heard in this endless mêlée of words '. . . Venice . . . astral influences . . . Exquisite . . . Point . . . Toward the Ideal . . . Osbert . . . Venice . . . Larmandie . . . uugh!'"[1]

Peladan's output was considerably diminished in 1896. According to the Peladan bibliography published in the special issue of the Nouvelle Revue du Midi, the last Salon de Joséphin Peladan was issued in the series of La Décadence latine.[2] In the series of Rosae+Crucis Acta, there appeared Le Prochaine conclave. Instructions aux Cardinaux (Paris: Dentu, n.d. [1896]). Chamuel brought out Le Prince de Byzance, a five-act drama written in 1893, as part of the series, Le Théâtre de la Rose+Croix.

The Sixth and Final Salon de la Rose+Croix

In March, 1897 the last Salon de la Rose+Croix was held in Georges Petit's Gallery, 8, rue de Sèze. It was Petit himself who sought out the Rosicrucians and made accessible to them his vast and sumptuous quarters. For Larmandie the last Salon was to be the apogee of them all.[3] The Exhibition ran from March 5 to March 21. It was preceded by a special critics' and journalists' vernissage to which 191 critics came. The public attendance on opening day reached 15,000 persons.[4]

[1] L'Evénement, March 20, 1896.

[2] I have been unable to locate this tract.

[3] Larmandie, L'Entr'acte idéal, pp. 135-136. [4] Ibid., p. 177.

In addition to the regular exhibitors, a large contingent of students of Gustave Moreau was present, as were several new figures, such as the sculptor Zachary Astruc, the decorator Paul Berthon and the Belgian Symbolist associated with the XX, Xavier Mellery. Among the less fervent exhibitors whose work we have already met earlier, there were Fernand Khnopff and Auguste de Niederhäusern-Rodo.

The Resignation of Armand Point

The opening of the exhibition was marred by a "Querrelle d'arrière-boutiques. Le Coca Mariani contre le quinquina Dubonnet."[1] Armand Point withdrew from the Rose+Croix. Several explanations were offered. Possibly he was motivated by a certain jealousy of Osbert-- imagining that Osbert's press had been more favorable than his--but there is no appreciable difference. He might also have been piqued at what he imagined to be a greater patronage of Osbert. It seems that Point informed Peladan that were Osbert present at the sixth exhibition, both he and Sarluys would withdraw their suffrage.[2] Peladan's reply is unknown, but in any event, Osbert's work was shown and Point left.

Mlle Yolande Osbert, daughter of the painter, believes that Point was annoyed with Peladan because both he and Osbert had been asked to execute a certain drawing, possibly an illustration of a novel. In this dispute it must also be kept in mind that in 1896 Point was greatly occupied with his Marlotte studio-workshop, Haute-claire, where he and his assistants were busy manufacturing colored

[1]Joseph Renaud, Le Jour, February 29, 1897. [2]Ibid.

enamels, complex picture frames, jewelry, ceramics and other hand
crafted objects. This studio, similar to William Morris' enter-
prises, was to become the center of Point's life. He was now the
head of his own idealist venture and may have felt that he had out-
grown Peladan's Rosicrucians. Moreover, in March, 1896, during the
Salon de la Rose+Croix, Point was touring in Italy, awaiting the
arrival of Elémir Bourges.[1]

The Catalog of the Sixth Exhibition

The catalog began with a short, lapidary notice to the "Hon-
est Visitor": "Art is the aristocracy of forms expressing the tradi-
tion of thought. . . . The true artist is a priest who officiates
the mystery through forms and colors. . . . Man needs neither pure
truth nor perfect realization; Man needs Mystery, not to penetrate
it but to experience it."[2]

The listing of 217 works was preceded by a disturbing and
suggestive note: "Since there have been abuses in Belgium as in
France, the Sâr withdraws all authority that in the past he would
have delegated to himself in the name of the organization of the
Salons de la Rose+Croix."[3] At the time of the exhibition, Peladan
was again absent, this time in Belgium, and Larmandie was once more
left in charge.

[1] Marie, op. cit., p. 127.

[2] Joséphin Peladan, Ordre de la Rose+Croix du Temple et du Graal. VI geste esthétique, sixième salon, catalogue, de 2 heures à 6 heures du soir, de 5 au 31 mars 1897 (Paris: Georges Petit, 1897), pp. 2-5.

[3] Ibid., p. 12.

The titles of the work sent by the regular contingent suggest nothing out of the ordinary or of special interest. Séon, who was to be handled by Petit, was densely represented by fifty-three works, thirty-three of them small framed groups of drawings. Fernand Khnopff sent, among other works, "Lèvres Rouges" (Fig. 61).

Zachary Astruc (1835-1907)

Astruc had been an acquaintance of Peladan since the days of Barbey d'Aurevilly. In the early 1890's Astruc executed a bust of Peladan in the robes of Sâr (Fig. 62)[1] and to the last Salon de la Rose+Croix he sent two portraits of Barbey d'Aurevilly, one a bronze head, the other a high relief. Possibly these works were studies for "Le Marchand des masques" (1883), which represents a standing youth holding aloft a collection of masks, portraits of illustrious artists through the ages (Fig. 63). The statue was erected in the Luxembourg gardens. Its socle is surrounded by masks in high relief. To the right of the boy's right leg is the mask of Barbey d'Aurevilly --probably the mask shown at the last Salon (Fig. 64). Peladan must have remembered the work and, wishing once more to render tribute to the "Constable of Letters," may have asked Astruc to exhibit them.

The Students of Gustave Moreau: Georges Rouault (1871-1958)

Larmandie pretends that, at the time of the last Salon, Gustave Moreau had had the intention of arranging a special exhibition

[1] A plaster cast is now in the reserves of the Bibliothèque de l'Arsenal; it entered in 1941 at the time the second portion of the Peladan succession was accepted.

of his works with the Rose+Croix.[1] This is difficult to admit after
Peladan's attack in 1895 unless, of course, Moreau had been persuaded
by Peladan's melodramatic appeal, which is equally unlikely. In any
event, Moreau died in 1898, and his special exhibition in the bosom
of the Rose+Croix never took place.

Larmandie further states that ten students of the master ex-
hibited with the Rose+Croix in 1897,[2] making it a special sub-unit
within the exhibition. This inclusion was dominated by Georges Rou-
ault. From individual references in newspaper reviews, the complete
Moreau faction, if Larmandie's figure is correct, would seem to be
as follows: Marcel Beronneau (1897), Jean Danguy (1895, 1897),
Raoul du Gardier (1896, 1897), Edgard Maxence (1895, 1896, 1897),
Charles Milcendeau (1897), Paul Renaudot (1897), Léon Printemps
(1897), Georges Rouault (1897), H. Thiriet (1897) and Philibert
Vigoureux (1897).

None of Moreau's subsequently famous Fauve students--except-
ing Rouault--Matisse, Puy, Marquet, Manguin, participated at the
last Rose+Croix exhibition, nor were two other of his well-known stu-
dents of distinctly Rosicrucian predispositions, Georges Desvalli-
ères, who co-founded with Maurice Denis the Studio of Sacred Art in
1919, and Ary Renan who may have avoided Peladan on account of the
Sâr's earlier attacks on his father. Peladan, we also remember, had
once solicited Renan's support in his review of the official Salon
of 1894. Ary Renan was shortly to become Gustave Moreau's first
major biographer.

[1]Larmandie, L'Entr'acte idéal, pp. 137-138. [2]Ibid.

195

As a group, the Moreau contingent favored, after themes from the New Testament, the theme of the poet or of Orpheus, a theme Moreau made particularly his own in a kind of exhausted variant very close in spirit to Peladan's own extreme form, the androgyne. Of the group, Rouault's section was the largest with thirteen works including the well-known "L'Enfant Jesus parmi les Docteurs"[1] (Fig. 65).

Henry Eon, comparing the "Dépositions" by Rouault and Beronneau, thought that they "took on the appearance of very old pictures, darkened by the candle-smoke and torch-light of some ancient chapel."[2] At this moment in Rouault's career when Moreau's influence is paramount, the young pupil was one of the few artists genuinely equipped to realize Peladan's Ideal art, an art at once conservative in form, elevated in theme, and yet personal. The irony, of course, is that Rouault radically turned on the form of his earlier production expressly out of the passionate spiritual and Christian sensibility which is evident, in an illustrative way, in his earlier works.[3] In his Fauve connection, Rouault is the one who focuses on the misery and displacement of oppressed figures rather than on the brighter Joie de vivre that one associates with Matisse.

[1]Jacques Lethève illustrates his article on the Rose+Croix with a "Christ Mort" which still remains in the Rouault estate.

[2]Henry Eon, "Expositions, La Rose+Croix," La Plume, March 15, 1897, p. 190.

[3]In reading through a trying typescript, Prof. Rewald made the following criticism which, I hope, is answered at least in small measure by the dissertation itself: "You can call it 'irony,'" he wrote, "it was inevitable since R.[Rouault] was an artist and not an anaemic puppet. You should have investigated why no artist could emerge from Peladan's Salons!" I am not in entire agreement with Prof. Rewald's view, although I am cognizant of its viability.

The Demise of the Salons de la Rose+Croix

The reviews of the last _Salon_, though mixed, were essentially favorable because of the widespread conservatism of the press. Maurice Giral, writing for _L'Artiste_, concluded that "With Peladan, the spectator hears the call of the beyond, even in front of an imperfect realization. The vibration of forms and colors on the retina resounds all the way to the soul and the spirit is illuminated by a rapid glimpse of absolute beauty that the wiseman Diotimus formerly revealed to the guests of the _Symposium_."[1] André Fontainas, in the _Mercure de France_, saw no more than "little Gustave Moreaus and Burne-Jones's."[2]

With the conclusion of the Sixth "Esthetic Gesture" the _Salons de la Rose+Croix_ were over. Larmandie said that Peladan "announced on his return . . . the dissolution of the chivalry-like intellectual order that had so brilliantly accomplished a creative and informative hexiade. Rosicrucians are not in the habit of discussing measures taken by their chief, confident that they conform to the reasons of his wisdom and the awakening of Brunhilde. But we did not disappear as the result of a defeat; our star went down in glory."[3] In short, Larmandie begged the question of the ending of the _Salons_, couching the issue in vague evasions. Indeed, there was at the time every indication that a Seventh _Salon_ was planned for 1898. The catalog of the Sixth Exhibition carried the "Regle du Septième Salon de la Rose+

[1]Maurice Giral, "Au Salon de la Rose+Croix," _L'Artiste_, March, 1897, pp. 198-202; p. 202.

[2]André Fontainas, "Art, Rose+Croix," _Mercure de France_, April, 1897, p. 184.

[3]Larmandie, _L'Entr'acte idéal_, p. 154.

Croix" which is merely a repeat of the now familiar text, and stated
that it would be held in March, 1898 in the Georges Petit Gallery.

Other explanations for the end of the exhibitions are possible. In the catalog, Peladan himself had referred to abuses within
the order without identifying them, and for the first time had de-
clined any artistic responsibility for the exhibition. Peladan's
presence in Belgium perhaps suggests that Jean Delville's "Salons
d'Art idealiste" in Brussels were in some measure an irritation to
him, particularly since Delville's manner and writing so dully aped
the Sâr's. Imitation is of course flattering but at length it is
also galling. By the end of the nineties, Jean Delville was to have
assured his position as the leading Idealist painter with his wholly
languid and androgynous "School of Plato" (Fig. 66), the copestone
of the Salon of Idealist Art of 1899.

Peladan also saw that his "Esthetic Gestures" were even be-
ing imitated in Paris, notably by "Les Artistes de l'âme" both at
Georges Petit and at La Bodinière--a group of artists, some of whom
were graduates of the Salons de la Rose+Croix, that Octave Mirbeau
was to lampoon wittily in a series of articles published throughout
1896 in Le Journal. The funniest perhaps is "Botticelli Protests!"
(Le Journal, October 4-11, 1896.) In it Botticelli, demoralized by
fads and fancies in the arts committed in his name, complains to an
unidentified companion (doubtless Mirbeau, himself): "Theories,
don't you see, are the death of art--it is confirmed impotence. When
one feels unable to create according to the laws of nature and the
sense of life, one resorts to pretexts and looks for excuses. Thus

one makes up theories, techniques, schools, rhythms. One becomes
mystic, mystico-larvist, or mystico-vermicellist. . . . Do I know?
This one says that art must be mystico--hyperconical and Kabbalo-
spiral, that one says that art must intensely affirm the octagon and
squarely the ellipsoid. . . ."[1]

In 1897 Chamuel brought out a curious book called L'Art de
Demain written by two occultists, Barlet and Lejay. This work es-
poused the cause of an Idealist art along divisions already set down
by Mellerio. Despite its attempt to recount the history of the
Idealist movement to date, it studiously avoided any questions relat-
ed to Peladan and the Salons de la Rose+Croix, the Idealist exhibi-
tions par excellence. The book ends with the announcement of a set
of plans for an exhibition of painting which calls on artists of
good will to collaborate in the project, asking them to contact Cha-
muel. The last sentence is obviously aimed at Peladan: "Gentlemen,
the artists are respectfully called on to observe that these propos-
als exclude no special school and are open to all styles."[2]

Still another reason for the cessation of the Salons doubt-
less had to do with the disintegration of Peladan's marriage, and
the probability that the funds Peladan had hoped to obtain from his

[1]Republished in Octave Mirbeau, Des Artistes (2 vols.; Paris;
Flammarion, 1922, 1924), I, 274-275. In addition to "Les Artistes de
l'âme," the "Salon d'Art religieux de Durendall" (Bruxelles, 1899)
reflected tendencies uncovered at the Salons de la Rose+Croix. Need-
less to say that many Rose+Croix figures including Bernard, Couty,
Gachons, Osbert, Séon, Point, etc., were present in this major Bel-
gian manifestation.

[2]F.-Ch. Barlet and J. Lejay, L'Art de demain (Paris: Chamuel,
1897), p. 73.

bride's estate were now withheld.

Jacques Lethève's appraisal of this puzzling situation seems correct. He regards Peladan as having grown conscious at last of the essential failure of the Salons de la Rose+Croix; after all, he had only succeeded in rallying but a small number of faithful under his banner. It is easy to recognize that the finest moments of the Salons were, with rare exception, those provided by artists not basically in line with Rosicrucian teaching. Indeed, any artist worthy of the name would have naturally resisted complete submission to Peladan's blind rationale. Lethève also suggests that Peladan, while not openly admitting it, had come to realize the inherent strength and viability of a more progressive critical viewpoint.[1] In a word, Peladan had grown tired of the Salons de la Rose+Croix; he was bored with the endless nuisances they entailed; he had outgrown them.

The sense of frustration caused by a popularization from which he reaped no benefit, a growing feeling of futility caused by the constant repetition of both the group of artists that exhibited with him and the kind of critical reception with which they were received, the almost certain economic friction, the enervating responsibilities of the exhibitions--add to these possibilities, any of which would suffice, the fact that Peladan was growing older, and in the absence of one single exact reason, one can still easily understand why, at the end of his description of the Sixth Salon de la

[1]Lethève, "Les Salons de la Rose+Croix," loc. cit., pp. 372-373.

Rose+Croix, Larmandie wrote in capital letters: "THIS WAS THE END OF THE IDEAL INTERLUDE."[1]

The Sâr in Retirement

With his liberation from the Salons de la Rose+Croix Peladan entered a new phase. Now in his middle years, he turned away from the exuberant, meridional eccentricities that marked his tenure as Magus and Sâr. While never renouncing his mission as Idealist spokesman, nor his fundamental attachment to art criticism as the core of a larger belletristic contribution, he accepted a more realistic appraisal of life as his animating flame cooled.

As a kind of celebration of his release from the Salons, Peladan made an extensive tour of the Middle East in 1898, visiting Greece, Egypt and Palestine where, Aubrun claims, he found the authentic tomb of Christ in the Mosque of Omar, "such an astonishing discovery that at any other period the Catholic world would have been shaken."[2] This voyage provided the background for La Terre du Sphinx (Paris: Flammarion, 1900), the first of a new, popularly-oriented series called Les Idées et les formes. At the beginning of the twentieth century this series replaced Peladan's esoteric framework, La Décadence latine. Not that Rosicrucian publications were definitely abandoned or the Amphithéâtre des sciences mortes. The The former continued to 1903 with the publication of several plays in the series Le Théâtre de la Rose+Croix, and the latter until 1920

[1] Larmandie, L'Entr'acte idéal, p. 154.

[2] Aubrun, op. cit., p. 27.

when Peladan's love poems to his second wife were brought out posthumously as Le Livre secret (Paris: La Connaissance). Peladan's novels were no longer issued as part of La Décadence latine but as part of a new series, called Les Drames de la conscience.

On his return from the Holy Land, Peladan was met by the news that Stanislas de Guaïta had died on December 19, 1897 from an overdose of drugs. Although the friendship had been broken seven years earlier and had not been mended at the time of the Boullan murder allegations, Peladan was stunned by the loss of his former comrade, disciple and peer—which reopened the wounds occasioned by the death of his father and brother. Peladan dedicated L'Occulte Catholique to his "Cher Adelphe." The work was proffered "in tender memory to the friend," and "in deep homage to the Kabbalist." Now in the company of Barbey d'Aurevilly and Armand Hayem, Peladan said of Stanislas de Guaïta that "I only desire to rewrite Your name in my work because I loved You: now I venerate You . . . I recommend myself once more to Your friendship, now celestial, in testimony of the one which long united us and which, I hope, will reunite us in eternity. So be it."[1]

Echoes of the Salons continued to be heard. In 1899, after the Nabis exhibition, "Homage to Odilon Redon," proved successful at Durand-Ruel's, Maurice Denis wrote to Gauguin in Tahiti asking him to join an exhibition of "Symbolist, Pointilist and Rose+Croix painters"[2] to be held the following year. But by this late date those

[1] Joséphin Peladan, L'Occulte Catholique, Amphithéâtre des sciences mortes (Paris: Chamuel, 1898), p. iii.

[2] R. H. Wilenski, Modern French Painters (New York: Harcourt Brace, 1954; first published in 1939), p. 160.

artists who might have been Peladan's best representatives were asso-
ciated with dealers such as Le Barc de Boutteville, Vollard and
Georges Petit. After all, Peladan had driven them away because of
their Neo-Impressionist tendencies or for their frankly anti-natural-
ist color.

The Nabis, now rallied around Gauguin, gradually became known
as the period's Symbolist representatives while Peladan's once notori-
ous group of Idealists faded from public attention, curiosity and
memory.

Camille Mauclair, writing early in the twentieth century,
stated pitilessly that the ascendancy of Gustave Moreau had been
seriously abused and as such "exercised the worst possible influence
on a certain number of indifferent painters who had their meeting
place during the last few years at the "Rose-Croix,' and who, born
for academism, degenerated into oddity by inventing ridiculous sym-
bols. Thus the beautiful and noble pre-Raphaelite movement which
restored in England the cult of the primitives, interpreted the
Northern myths, and connected the art of painting with that of
beautiful lyric poetry, has been parodied and dragged down by a
crowd of sentimental allegories of wearisome preciosity."[1] This
from a critic who was to compose the most touching literary evoca-
tion we have of Peladan in Servitudes et grandeurs littéraires and
who was to preface a posthumous edition of Peladan's novel Modestie
et Vanité with the statement that Peladan was "the most erudite, the

[1]Camille Mauclair, The Great French Painters and the Evolu-
tion of French Painting from 1830 to the Present Day, trans. P. G.
Konody (New York: Dutton, 1903), pp. 93-94.

most passionate, the most complete of men to write on art since Bau-
delaire; and perhaps this is the most enduring part of his work."[1]

In the meantime, Peladan's work diverged in more clearly
marked directions. The long-standing italianate taste received still
closer historical affirmation[2] and the tiresome racial debate of
France versus Germany grew more transparently chauvinistic, culminat-
ing in Peladan's anti-Boche prose of World War I. Not even the early
terms of the problem--Latin, Mediterranean culture weighed against
Saxon, Protestant kultur--or Peladan's total submission to Wagner can
mitigate this final distortion.

In 1907 the Mercure de France published Leonardo's Textes
Choisis, pensées, théories, préceptes, fables, facéties, traduits
dans leur ensemble pour la première fois, d'après les manuscrits
originaux et mis en ordre méthodique, avec une introduction, par
Peladan. Doyon insists that this work, crowned by the French Academy
in 1908, does not measure up to the conditions of Peladan's title. He
contends that it was, in part, a plagiarism from Ravaisson-Mollien
who earlier had deciphered the Leonardo manuscripts in the collec-
tions of the Institute de France.[3] In 1910 Delagrave brought out the
first complete French edition of Leonardo's Paragone translated by
Peladan.[4]

[1] Joséphin Peladan, Modestie et Vanité. La Décadence latine,
Ethopée 16, intro. Camille Mauclair (Paris: Les Editions du monde
moderne, 1926), p. viii.

[2] E.g., "Caporali (vers 1460), Bonfigli (m. en 1496), Fiorenzo
de Lorenzo (m. en 1520), Précurseurs du Pérugin," Revue Universelle,
No. 59 (April 1, 1902), pp. 180-182.

[3] Doyon, op. cit., pp. 180-181.

[4] Léonard da Vinci, Traité de la peinture, traduit intégrale-
ment pour la première fois en francais sur la codex Vaticanus (Urbi-
nas) 1270, trans. J. Peladan (Paris: Delagrave, 1910).

Immediately prior to World War I, Peladan published perhaps his last piece of valuable criticism, _Nos Eglises artistiques et historiques_ (Paris: De Boccard, 1913) after which he fell into undignified anti-German propaganda.

Camille Mauclair has left an extremely moving picture of the former Sâr at this time. First he speaks of Peladan's early campaigns, the days of velvet doublets and lace _jabots_, the suède boots, the unruly coiffure, the affectation and artificiality, in sum, all those features he once had found so regal and objectionable. Then he turns to the figure before him:

> He aged, renounced his hazardous apostolate, lived in relative retreat, entered the ring once more, dressed no matter how. He carried articles to reviews, to live, and simply signed his name "Peladan." After having been systematically hooted down, along with his fanatical partisans, he was systematically forgotten, by his partisans as by his enemies. . . .
> One sad winter's day, at the _Petit Palais_ among the fragments of "art assassinated" by the Germans . . . I met Peladan, graying, poorly dressed. We chatted for a long time among this piously reassembled débris--and I had the revelation of a very beautiful soul that deception and pain had delivered from all vanity. . . . I cannot render the troubling sensation of pity and of human respect that I carried away from this conversation in that cold and dark room with a defeated person. . . . Leaving, shivering in a too-light top-coat that inadequately protected him from the winter wind, Peladan told me admirable things about the drawings of Leonardo. . . .[1]

[1]Camille Mauclair, _Servitude et Grandeurs littéraires_ (Paris: Ollendorff, 1922[?]), pp. 80-81.

APPENDIX I

THE MANIFESTO OF THE ROSE+CROIX[1]

How could an insertion in the Petites Affiches so arouse the press? Why does the announcement of a third Salon excite such streams of malevolence? By what obscure foreboding did the press, more clamoring than the Cassandre of Berlioz, denounce to the public as inauspicious a work of peace worthy of Pallas?

The Rose+Croix du Temple. For a week these simple words have been counterpointed and fugued by the kapelmeisters of journalism. Such a fuss bears witness that our Will, blessed by Providence, will polarize Necessity with Destiny.

The Salon de la Rose+Croix will be the first realization of an intellectual order which originates, by theocratic principle, with Hugh of the Pagans; with Rosenkreutz by the idea of individualistic perfection.

The infidel today, he who profanes the Holy Sepulchre, is not the Turk, but the sceptic; and the militant monk with his motto "ut leo feriatur" can no longer find a place for his effort.

On the black and white standard, sign of theocracy, we inscribe the Rose+Croix, Symbol of Beauty manifesting Charity.

[1]Translated from Peladan's corrected version of the article which first appeared in Le Figaro, September 2, 1891, and which was republished in Le Panthée (Paris: Dentu, 1892), pp. 307-313.

For ten years we have awaited a comrade in arms who burned with the same artistic piety and at last we have met such a one impatient to undertake the same crusade: Antoine de La Rochefoucauld.

In only citing after the Grand Prior the Commanders Elémir Bourges, that admirable spirit, Count de Larmandie, that valiant knight, Gary de Lacroze, that subtle esthete, and the three others still pseudonymous, one can predict that, transposed to its intellectual meaning, the proud thought of Saint Bernard will be justified.

The Politicians and clergy who have accepted the constitution can be reassured: until next Spring the entire order will be exclusively esthetic.

The artist and the public need not ponder on what the Temple meditates, what the Rose+Croix prepares: simply the victorious manifestation of the Norms of Beauty which for twelve years we have offered.

The Salon de la Rose+Croix will be a temple dedicated to Art-God, with masterpieces for dogma and for saints, geniuses.

In all periods, the arts reflect letters. Delacroix, the greatest French master, incarnates Romanticism. Now for twenty years the arts have reflected the hackwork of Médan. Through his ignorance and base instinct, the author of La Terre has cast a spell on Manet; and Seurat, near death cried: "Huysmans led me astray!" Imagine making a picture after Un Coeur simple by Flaubert! one would fall into the inanity of Bastien Lepage and under the terrible judgment of Blaise Pascal: "What vanity that painting would have us admire the representation of what one disdains in reality."

The sentiment of Pascal is that of the Rose+Croix. We said in our last Salon: "I believe that the aim of all arts is the beautiful. . . . I will defend the cause of Art against the palette workers and the sculpture practitioners.

"The Jury of the <u>Champ-de-Mars</u> is as hostile to abstract, religious, or simply artistic ideas, as that of the <u>Champs-Elysées</u>.

"Whosoever is practitioner, whosoever is mystical has nothing to hope for, neither from Carolus Duran nor from Bouguereau. Officially, the Ideal is vanquished! Oh well! <u>sed victo Catoni</u>, next Spring will witness a manifestation of Art against the arts, of the beautiful against the ugly, of the Dream against the real, of the Past against the infamous present, of Tradition against the hoax!"

Above all schools, without technical preference, admitting optical mixture as well as the Italian method of Desboutin, the Rose+ Croix only insists upon the <u>ideality</u> of its works.

Among the eighty artists already elected and practically all adherents at this hour, it suffices to name the following: the great Puvis de Chavannes, Dagnan-Bouveret, Merson, Henri Martin, Aman-Jean, Odilon Redon, Khnopff, Point, Séon, Filiger, de Egusquiza, Anquetin, the sculptors Dampt, Marquest de Vasselot, Pezieux, Astruc and the composer Erik Satie.

We will go to London to invite Burne-Jones, Watts and the five other Pre-Raphaelites; we will invite the Germans Lehnbach and Boecklin.

The Order grows through invitation and the invited only have to observe the rule of ideality.

It banishes all contemporary, rustic or military representation; flowers, animals, genre treated like history-painting, and portraiture like landscape.

It accepts all allegory, legend, mysticism and myth and even the expressive head if it is noble or the nude study if it is beautiful.

You have to create BEAUTY to get into the Salon de la Rose+Croix.

One may wonder, in view of the small number of confirmed idealists as Lagarde [?], de Egusquiza, Antoine de La Rochefoucauld, how we will recruit our exhibitors.

In selecting ideal work, frequent in the production of the realists themselves, like the triptych of Saint Cuthbert of a Duez or the Meneuse de Cygnes and the Charmeuse d'Etoiles by Besnard.

As ti landscpe, it must be in the manner of Poussin, composed and subordinated to the figures; as to portraiture, excellence of execution will not suffice--the Order must also desire to honor the sitter. The 10th of March 1892, Paris will be able to contemplate, at the Durand-Ruel Gallery, the masters of which it is unaware; it will not find one vulgarity.

The Rose+Croix does not limit its solicitude to painting and sculpture; the Soirées de la Rose+Croix, held in the same place as the Salon, will be devoted to the fugues of Bach and Porpora, the quartets of Beethoven, to recitations of Parsifal. An evening will be set aside to the glorification of César Franck, the greatest French musician since Berlioz.

Among the idealist composers that the Rose-Croix will shed light on, it is proper to mention Erik Satie again, of whose work one will hear the harmonic suites for le Fils des Étoiles and the preludes to the Prince de Byzance.

Certain radical Leftist newspapers, beliving in obligatory calumny against Christian artists, have denounced the Salon de la Rose+Croix as a speculative venture.

Should there be profits they will be used for reedition--so necessary to artists--of the Treatise on Painting by Leonardo da Vince, the divine Leonardo.

It has been proposed to the Council that the Order buy works to make gifts of them to provincial museums; but this point, like several others, must remain in abeyance until October when the Règle esthétique des Rose+Croix will appear.

Opinion forestalls our preparations and forces us to more immediate declarations which were unforeseen. Contrary to what one reads in the Papers, no work by a woman will be accepted because in our renovation of esthetic laws we faithfully observe magical laws.

In 1886 we wrote: "Merodack, Nebo, Alta, Tammuz, these Orphic figures, I have raised them in my work to foretell of the solemn day when the Eose+Croix, cleansed of Masonic contamination, purified of all heresy and blessed by the Pope, will be welded to the key of Peter, urbi et orbi."

This solemn day will be the 10th of March, 1892: The day will begin with festivals of the mind as noble as those celebrated at Bayreuth; this day the Ideal will have its temple and knights and we,

the Maccabeans of Beauty, will bring to Our-Lady, lat the the feet of our Suzerain Jesus, the homage of the Temple and the genuflection of the Rose+Croix.

We believe neither in progress nor salvation. For the latin race which is about to die, we prepare a last splendor, in order to dazzle and soften the barbarians who are coming.

We desire to add some statues and frescoes to the latin cathedral before it crumbles. Last enthusiasts, we arrive, amidst the braying of the _Marseillaise_ and the cabarets, to entone a supreme hymn to Beauty, which is God, and thus one day earn the right to contemplate the mystical Rose through the achievements of Our-Lord's passion.

Ad Rosem per Crucem. Ad crucem per Rosam. In ea, in eis, gemmatus resurgam.

Sâr Peladan

APPENDIX II

RULES OF THE SALON DE LA ROSE+CROIX[1]

I

The Order of the Rose+Croix du Temple is now enlarged to en-
compass the Rose+Croix esthétique in order to restore the cult of
the IDEAL in all its splendor, with TRADITION as its base and BEAUTY
as its means.

II

The Salon de la Rose+Croix wants to ruin realism, reform
Latin taste and create a school of idealist art.

III

There is neither jury nor entry fee. The Order, which grows
by invitation only, is too respectful of the artist to judge him on
his method and imposes no other program than that of beauty, nobil-
ity, lyricism.

IV

For greater clarity, here are the rejected subjects, no mat-
ter how well executed, even if perfectly:

1 - History painting, prosaic and from a textbook, like
 Delaroche;

2 - Patriotic and military painting, such as by Meisson-
 nier, Neuville, Detaille;

3 - All representations of contemporary, private or public
 life;

4 - The portrait--except if it is not dateable by costume
 and achieves style;

[1]Translated from Joséphin Peladan's Salon de la Rose+Croix,
Règle et Monitoire (Paris: Dentu, 1891).

5 - All rustic scenes;

6 - All landscape, except those composed in the manner of Poussin;

7 - Seascape; sailors;

8 - All humorous things;

9 - Merely picturesque orientalism;

10 - All domestic animals and those relating to sport;

11 - Flowers, still life, fruits, accessories and other exercises that painters ordinarily have the effrontery to exhibit.

V

The Order favors first the Catholic Ideal and Mysticism. After Legend, Myth, Allegory, the Dream, the Paraphrase of great poetry and finally all Lyricism, the Order prefers work which has a mural-like character, as being of superior essence.

VI

For greater clarification, here are the subjects which will be welcome, even if the execution is imperfect:

1 - Catholic Dogma from Margharitone to Andréa Sacchi;

2 - The interpretations of oriental theogonies except those of the yellow races;

3 - Allegory, be it expressive like "Modesty and Vanity," be it decorative like a work by Puvis de Chavannes;

4 - The nude made sublime, the nude in the style of Primaticcio, Coreggio, or the expressive head in the manner of Leonardo and of Michelangelo.

VII

The same rule applies to sculpture. Ionic harmony, Gothic subtlety, and the intensity of the Renaissance is equally acceptable.

Rejected: Historical, patriotic, contemporary and picturesque sculpture, that is sculpture which only depicts the body in movement without expressing the soul. No bust will be accepted except by special permission.

VIII

The Salon de la Rose+Croix admits all forms of drawing from

simple lead-pencil studies to cartoons for fresco and stained glass.

IX

Architecture: since this art was killed in 1789, only restorations or projects for fairy-tale palaces are acceptable.

X

The theocratical nature of the Order of the R+C in no way entails the artists; their individuality remains outside the character of the Order.

They are only the Invited, and consequently are in no way in solidarity with the Order from a doctrinal point of view.

XI

The artist who produces a work conforming to the program of the R+C will be accepted even though his earlier work was of a different or realist nature, as the Order bases its judgments on what it is presented with and not with the development of a talent.

XII

The artist who lives abroad and who wishes to exhibit with the R+C must send a photograph, on the basis of which his work will be accepted or rejected.

Kindly indicate dimensions of the work.

XIII

As the Order, despite its solicitude, may be ignorant of the existence of idealist artists, it is permissible to whosoever believes that he has created a work conforming to the program of the R+C, to present it on the first of March to the Archonte of Fine Arts at the Gallery Durand-Ruel, 11, rue Le Peletier. He will be informed of an admission or a refusal on the seventh, in which case the sender will see to it to remove his work before the ninth.

XIV

Artists who might be prevented from framing their pictures may send their cnasses on stretchers.

XV

For the Order of the Rose+Croix the word "foreign has no meaning.

This Salon assumes an international character in the highest degree.

XVI

It will officially open the 10th of March, 1892, and will terminate the 10th of April.

XVII

From the 25th of February to the third of March, the artists invited to exhibit who live in Paris will receive the visit of the Sâr and the Archonte to whom they will remit a signed notice stating name, first name, subject of work, dimensions and selling price.

XVIII

The invited artists who live in the provinces or abroad must send their works between the first and fifth of March (at the very latest), carriage paid, to the Archonte of the Salon de la Rose+ Croix, Gallery Durand Ruel, 11, rue Le Peletier.

XIX

The work must bear a label on which is clearly written the name of the artist and subject of work.

XX

In the case of loss or damage the Order declines all financial responsibility.

The R+C warns that the works of the Salon are not insured.

XXI

Works must be picked up in the three days following the closing of the exhibition.

XXII

From the 8th of March, 1892, beginning at 11 o'clock, the

critics will be admitted on presentation of special cards which will already have been given them.

On the same day, at 8 P.M., a reception will be held for the Ambassadors and for the Minister of Public Instruction and the Fine Arts.

XXIII

The 9th of March, exhibition by named invitation.

The 10th, Opening Day. (Entry fee: 20 francs.)

XXIV

The following days the entry fee will be 2 francs from 10 A.M. till noon, 1 franc until 6 P.M.---except Sunday which is 50 centimes.

Fridays will be 5 francs, as well as closing day (open between 10 A.M. and 6 P.M.). XXV

XXV

Paris school children, accompanied by their teacher will be admitted with no charge on Thursday afternoons.

XXVI

There will be five kinds of cards:

 the white card of the critic
 the red card of exhibition (by name)
 the permanent green card (exhibitors)
 the blue card, good for only one visit
 the yellow card, good for the whole month and permit-
 ing one to escort a lady (price: 5 Louis).

XXVII

A Solemn Mass of the Holy Ghost will be celebrated on the 10th of March at 10 o'clock in the morning at the church of Saint Germain l'Auxerrois.

The Prelude, the Last Supper of the Grail, the Good Friday Spell and the Finale of the Redemption from **Parsifal** by the superhuman Wagner will be played.

The Mass will be preceded by the three fanfares of the Order composed by Erik Satie for harp and trumpet.

All participants will hold reserved seats.

P.S. Following Magical law, no work by a woman will ever be exhib-
ited or executed by the Order.

LIST OF ARTISTS WHO EXHIBITED AT THE

SALONS DE LA ROSE+CROIX

Following L'Entr'acte idéal, Léonce de Larmandie presents a list of 170 painters and sculptors who exhibited at the Salons de la Rose+Croix. This list is both incomplete and, in places, incorrect, as for example, when the same artist is listed twice because of faulty orthography. According to my research and taking into account the vagaries of spelling, the minimum number of artists to have shown with the Rose+Croix is 193. To this must be added at least three "anonymous" modern artists and, at maximum, thirty-five "old masters" reproduced in 1893 catalog, bringing the total number of exhibitors over the 1892-1897 period to 231. In the following list the earlier masters are not mentioned.

	1892	1893	1894	1895	1896	1897
Aabals						X
Agache**1						
Albinet, Gabriel			X			
Aman-Jean, Edmond François	X	X				
Asp, Sigurd		X				
Astruc, Zachary						X
Atalaya	X					
Azambre, Etienne			X	X	X	
Berangier, Charles		X				
Bernard, Emile	X					
Beronneau, Marcel						X
Berthon, Paul						X
Béthune, Gaston	X	X				
Bloche, Roger		X				

[1]Double asterisks indicate source from Larmandie list. Name could not be found in any of the catalog listings.

	1892	1893	1894	1895	1896	1897	
Bojidar, Prince Karageorgevitch		X					
Boom, A			X				
Boucher, Louis					X		
Bourbon, Antonin						X	
Bourdelle, Emile-Antoine	X	X					
Bouhy, Gaston		X					
Brémond, Jean-Louis	X		X		X		
Bussière, A.		X	X	X			
Cadel, Eugène	X					X	
Cairon, B.			X				
Caldain, Jean de					X	X	
Carabin, François-Rupert	X						
Chabas, Maurice	X	X	X	X	X	X	
Chalon, Louis	X						
Charpentier, Alexandre	X						
Chatigny						X	
Ciamberlani, Albert	X	X					
Clark, John		X					
Cool, Arnould de					X		
Cool, Gabriel de					X		
Compton**							
Cornette						X	
Cornillier, Pierre-Emile	X	X	X	X	X	X	
Coulon, Emile-Antoine	X	X					
Couty, Edmé			X	X	X	X	X
Dampt, Jean	X						
Danguy					X		X
Darasse, Vincent	X						
Delacroix, Eugène		X					
Delfosse					X		
Delville, Jean	X	X	X	X			
Déneux, Gabriel		X					
Desboutin, André	X						
Desboutin, Marcellin	X	X					

	1892	1893	1894	1895	1896	1897
Deschamps				X		
Desrivières, Gabriel					X	
Dubois, Fernand				X		
Du Jardin, Jules			X			
Dumont, L.-A.**						
Du Pasquier, Bernard		X				
Duthoit, Adrien		X	X	X	X	X
Duval						X
Duverney**						
Edouard, A.		X				
Egusquiza, Rogelio de	X	X			X	X
Ehrmann		X				
Elonir				X		
Eymien, B.-L.			X			
Fabry, Emile		X		X		
Feure, Georges de		X	X			
Filiger, Charles	X					
Fox, G.-B.		X				
Gachons, Andhré des		X	X	X	X	X
Gaillard		X				
Gardier, Raoul Du					X	X
Gérin, Réné		X		X		
Gillet, Numa				X		
Godebski, Cyprian						X
Granier**						
Grasset, Eugène	X					
Guillonet						X
Habert, E.		X				
Hannotiau, Alexandre Auguste		X				
Haraucourt, Edmond	X					
Hawkins, Louis-Welden			X	X		
Hodler, Ferdinand	X					
Icard	X					
Isaac-Dathis	X					

	1892	1893	1894	1895	1896	1897
Jacques, Léon		X		X		
Jacquin, Georges-Arthur	X	X	X			
Jacquin, Fernan				X		
Jouven		X				
Khnopff, Fernand	X	X	X			X
La Barre Duparc, Leon-Charles de	X					
La Dumond		X				
Lalyre, Adolphe		X	X	X	X	
Lambert, Maurice de						X
Lambert-Fovras	X					
de La Perche-Boyer	X					
La Rochefoucauld, Antoine de	X					
La Rochefoucauld, Hubert de	X					
Lee, William	X					
Legrand, Paul	X	X				
Lel**						
Lelong						X
Lenoir, Marcel						X
Le Petit, Alfred		X				
Lévéque			X			
Lorin, Georges	X	X				
Losik, Thomas				X		
Lowenberg	X					
Malval, Edouard de	X	X				
Marchand, Raymond				X		
Marcius-Simmons, Pinky		X	X	X		X
Marquest de Vasselot		X		X		X
Martin, Henri	X					
Massy, Baron de	X	X				
Maurin, Charles	X			X		X
Maxence, Edgard				X	X	X
Meilet		X				
Mell-Dumont, F.		X				
Mellerio**						

	1892	1893	1894	1895	1896	1897
Mellery, Xavier						X
Merentier, François		X				
Middeleer, Joseph			X	X		X
Milcendeaux, Charles						X
Minne, Georges	X					
Monchablon, Auguste	X					
Moreau-Néret		X			X	X
Moreau-Vauthier, Charles					X	
Morren, Georges		X				
Morisset					X	
Munier		X				
Murphy					X	
Noel, Louis		X				
Nouvion		X				
Niederhäusern-Rodo, Auguste de	X					X
O'Bonnal						X
Ogier, Charles-Jean	X	X				
Osbert, Alphonse	X	X	X	X	X	X
Ottevaere, Henri		X	X	X	X	
Oudart, Felix		X				
Outhot, O. D'		X				
Payne, Lord Arthur	X	X				
Pepper					X	
Petrowitch, J.		X				
Pezieux, Jean-Alexandre	X	X				X
Pierrey, Maurice		X				
Placide, C.		X				
Point, Armand	X	X	X	X	X	
Previati, Gaetano	X					
Prouho			X			
Printemps, Leon						X
Quadrelli, Emile	X					
Raissiquier, Emile-Paul de	X					

	1892	1893	1894	1895	1896	1897
Rambaud, Pierre	X	X	X	X		
Ranft, Richard	X					
Raybaud	X					
Regamey, Felix		X				
Renaudot, Paul						X
Ridel, Leopold	X					
Rigaud, Julien			X	X	X	
Rigaud, Gaston					X	
Rignard, J.**						
Riquet, Gustave			X			X
Rodrigue, Gabriel						X
Rosenkrantz, Lensbaron Arild	X	X	X			
Rouault, Georges						X
Saïn, Edouard						X
Sainville, Emmanuel de	X	X				
Sala, Thomas				X	X	
Sarluis, Leonard					X	
Savine, Leopold	X	X				
Schwabe, Carlos	X					
Séon, Alexandre	X	X		X	X	X
Servat, Albert Gabriel	X					
Simeon, P.		X				
Sonnier, Léon-Julien	X					
Steck, Paul					X	
Stepvens, J. M.						X
Terrey	X					
Thiriet						X
Tholenaar		X				
Tonetti-Dozzi	X	X				
Tonio, G.		X				
Tooroop, Jean	X					
Trachsel, Albert	X					
Vallotton, Félix	X					
Van Bostherout						X

	1892	1893	1894	1895	1896	1897
Vibert, James				X		
Vigoureux, Philibert						X
Wagner, Pierre-Théo	X					
Walgren		X				X
Walter				X		X
Wertheimer						X
Wickenden					X	
Willette, A.		X				
Ziloken, Philippe		X				

APPENDIX IV

LIST OF EMILE-ANTOINE BOURDELLE'S ENTRIES TO THE SECOND

SALON DE LA ROSE+CROIX, 1893[1]

No.

287 - Enterrement en forêt (drawing)
288 - Deuil (drawing)
289 - Sommeil (drawing)
290 - Bacchus endormi (sculpture)

291 - Marsyas
292 - Prière des blés
293 - Le Rire (sculpture)
294 - Femme riant aux caresses de la me (sculpture)

295 - Invention de la sculpture (sculpture)
296 - Douloureuses pensées (drawing)
297 - Le départ (drawing)
298 - Rêve de pastoure (drawing)

299 - Fleurs de pommiers (drawing)
300 - Les pleurs (drawing)
301 - Visions intérieures (drawing)
302 - L'Innocent (drawing)

303 - Crépuscule et prière (drawing)
304 - La Tristesse des étoiles (drawing)
305 - Amertume (drawing)
306 - Peintures

307 - Le Rêve
308 - Le Laurier
309 - Michel-Ange Buonarotti
310 - Etudes

311 - Etude
312 - L'Amour agonisant
313 - Sourire
314 - Amertune

315 - Méduse
316 - Etude
317 - Eve
318 - Jeanne d'Arc

[1]Taken from the supplement to the catalog of the Salon de la Croix.

BIBLIOGRAPHY

Works by Joséphin Peladan[1]

Books

Miss Sarah [Pseud.]. _Autour du Péché_. Paris: Librairie des Auteurs Modernes, 1885.

La Princess A. Dinska [Pseud.]. _Etrennes Aux Dames: Le Livre du Désir_. Paris: Librairie des Auteurs Modernes, 1885.

Marquis de Valognes [Pseud.]. _Femmes Honnêtes: avec une frontispice de Felicien Rops et douze compositions de Bac_. Paris: Monnier, 1885.

La Décadence Latine, Ethopée I, Le Vice Suprême. Preface de Jules Barbey d'Aurevilly. Paris: Le Librairie de La Presse Laurens, 1886.

La Décadence Latine, Ethopée II, Curieux. Paris: Librairie de La Presse Laurens, 1886.

Oraison Funèbre du Docteur Adrien Peladan fils, avec deux portraits d'après un tableau et une photographie dessinés par L. Legrand. Paris: Librairie de La Presse, 1886. 2d ed. Paris: Laurens, 1886.

La Décadence Latine, Ethopée III, L'Initiation Sentimentale. Paris: Edinger, 1887. Republished Paris: Dentu, 1892.

Femmes Honnêtes (IIe serie), avec un frontispice de Fernand Knopff [sic] et douze compositions de José Roy. Paris: Dalou, 1888.

La Décadence Esthétique IV, L'Art Ochloratiques, avec une lettre de Barbey d'Aurevilly. Paris: Dalou, 1888.

La Décadence Latine, A Coeur Perdu. Paris: Edinger, 1888.

La Décadence Latine, Istar. Paris: Edinger, 1888.

[1]Listed in chronological order according to date of publication.

1888, le Salon de Joséphin Peladan, cinquième année. Paris: Dalou, 1888.

La Décadence Latine, Ethopée VI, La Victoire du Mari, avec commémoration de Jules Barbey d'Aurevilly et son médaillon inédit par la Comtesse Antoinette de Guerre. Paris: Dentu, 1889.

La Décadence Esthétique (Hiérophanie) XIX^e, Le Salon de Joséphin Peladan (Neuvième année), Salon National et Salon Jullian, suivi de trois mandements de la Rose+Croix Catholique à L'Aristie. Paris: Dentu, 1890.

La Décadence Latine, Ethopée VII, Coeur en Peine, Commémoration du Chevalier Adrien Peladan et son portrait inédit par Séon. Paris: Dentu, 1890.

Le Salon de Joséphin Peladan IX^e et X^e Années. Paris: Dentu, 1890-91.

La Décadence Esthétique (Hiérophanie) XX, Le Salon de Joséphin Peladan (Dixième Année), avec Instauration de la Rose+Croix Esthétique. Paris: Dentu, 1891.

La Décadence Latine, Esthétique VIII, L'Androgyne. Paris: Dentu, 1891.

La Décadence Latine, Esthétique IX, La Gynandre. Paris: Dentu, 1891.

Le Salon de Joséphin Peladan (Dixième Année), avec instauration de Rose+Croix esthétique. Paris: Dentu, 1891.

Salon de la Rose+Croix, Règle et Monitoire. Paris: Dentu, 1891.

Le Panthée, La Décadence Latine X. Paris: Dentu, 1892.

La Décadence Latine, Esthétique XI, Typhonia avec La Règle Esthétique du Grand Salon de La Rose+Croix. Paris: Dentu, 1892.

La Queste du Graal, Proses Lyriques de l'Ethopée de La Décadence Latine. Paris: Au Salon de la Rose+Croix, n.d. [1892].

Amphithéâtre des Sciences Mortes, II, Comment on Devient Fée (Erotique), avec une couverture symbolique d'Alexandre Séon et portrait gravé inédit du Sâr. Paris: Chamuel, 1893.

La Rose+Croix, Organe Trimestiel de L'Ordre, Salon du Champ-de-Mars, Règle pour la Geste Esthétique de 1893. Paris: Commanderie de Tiphereth, n.d. [1892].

Amphithéâtre des Sciences Mortes, III, Comment on Devient Artiste (Esthétique), avec une couverture symbolique d'Alexandre Séon et portrait gravé inédit du Sâr. Paris: Chamuel, 1894.

L'Art Idéaliste et Mystique. Doctrine de l'Ordre du Salon Annuel des Rose+Croix. Paris: Chamuel, 1894.

Diathèse de Décadence. Psychiatrie. Le Septénaire des Fées. I. Mélusine. Paris: Ollendorff, 1895.

Les XI Chapitres Mystérieux du Sepher Bereschit du Kaldeen Mosché, Révélés par Le Sâr Peladan, pour ceux de la Rose+Croix du et du Graal. L'An 1894 de J.C. VIIe de la Rénovation de l'Ordre. Bruges: De Voluy, 1894.

Le Théâtre Complet de Wagner. Les XI Opéras Scène par Scène. Paris: Chamuel, 1895.

Sâr Merodack [Pseud.]. Amphithéâtre des Sciences Mortes. V. L'Occulte Catholique. Paris: Chamuel, 1899.

Les Idées et Les Formes: La Terre du Christ. Paris: Flammarion, 1901.

Supplique à S.S. Le Pape Pie X pour La Réforme des Canons en Matières de Divorce. Paris: Mercure de France, 1904.

Les Idées et Les Formes. Introduction à l'Esthétique. Paris: Sansot, 1907.

Les Idées et Les Formes. Antiquité Orientale. Paris: Mercure de France, 1908.

Les Idées et Les Formes. De l'Androgyne. Théorie Plastique. Paris: Sansot, 1910.

Das Allmächtige Gold. Roman. Translated by Emil Schering. München, Leipzig: Müller, 1911.

Ernest Hébert. Son Oeuvre et Son Temps, d'après sa Correspondance Intime et des Documents Inédits. Preface by Jules Clarétie. Paris: Delagrave, 1911.

L'Athlétie et la Statuaire Antique. Paris: Sansot, 1912.

Nos Eglises Artistiques et Historiques. Paris: Fontemoing, 1913.

Le Livre Secret. Paris: La Connaisance, 1920. (Written in 1900.)

Les Dévôtes d'Avignon. Paris: Editions du Monde Moderne, 1922.

Modestie et Vanité, La Décadence Latine, Ethopée XVI. Paris: Les Editions du Monde Moderne, 1926.

Histoire et Légende de Marian de Lorme. Paris: La Connaissance, 1927.

Articles

"Le Matérialisme Dans l'Art," Le Foyer. Journal de Famille, No. 300 (August, 1881), pp. 177-79.

"Le Chemin de Damas," Le Foyer. Journal de Famille, No. 304 (September 18, 1881), pp. 246-50; No. 304 (September 25, 1881), pp. 268-71.

"Rembrandt," L'Artiste, September,1881, pp. 326-35. Published also as Rembrandt. Paris: Henri Loones, 1881.

"L'Art Mystique et La Critique Contemporaine," Le Foyer, Journal de Famille, No. 313 (November 20, 1881), pp. 387-88.

"Histoire et Légende de Marian de Lorme," L'Artiste, March, 1882, pp. 371-86; April, 1882, pp. 473-97; May, 1882, pp. 585-90. Republished Paris: La Connaissance, 1927.

"Etudes de Sciences Mortes, Le Grand Oeuvre, d'apres Lionardo da Vinci," L'Artiste, January, 1883, pp. 41-48.

"Les Musées de Province: Le Musée Municipal de Nîmes," L'Artiste, February, 1883, pp. 93-105.

"L'Esthétique à l'Exposition Nationale des Beaux-Arts," L'Artiste, October, 1883, pp. 257-304; November, 1883, pp. 353-86; December, 1883, pp. 433-75.

"Le Procédé de Manet d'apres l'Exposition de l'École des Beaux-Arts," L'Artiste, February, 1884, pp. 101-17. An English translation of this article by Michael Ross appears in Portrait of Manet by Himself and His Contemporaries. Edited by Pierre Courthion and Pierre Cailler. New York: Roy Publishers, 1960.

"Salon de 1884, Peinture," L'Artiste, June, 1884, pp. 414-54.

"Les Musées de Province: Le Musée Gower de Nîmes," L'Artiste, July, 1884, pp. 32-43.

"L'Oeuvre de Edmond et Jules de Goncourt," L'Artiste, August, 1884, pp. 120-129.

Guy de Valognes" [Pseud.]. "La Seconde Renaissance Française et son Savanarole," L'Artiste, September, 1884, pp. 205-17.

"Gustave Courbet," L'Artiste, December, 1884, pp. 406-12.

"Les Maîtres Contemporains, Félicien Rops, Première Étude," extrait de La Jeune Belgique. Bruxelles: Callewaert, 1885. Republished in La Plume, June, 1896.

"J. Barbey d'Aurévilly et son Oeuvre Critique," L'Artiste, July, 1885, pp. 31-36.

"Boite Aux Lettres," Le Figaro, October 8, 1885.

"Franz Hals," L'Artiste, April, 1886, pp. 241-45.

Trinculo [Pseud.]. "Le Mois, Salon de 1886," Revue du Monde Latin, April, 1886, pp. 467-77; May, 1886, pp. 102-20.

"La Salon de La Rose+Croix," Le Figaro, September 2, 1891.

"A Ma Mère, Comment ou Devient Fée," L'Ermitage, February, 1893, pp. 10-11.

"Le Salon du Champ de Mars, Peinture, La Rose+Croix au Salon," La Presse, April 24-27, 1894.

Revue des Livres et des Estampes. Critique Mensuelle de Tout ce qui s'Imprime en France, Peladan ed.-directeur Gerant, 3 issues: October, November, and December 1-15, 1894.

"Gustave Moreau," L'Ermitage, January, 1895, pp. 29-34.

"Quatrième Salon de La Rose+Croix," Bulletin Mensuel de La Rose+Croix du Temple et du Graal, IIIe Année, Serie esoterique, No. 2 (May, 1895), pp. 36-42.

"Paul Chenavard," L'Artiste, May, 1895, pp. 356-62.

"Les Grands Méconnus: Sèon," La Revue Forézienne Illustrée, No. 49 (January, 1902), pp. 7-20.

"Caporali (vers 1460), Bonfigli (m.en 1496), Fiorenzo di Lorenzo (m. en 1520), Précurseurs du Pérugin," Revue Universelle, No. 59 (April, 1902), pp. 180-82, and 3 illustrations.

"Les Arts du Théâtre, Un Maître de Costume et du Décor: Léon Bakst," L'Art Décoratif. Revue de l'Art Ancien et de La Vie Artistique Moderne, No. 153 (June, 1911), pp. 285-300, and 16 illustrations (4 in color).

"La Joconde: Histoire d'un Tableau," Les Arts, January, 1912, pp. 1-9.

Catalogue

IIe Geste Esthétique. Catalogue Officiel Illustré de 160 Déssins du Second Salon de La Rose+Croix, avec La Règle Esthétique et Les Constitution de l'Ordre, 28 mars au 30 avril 1893. Paris: Nilsson, 1893.

General Works

Books

Aman-Jean, François. L'Enfant Oublié. Chronique. Paris: Buchet/
 Chastel, 1963.

Arnold, Paul. Histoire des Rose-Croix et les Origines de la Franc-
 Maçonnerie. Paris: Mercure de France, 1955.

Aubrun, René-Georges. Peladan. Paris: Sansot, 1904.

d'Aurevilly, Jules Barbey. Sensations d'Art. Paris: Frinzine, 1886.

Barlat, F.-Ch., and Lejay, J. L'Art de Demain. Paris: Chamuel,
 1897.

Baldick, Robert. The Life of J.-K. Huysmans. Oxford: Clarendon,
 1955.

Barrès, Maurice. Renovateur de l'Occultisme. Stanislas de Guaïta
 (1861-1898). Souvenirs par Maurice Barrès, avec deux por-
 traits de Stanislas de Guaïta. Paris: Chamuel, 1898.

Bertholet, Dr. Ed. La Pensée et les Secrets du Sâr Joséphin Peladan.
 Lausanne: Genillard, Edition Rosicruciennes, 1952.

Blanchet, Jacques-Emile. La Pêche aux Souvenirs. Paris: Flammarion,
 1949.

Bourdelle, Antoine, André Suarès. Correspondance. Paris: Plon, 1961.

Bricaud, Joanny. L'Abbé Boullan. Paris: Chacornac, 1927.

Caillet, Albert L. Manuel Bibliographique des Sciences Psychiques ou
 Occultes. 3 vols. Paris: Dorbon, 1912, 1913.

Carter, A. E. The Idea of Decadence in French Literature. 1830-1900.
 Toronto: University of Toronto Press, 1958.

Charbonnel, Victor. Les Mystiques dans la Littérature Présente.
 Paris: Mercure de France, 1897.

Chassé, Charles. Le Mouvement Symboliste dans l'art du XIXᵉ Siècle.
 Paris: Floury, 1947.

_____. Les Nabis et Leur Temps. Paris: La Bibliothèque des Arts,
 Lausanne, 1960.

Clymer, R. Swinburne. The Book of Rosicruciae. Vol. II. Philadel-
 phia: Philosophical Publishing Co., 1947.

Cohn, Norman. _Pursuit of the Millenium: Revolutionary Messianium in Medieval Europe and Its Bearing on Modern Totalitarian Movements_. New York: Harper, 1961. First published in 1957.

Coquiot, Gustave. _Les Indépendants: 1884-1920_. Paris: Ollendorf, n.d.

Courthion, Pierre. _Georges Rouault_. Paris: Flammarion, 1962.

Delville, Jean. _La Mission de l'Art: Etude d'Esthétique Idéaliste_. Bruxelles: Balat, 1900.

Dimier, L. _Histoire de la Peinture Française au XIXe Siècle: 1793-1903_. Paris: Delagrave, 1914.

Divoire, Fernand. _Les Deux Idées: Faut-il devenir Mage? Eliphas Lévi et Peladan; Nietzsche, Le Surhomme et le Mage; La Doctrine des Forts_. Paris: Falgue, 1909.

Doyon, R. L. _La Douloureuse Aventure de Peladan_. Paris: La Connaissance, 1946.

Dumont-Wilden, Louis. _Fernand Khnopff_. Bruxells: Van Oest, 1907.

Eemans, Nestor. _Fernand Khnopff_. Anvers: de Sikkel, 1950.

Eliade, Mircea. _Mephistophélès et l'Androgyne_. Paris: Gallimard NRF, 1962.

Encausse, Philippe. _Science Occultes ou 25 Année d'Occultisme Occidental. Papus. Sa Vie, Son Oeuvre_. Paris: Ocia, 1949.

Exsteen, Maurice. _L'Oeuvre Gravé et Lithographié de Félicien Rops_. 4 vols. Paris: n.p., 1928.

Figuier, Louis. _Histoire du Merveilleux dans les Temps Modernes_. Vol. IV. 2d ed. Paris: Hachette, 1861.

Figures Contemporains tirées de l'Album Mariani. Edited by Octave Uzanne. Vol. XII. Paris: Floury, 1910.

Focillon, Henri. _La Peinture aux XIXe et XXe Siècles_. 2 vols. Paris: Renouard, 1927-1928.

Fontanes, Jean de. _La Vie et L'Oeuvre de James Vibert_. Genève: Perret-Gentil, 1942.

Fouillée, Alfred. _Le Mouvement Idéaliste et la Réaction contre la Science Positive_. Paris: Alcan, 1896.

Geoffroy, Gustave. _La Vie Artistique_. Vol. II. Paris: Dentu, 1893.

Gille, Philippe. <u>La Bataille Littéraire: 1889-1890</u>. Vols. V-VII. Paris: Victor-Havard, 1894.

Gourmont, Rémy de. <u>L'Idéalisme</u>. Paris: Mercure de France, 1893.

_____. <u>Le Livre des Masques</u>. 2 vols. Paris: Mercure de France, 1896, 1898.

_____. <u>Le Latin Mystique: Les Poètes de l'Antiphonaire et La Symbolique au Moyen-age</u>. Paris: Mercure de France, 1892.

Guaïta, Stanislas de. <u>Essais de Sciences Maudites. Au Seuil du Mystère</u>. 5th ed. from 3d ed. of 1894. Paris: Durville, 1915.

_____. <u>Lettres Inédites de Stanislas de Guaïta au Sâr Joséphin Peladan. Une page inconnue de l'histoire de l'occultisme à la fin du XIX^e siècle</u>. Introduction by Dr. Ed. Bertholet. Neuchatel: Editions Rosicruciennes, 1952.

Guénon, René. <u>Le Théosophisme: Histoire d'une Pseudo-Religion</u>. Paris: Nouvelle Librairie Nationale, 1921.

Hahnloser-Bühler, Hedy. <u>Félix Vallotton et ses Amis</u>. Paris: Sedrowski, 1936.

Huret, Jules. <u>Enquête sur l'Evolution Littéraire</u>. Paris: Charpentier, 1894.

Ibels, André. <u>Critiques Sentimentales: James Vibert</u>. Paris: Bibliothèque d'Art et de la Critique, 1898.

Janin, Noel-Clement. <u>La Curieuse Vie de Marcellin Desboutin</u>. Paris: Floury, 1922.

Jennings, Hargraves. <u>The Rosicrucians. Their Rites and Mysteries</u>. London: John Camden Hotten, 1870.

Larmandie, Léonce de. <u>Du Faubourg Saint-Germain en l'An de Grâce 1889: Etude Physiologique et Documentaire</u>. Paris: Dentu, n.d.

_____. <u>Notes de Psychologie Contemporaine. L'Entr'acte Idéal: Histoire de la Rose+Croix</u>. Paris: Bibliothèque Chacornac, 1903.

Leonardo da Vinci. <u>Traité de la Peinture</u>. Traduit intégralement pour la première fois en français sur le codex vaticanus (urbinas), 1270 par Jos. Peladan. Paris: Delagrave, 1910.

Lockspeiser, Edward. <u>Debussy: His Life and Mind</u>, Vol. I: 1862-1902. London: Cassell, 1962.

Loeffler-Delachaux, Marguerite. <u>Le Cercle. Un Symbole</u>. Genève: Les Editions du Mont-Blanc, 1947.

Loosli, C. A. _Ferdinand Hodler, Leben, Werk und Nachlass_. Vol. I of
 4 vols. Bern: R. Suter, 1921.

Lorenz, Otto. _Catalogue Général de la Librairie Française depuis
 1840_. Paris: chez l'auteur, 1887.

Maillard, Emile. _L'Art à Nantes au XIX^e Siècle_. Paris: Librairie des
 Imprimeries Réunies, n.d.

Maillard, Léon. _La Lutte Idéale, Les Soire de La Plume_. Paris: La
 Plume, 1892.

Marie, Gisèle. _Elémir Bourges ou l'éloge de la Grandeur, Correspond-
 ance Inédite avec Armand Point_. Paris: Mercure de France,
 1962.

Marieton, Paul. _Joséphin Soulary et la Pléiade Lyonnaise_. Paris:
 Marpon, Flammarion, 1884.

Mauclair, Camille. _The Great French Painters and the Evolution of
 French Painting from 1830 to the Present Day_. Translated by
 P. G. Konody. New York: P. Dutton & Co., 1903.

_____. _Servitudes et Grandeurs Littéraires_. Paris: Ollendorff,
 n.d.

Maus, Madelaine Octave. _Trente Années de Lutte pour l'Art, 1884-1914_.
 Bruxelles: Librairie de l'Oiseau Bleu, 1926.

Mellerio, André. _Le Mouvement Idéaliste en Peinture_. Paris: H.
 Floury, 1896.

Mercereau, Alexandre. _La Littérature et les Idées Nouvelles_. Paris:
 Fiquière, 1912.

Michaud, Guy. _Message Poétique du Symbolisme_. Vol. III. Paris:
 Nizet, 1947.

Michel, André. _Histoire de l'Art_. 3 books of 8 vols. Paris: Colin,
 1925, 1926, 1929.

Michelet, Victor-Emile. _Les Compagnons de la Hiérophanie, Souvenirs
 du Mouvement Hermétiste à la Fin du XIX^e Siècle_. Paris:
 Dorbon-Aîne, n.d.

Mirbeau, Octave. _Des Artistes_. 2 vols. Paris: Flammarion, 1922,
 1924.

Mourey, Gabriel. _Les Arts de La Vie et le Regne de la Laideur_.
 Paris: Ollendorff, n.d.

_____. _Passé le Détroit, La Vie et l'Art à Londres_. Paris, Ollen-
 dorf, 1895.

Mourey, Gabriel. Poèmes Complets d'Edgar Allen Poe. Introduction by Joséphin Peladan. Paris: Dalou, 1889.

Muther, Richard. Die Belgische Malerei im Neunzehnten Jahrhundert. Berlin: Fischer, 1909.

Nordau, Anna and Maxa. Max Nordau, a Biography. New York: Nordau Committee, 1943.

Nordau, Max. Degeneration. Anonymous translation from the 2d ed. of the German work. New York: Appleton, 1895.

Paulhan, François. Le Nouveau Mysticisme. Paris: Alcan, 1891.

Philipon, René. Stanislas de Guaïta et Sa Bibliothèque Occulte. Paris: Dorbon, 1899.

Provost, Michel, an' D'Amat, Roman. Dictionnaire de Biographie Française. Paris: Letouzey, 1954.

Puyvelde, Leo Van. Georges Minne. Bruxelles: Ed. des "cahiers de Belgique," 1930.

Ramiro, Erasthène (Eugène Rodriques]. Catalogue Descriptif et Analytique de l'Oeuvre Gravé de Félicien Rops. Paris: Conquet, 1887.

Regamey, Félix. Horace Lecoq de Boisbaudran et Ses Elèves. Notes et Souvenirs. Paris: Champion, 1903.

Retté, Adolphe. Le Symbolisme, Anecdotes et Souvenirs. Paris: Vanier, 1903.

Rewald, John. The History of Impressionism. New York: The Museum of Modern Art, 1946.

_____. Post-Impressionism from Van Gogh to Gauguin. New York: Museum of Modern Art, 1956.

Richard, Noel. A L'Aube du Symbolisme. Hydropaths, Fumistes et Décadents. Paris: Nizet, 1961.

Rosseti, Dante-Gabriel. La Maison de Vie, Sonnets, Traduits Littéralement et Littérairement par Clémence Couve. Introduction by Joséphin Peladan. Paris: Lemerre, 1887.

Rouchon, Ulysse. Charles Maurin, 1856-1914. Le Puy en Vélay: n.p., 1922.

Sandström, Sven. Le Monde Imaginaire d'Odilon Redon: Etude Iconoloclast. Lund and New York: CWK Gleerup & Wittenberg, 1955.

Satie, Erik. _Le Fils des Etoiles, Wagnérie Kaldéenne du Sâr Peladan, Preludes._ Paris: Rouart, Lerolle et Cie., n.d.

Scholem, Gershom G. _Major Trends in Jewish Mysticism._ New York: Schocken, 1956. First published in 1941.

Scott, Walter. _Hermetica: The Ancient Greek and Latin Writings Which Contain Religious and Philosophic Teachings Ascribed to Hermes Trismegistus._ Vol. 1: Introduction, texts and translation. Oxford: Clarendon, 1924.

Sédir, Paul. _Histoire des Rose+Croix._ Paris: Librairie du XXᵉ Siècle, 1910.

Sert, Misia. _Misia and the Muses: The Memoirs of Misia Sert._ Translated by Moura Budberg. New York: John Day, 1953.

Sizeranne, Robert de la. _Le Peinture Anglaise._ Paris: Hachette, 1895.

de Son, Suenolbert-Maria-Frederic. _Princeps Princeporium Oeuvre Rosicrucienne._ Introduction by J. Peladan. Parris: Messein, 1911.

Starkie, Enid. _Arthur Rimbaud._ New York: New Directions, 1961.

Thieme, Hugo P. _Bibliographie de la Littérature Française de 1800 à 1930._ Tome II: L-Z. Paris: Droz, 1933.

Vanzype, Gustave. _Histoire de la Peinture et de la Sculpture en Belgique, 1830-1930._ Bruxelles: Van Oest, 1930.

Verlaine, Paul. _Oeuvre Complète de Paul Verlaine._ Vol. V. Paris: Leon Vanier, 1908.

Vitoux, Georges. _Les Coulisses de l'Au-delà._ Paris: Chamuel, 1901.

Vollard, Ambroise. _Recollections of a Picture Dealer._ Translated by Violet M. MacDonald. Boston: Little, Brown, 1936.

Wilenski, R. H. _Modern French Painters._ New York: Harcourt Brace, 1954. First published in 1930.

Articles

Apollinaire, Guillaume. "Mort de Joséphin Peladan," _Mercure de France_, August, 1918, pp. 372-73.

Aymé, J. "Tribune Libre, M. Joséphin Peladan, L'Amour Platonicien en 1891," _La Revue Indépendante_, XXI (September, 1891), 311-44.

Baldick, Robert. "J.-K. Huysmans et Gabriel Mourey: Correspondance
 Inédites," *Bulletin de La Société J.-K. Huysmans*, No. 26
 (1953), pp. 27-38.

Barrès, Maurice. "Les Mages," *Le Figaro*, No. 178 (June 27, 1890).

Bazalgette, Maurice. "Joséphin Peladan," *La Revue Independante*,
 XXII (1892), 340-360.

Bernard, Emile. "Critique d'Art," *La Plume*, December 15, 1891, p. 441.

_____. "De L'Art Naïf et de l'Art Savant," *Mercure de France*,
 April, 1895, pp. 86-91.

Boyer, Raymond. "Les Antimonies de l'Art Actuel, II, Joséphin Pela-
 dan," *L'Ermitage*, II (1872), 363-366.

Bricaud, Joanny. "Le Chevalier Adrien Peladan," *Revue d'Histoire de
 Lyon, Etudes, Documents, Bibliographie*, III, Fasc. 3 (May-
 June, 1904), 228-232.

Brisson, Adolphe. "M. Joséphin Peladan," *Notes et Impressions de
 Littérature, 16 R. pièce 1241*. A booklet without date or
 place of publication, Bibliothèque Nationale, Paris. Pp.
 337-344.

P. Bruno de J.-M. "La Confession de Boullan," *Les Etudes Carmeli-
 taines*. Paris: Desclèe de Brouwer, 1948.

Buet, Charles. "Les Dimanches de Barbey d'Aurèvilly," *La Revue
 Encyclopedique*, 1896, pp. 31-36.

Chobaut, H. "Les Ancêstres de Joséphin Peladan," *Nouvelle Revue de
 Midi, Bas-Langue doc et Provence*, No. 10 (December, 1924),
 pp. 5-12.

Christophe, Jules. "Le Salon de La Rose+Croix," *L'Endehors*, May 20,
 1892.

Croze, J.-L. "Chez l'Imagier," *La Plume*, 1892, p. 10.

Durand-Tahier, H. "Le Salon de La Rose+Croix," *La Plume*, March, 15,
 1892, pp. 131-132.

Eon, Henry. "Exposition: La Rose+Croix," *La Plume*, March 15, 1897,
 p. 190.

Evenepoel, Henri. "Gustave Moreau et ses éleves: lettres d'Henri
 Evenepoel à son père," *Mercure de France*,

Fénéon, Felix. "Pont-Neuf, Vêtemente sur mesure, Rose-Croix (galerie Durand-Ruel, mars-avril)," Le Chat Noir, March 19, 1892, pp. 1924 and 1926.

Flat, Paul. "Nos Intellectuels, Comment ils manifestent, IV, M. J. Peladan, I," Revue Bleue, Revue Politique et Litteraire, No. 11 (May 26-June 2-9, 1917), pp. 325-329.

Fleury, Albert. "Le Sâr Peladan," La Plume, November, 1894, pp. 445-447.

Fontanes, André. "Art, Rose+Croix," Mercure de France, April, 1897, p. 184.

France, Anatole. "Joséphin Peladan: La Victoire du Mari," Le Temps, January 5, 1890 (Column: La Vie Littéraire).

Germain, Alphonse. "Le Salon de 'La Plume,' Les Mal Connus, Alexandre Séon," La Plume, August 1, 1893, pp. 336-340.

_____. "Une Peintre-Idéiste, Alexandre Séon," L'Art et l'Idée, I (January-June, 1892), 107-112.

_____. "L'Idéal et l'Idéalisme, Salon de La Rose+Croix," L'Art et l'Idée, I (January-June, 1892), 176-180.

Giral, Maurice. "Au Salon de La Rose+Croix," L'Artiste, March, 1897, pp. 198-202.

Gonzague-Privat, "Chronique de Paris: 'Mage et Images,'" L'Evenement, November 28, 1891.

Gourmont, Remy de. "Les Premiers Salons," Mercure de France, May, 1892, p. 63.

Hamel, Maurice. "Mérovak, l'Homme des Cathédrales," Gazette des Beaux-Arts, January, 1962, pp. 53-60.

Hautfort, Felix. "L'Homme des Cathédrales: Mérovak Évoquera l'Âme Gothique," La Plume, May, 1899, pp. 328-335.

Homme, F. L. "La Comédie d'Aujourdhui," L'Art, Revue Bi-mensuelle Illustrée, III (1892), 177-179.

Jarry, Alfred. "Filiger et Les Images d'Epinal," L'Ymagier, No. 1 October, 1894), p. 65.

Jourdain, Francis. "Notes Sur Le Peintre Emile Bernard," La Plume, September, 1896, pp. 390-397.

Kahn, Gustave. "Maurice Chabas," L'Art et Les Artistes, VII (July, 1923), 384-388.

La Rochefoucauld, Antoine de. "Charles Filiger," Le Coeur, Nos. 4-5 (July-August, 1893), pp. 3-6.

Latzarus, Bernard. "Poète et Prophète, Le Chevalier Adrien Peladan," Nouvelle Revue de Midi, Bas-Languedoc et Provence, No. 1 (January, 1924), pp. 4-36, and No. 4 (April, 1924), pp. 193-203.

Leclerq, Julien. "Sur La Peinture de Bruxelles à Paris," Mercure de France, March, 1894, pp. 71-77.

LeGrand, Francine-Claire. "Fernand Khnopff--Perfect Symbolist," Apollo, April, 1965, pp. 278-287.

Lethève, Jacques. "La Connaissance des Peintres Préraphaélite en France," Gazette des Beaux-Arts, May-June, 1959, pp. 315-328.

_____. "Les Salons de La Rose+Croix," Gazette des Beaux-Arts, December, 1960, pp. 363-374.

Maillard, Léon. "Notes Pour Demain, I, l'Imagier Andhré des Gachons," La Plume, 1892, p. 10.

Malingue, Maurice. "Revelations on the Prophets," The Selective Eye, IV (1960), 42-51.

Mauclair, Camille. "Art, Exposition de La Rose+Croix," Mercure de France, May, 1896, pp. 315-316.

Merrill, Stuart. "Le Salon de La Plume, Albert Trachsel," La Plume, February, 1893, pp. 53-57.

Museux, E. "La Rose+Croix," La Plume, November, 1891, pp. 409-410.

Nocq, Henry. "La Rose+Croix," Journal des Artistes, 1894.

Pilon, Edmond. "Quatrième Salon de La Rose+Croix," La Plume, April, 1895.

Rambosson, Yvanhoë. "Le Mois Artistique," Mercure de France, June, 1893, pp. 178-180.

Sizeranne, Robert de la. "Rose+Croix, Pré-Raphaélites et Esthètes, La Renaissance Esthétique des Deux Côtés de La Manche," Le Correspondant, March 25, 1892, pp. 1127-1140.

Tisseur, Claire. "Lettres d'Hippolyte Flandrin," Revue du Lyonnais, Receuil Historique et Littèraire, No. 29 (May, 1888), pp. 341-350.

Vial, Eugene. "Adrien Peladan père, Journaliste à Lyon (1856-1870)," Revue du Lyonnais, No. 6 (1922), pp. 91-104.

Vielliard, F. "Salon de La Rose+Croix," L'Art Littèraire, No. 7 (June, 1893), p. 27.

Weyl, Fernand. "Les Artistes de l'Ame: Jean Dampt," L'Ermitage, I (1895), 129-137.

Catalogues[1]

Catalogue du Salon de La Rose+Croix (10 mars au 10 avril) à Paris. Galerie Durand-Ruel, 11 rue Le Peletier, 1892.

Catalogue des Oeuvres de Peinture, Dessin et Sculpture Exposées au Troisième Salon de La Rose+Croix, du 8 avril au 7 mai. Paris, n.d. [1894].

Salon de La Rose+Croix, Galérie des Arts Réunis, 28, Avenue de L'Opera, du 20 mars au 20 avril 1896. Catalogue des Oeuvres Exposées.

Ordre de La Rose+Croix du Temple et du Graal, VIe Geste Esthétique, Sixième Salon, Catalogue, 31 mars 1897. Paris: George Petit, 1897.

Ville de Nantes, Musée Municipal des Beaux-Arts. Catalogue by Marcel Nicolle with collaboration of Emile Darier. Nantes: Musée des Beaux-Arts, 1913.

Hodler Gedächtnis-Austellung. Berne, Switzerland, 1921.

Centenaire de Gustave Moreau, 1826-1898; Exposition Gustave Moreau et quelques uns de ses élèves. Preface by George Desvallières. Galerie Georges Petit.

Les Etapes de l'Art Contemporain, II, Gauguin et Ses Amis: L'Ecole de Pont-Aven et l'Académie Julian. Paris: Wildenstein Galleries, February-March, 1934.

Cinquantenaire du Symbolisme. Introduction by Edmond Jaloux. Paris: Bibliothèque Nationale, 1936.

Puvis de Chavannes et La Peinture Lyonnais au XIXe Siècle. Musée de Lyon, 1937.

Eugène Carrière et Le Symbolisme: Exposition en l'Honneur du Centenaire de La Naissance d'Eugène Carrière, déc. 1949-jan. 1950. Introduction and catalogue by Michel Floorisoone, notations by Jean Leymarie. Editions des Musées Nationaux Orangerie des Tuileries, 1949.

[1]Listed according to date of exhibition.

Ville de Nantes. Musée des Beaux-Arts; Catalogue et guide par Luc Benoist. Nantes: Musée des Beaux-Arts, 1953.

Charles Filiger, 1863-1928; introduction by Charles Chassé. Paris: Le Bateau Lavoir, 1962.

Neo-Impressionists and Nabis in the Collection of Arthur Altschul. New Haven: Yale University, 1965.

Les Salons de la Rose+Croix. Introduction and catalogue by Robert Pincus-Witten. London: Piccadilly Gallery, 1968.

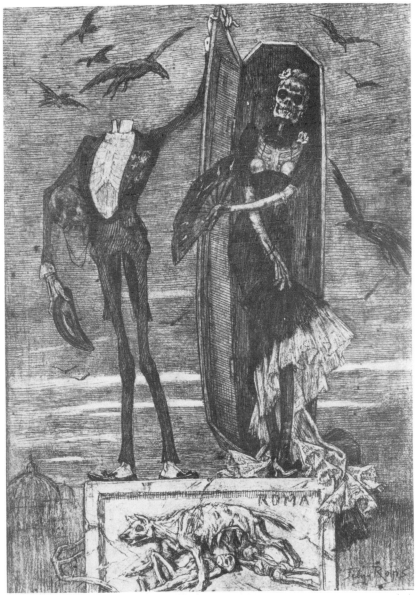

Fig. 1.--Felicien Rops. Frontispiece to Joséphin Peladan's
Le Vice Suprême, 1886.

Fig. 2

Fig. 3

Fig. 2.--Fernand Khnopff. Frontispiece to Joséphin Peladan's __Istar__, 1888.

Fig. 3.--Marcellin Desboutin. Portrait of Peladan, 1891. Angers Museum.

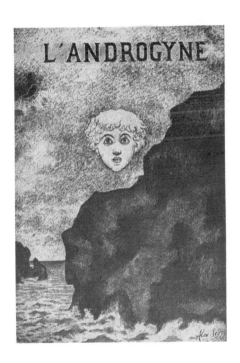

Fig. 4.--Alexandre Séon. Frontis-
piece to L'Androgyne, 1890.

244

Fig. 5.--Claude-Emile Schuffenecker. Catalog Cover for His One-Man Show, 1896.

Fig. 6.--Claude-Emile Schuffenecker. Poster for an Exhibition of Esoteric Art.

Fig. 7.--Jacques-Emile Blanche. L'Hôte, 1892. Rouen Museum.

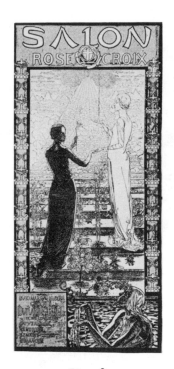

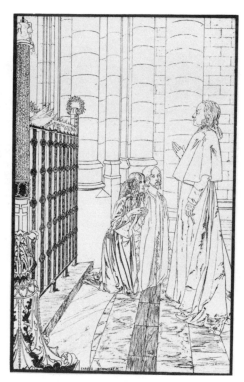

Fig. 8

Fig. 9

Fig. 8.--Carlos Schwabe. Poster for the First Salon de la Rose+Croix, 1892.

Fig. 9.--Carlos Schwabe. Illustrations to Emile Zola's Le Rêve, 1892.

Fig. 10.--Carlos Schwabe.　Drawing, 1897.

ORDRE DE LA ROSE+CROIX DU TEMPLE

Geste esthétique de 1892

SALON & SOIRÉES
DE LA

ROSE†CROIX

GALERIES DURAND-RUEL
11 — Rue Le Pelletier — 11

INVITATION D'HONNEUR

A l'inauguration du Soir, le Mercredi 9 Mars 1892

OFFERTE

à LL. SS. les Artistes exposants ou affiliés

à LL. EE. les Ambassadeurs séants à Paris

et aux Personnalités que l'Ordre veut honorer

L'Ordre invite

à l'inauguration du Mercredi 9 Mars, à 9 heures

du soir, au Salon de la Rose † Croix.

Le Grand Maître, L'Archonte,

SAR PELADAN

Fig. 11.--Invitation to the First Salon
de la Rose+Croix, 1892.

249

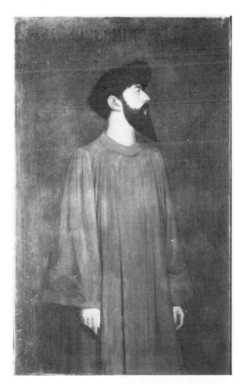

Fig. 12.--Alexandre Séon. Le Sâr José-
phin Peladan, 1891. Musée de Lyon.

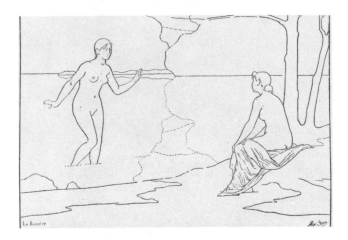

Fig. 13.--Alexandre Séon. La Rivière.

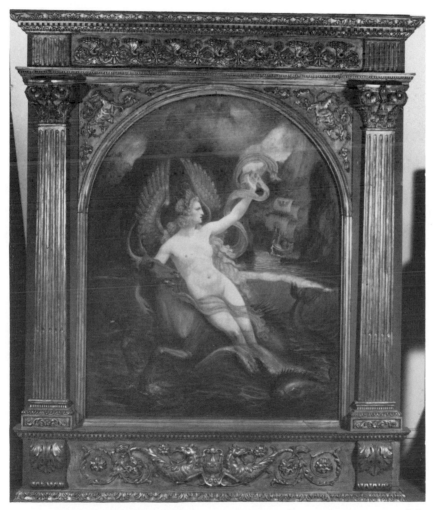

Fig. 14.--Armand Point. La Sirène. (La Sirène de Lacs [?]
Salon de la Rose+Croix, 1896).

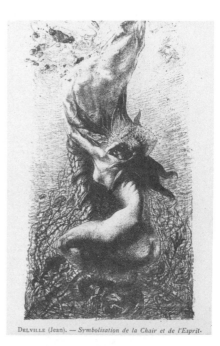

DELVILLE (Jean). — *Symbolisation de la Chair et de l'Esprit.*

Fig. 15 Fig. 16

Fig. 15.--Fernand Khnopff. La Sphynge. Bruxelles, Cabinet des Estampes.

Fig. 16.--Jean Delville, Symbolisation de la chair et de l'esprit, 1892.

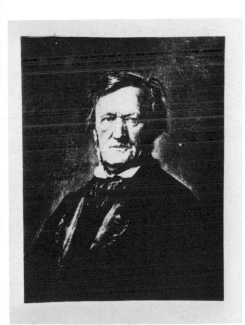

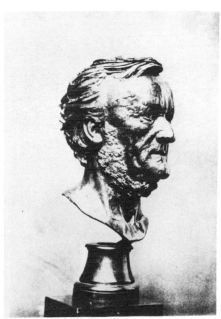

Fig. 17.--Rogelio de Egus-
quiza. Wagner, Painting.

Fig. 18.--Rogelio de Egusquiza.
Wagner, Bronze bust.

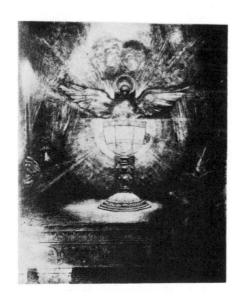

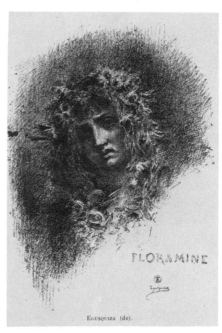

Fig. 19.--Rogelio de Egusquiza.
The Holy Grail.

Fig. 20.--Rogelio de Egusquiza.
Floramine.

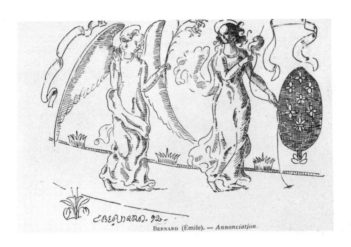

BERNARD (Émile). — *Annonciation*.

Fig. 21.--Emile Bernard. Annonciation, 1892.

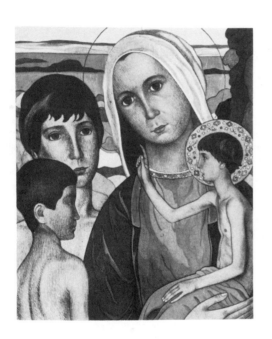

Fig. 22 Fig. 23

Fig. 22.--Charles Filiger. Saint Famille. Altschul Collection,
New York City.

Fig. 23.--Charles Filiger. La Prière.

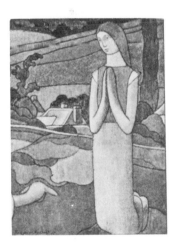

Fig. 24.--Charles Filiger. La
Prière. Gouache.

Fig. 25.-- Charles Filiger.
Sainte en Prière, 1892.

258

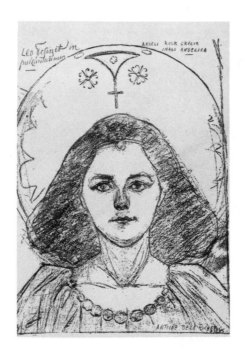

Fig. 26.--Antoine de La Rochefoucauld.
Rose+Croix Angel.

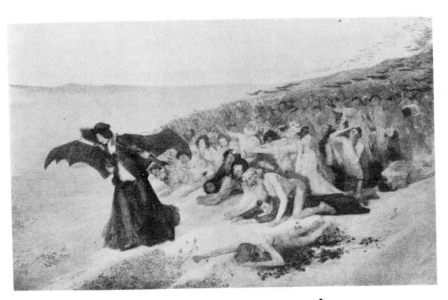

Fig. 27.--Henri Martin. Vers l'abîme.

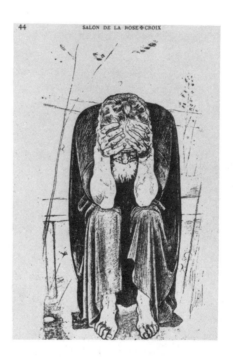

Fig. 28.--Ferdinand Hodler. Study for Entäuschte Seelen.

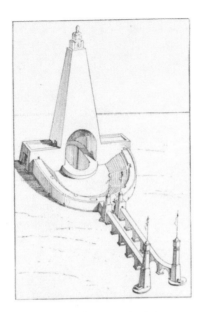

Fig. 29.--Albert Trachsel. Exécution d'une symphonie et re-
traite joyeuse.

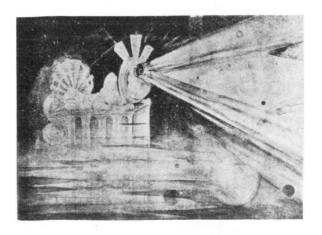

rig. 30.--Albert Trachsel. Le regard sur l'Infini.

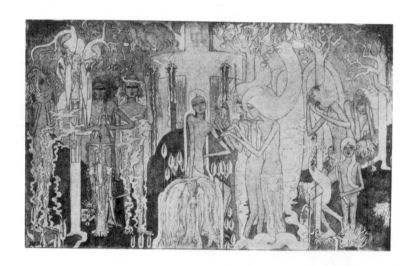

Fig. 31.--Jan Tooroop. L'Annonciation d'une mysticisme nouvelle.

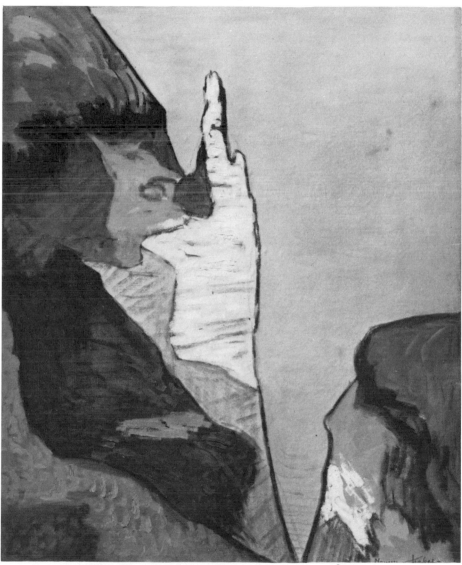

Fig. 32.--Maurice Chabas. Falaise, c. 1895.

264

Fig. 33.--Auguste de Niederhâusern-
Rodo. Verlaine.

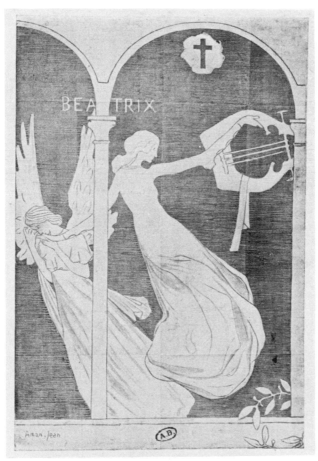

Fig. 34.--Aman-Jean. Poster for the Second Salon de La Rose+Croix, 1893.

Fig. 34.--Armand Point. Head of a woman.

Fig. 36.--Alphonse Osbert. Vision, in the studio of the artist, 1892.

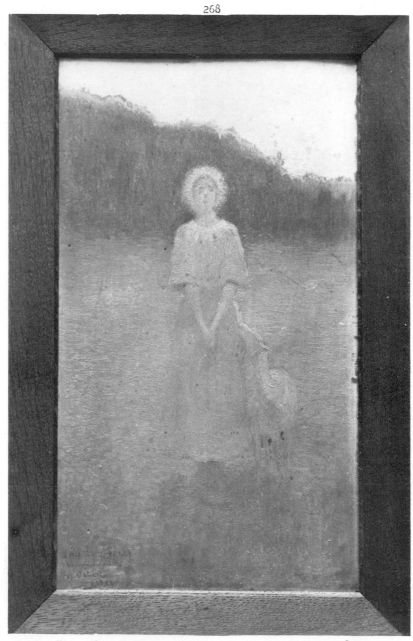

Fig. 37.--Alphonse Osbert. Study for Vision, 1892.

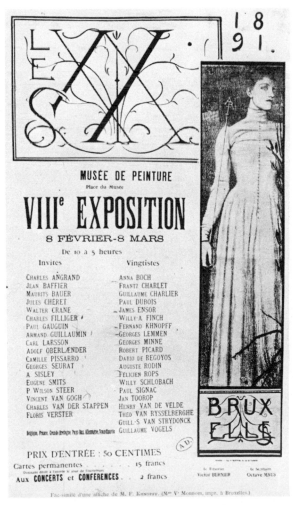

Fig. 38.--Fernand Khnopff. Poster for
the Eighth Exhibition of Les XX, Bruxelles,
1891.

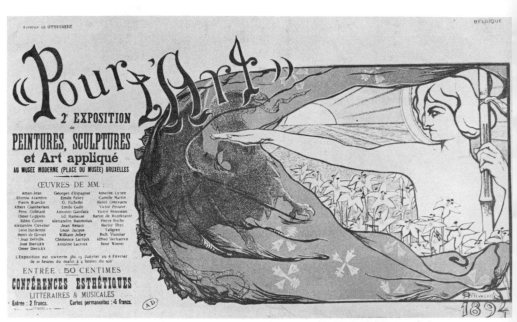

Fig. 39.--Henri Ottevaere. Poster for <u>Pour L'Art</u>, 1894.

271

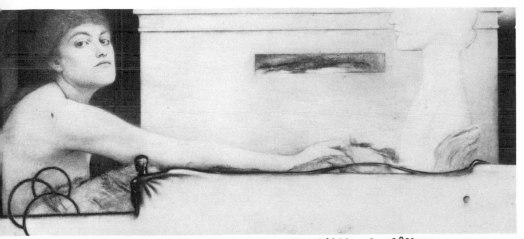

Fig. 40.--Fernand Khnopff. L'Offrande. 1891.

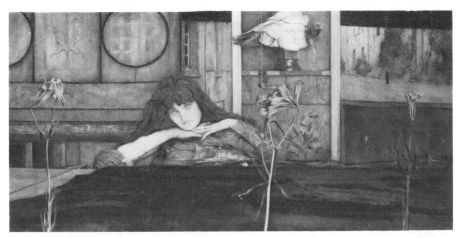

Fig. 41.--Fernand Khnopff. I lock the door upon myself, 1893,
Neue Pinakothek, Munich.

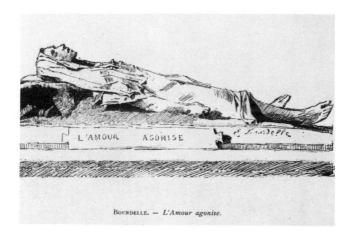

BOURDELLE. — *L'Amour agonise.*

Fig. 42.--Antoine Bourdelle. L'amour Agonise.

273

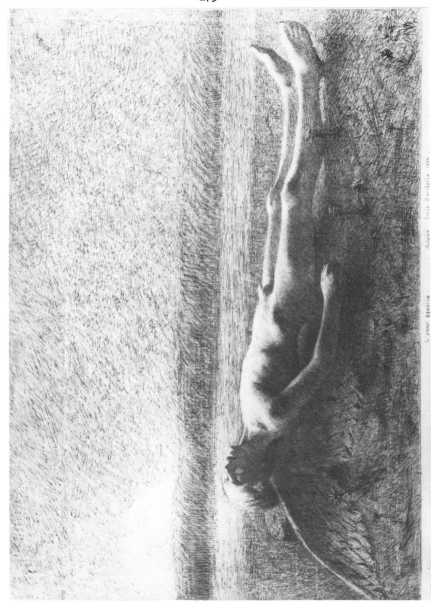

Fig. 43.--Antoine Bourdelle. L'amour Agonise. Drawing.

CÉSETTE

Fig. 44.--Antoine Bourdelle. Drawing for title
page of Pouvillon's Césette. Musée Bourdelle, Paris.

Fig. 45.--Antoine Bourdelle. Le Rêve du Pastore.
Musée Bourdelle, Paris.

Fig. 46.--Antoine Bourdelle. Michel-Ange Buo-
narotti. Musée Bourdelle, Paris.

Fig. 47.--Antoine Bourdelle. La mer roule, les
gemmes et les perles. Musée Bourdelle, Paris.

Fig. 48.--Antoine Bourdelle. Le Rire. Musée
Bourdelle, Paris.

Fig. 49.--Antoine Bourdelle. Bacchus endormi.
Musée Bourdelle, Paris.

277

Fig. 50.--Rupert Carabin. Chair.

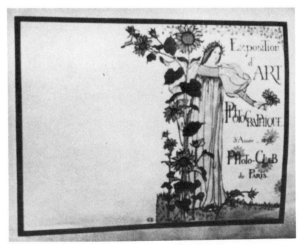

Fig. 51.--Edmé Couty. Poster for Exposition
d'Art Photographique.

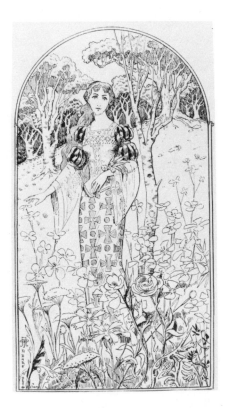

Fig. 52.--Andhré Gachones. Drawing.

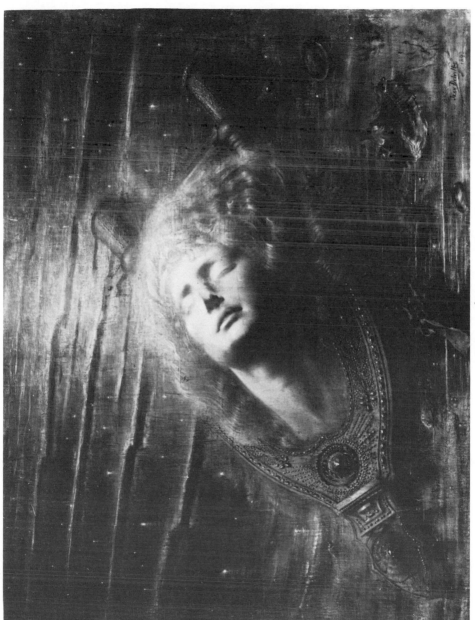

Fig. 53.--Jean Delville. Tête d'Orphée, 1893.

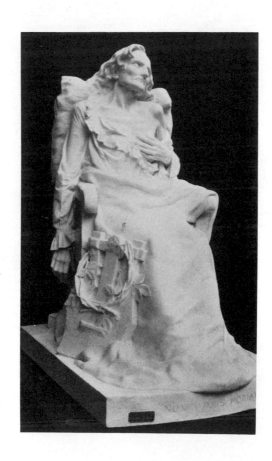

Fig. 54.--Pierre Rambaud. Berlioz mourant [?].

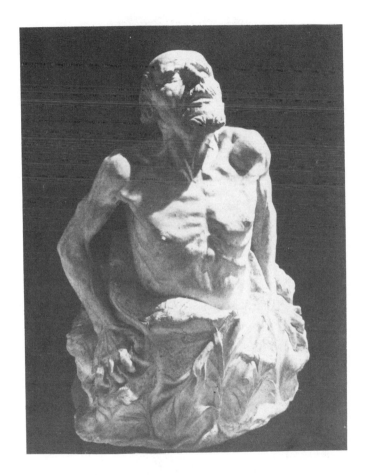

Fig. 55.--James Vibert. Vita in Morte.

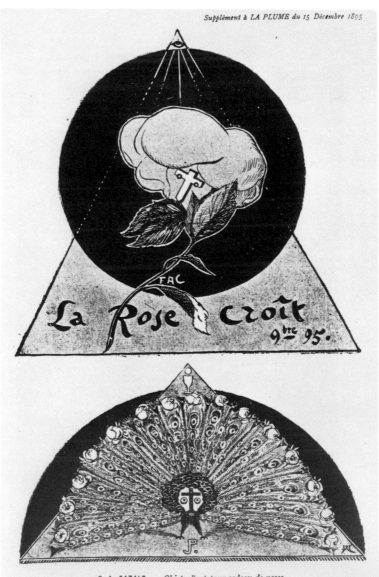

Supplément à *LA PLUME* du 15 Décembre 1895

F.-A. CAZALS. — *Objets d'art pour cadeau de noces.*

Fig. 56.--F. A. Cazals. "La Rose Croît" (<u>La Plume</u>, December, 1895).

Fig. 57.--Visiting card of Sâr and Princess Peladan.

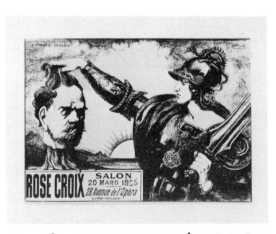

Fig. 58.--Armand Point and Léonard Sarluys.
Poster for Fifth Salon de la Rose+Croix, 1896.

284

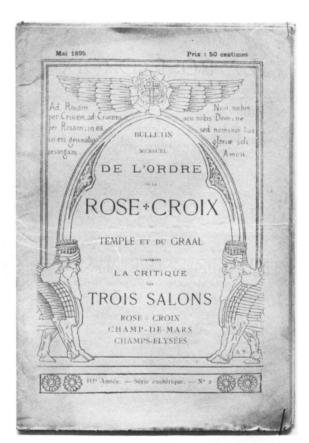

Fig. 50.--Alexandre Séon. Cover design for
Bulletin Mensuel de L'Ordre de la Rose+Croix.

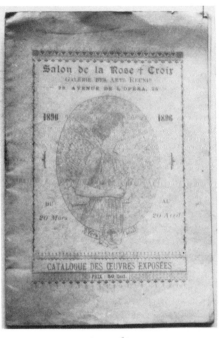

Fig. 60 Fig. 61

Fig. 60.--Alexandre Séon. Cover of the catalog for the
Fifth Salon de la Rose+Croix, 1896.

Fig. 61.--Frenand Khnopff. Lèvres Rouges.

Fig. 62.--Zachary Astruc. Bust of
Sâr Peladan. Bibliothèque de l'Arsenal,
Paris.

287

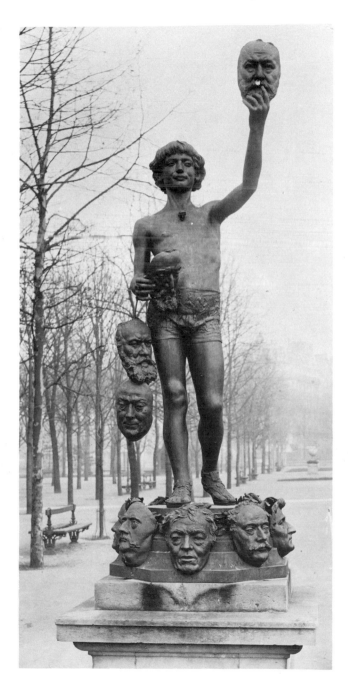

Fig. 63.--Zachary
Astruc. Le Marchand
de Masques. Bronze.
Jardin du Luxembourg.

Fig. 64.--Zachary Astruc. Detail
from Marchand de Masques. Mask of Jules
Barbey d'Aurevilly.

Fig. 65.--Georges
Roualt. Study for
L'Enfant Jesus parmi
les Docteurs, 1894.

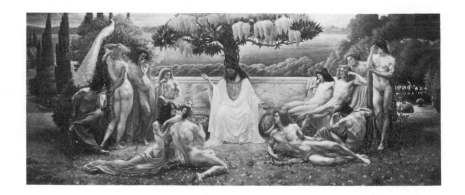

Fig. 66.--Jean Delville. L'Ecole de Platon.

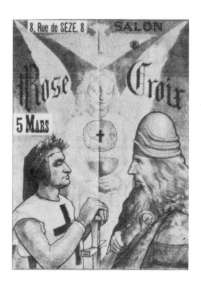

Fig. 67.--Gabriel Albinet. Poster
for the third <u>Salon de la Rose+Croix</u>.